From Camera to Computer

How To Make Fine Photographs Through Examples, Tips, and Techniques

George Barr

George Barr (www.georgebarr.com)

Editor: Joan Dixon
Copyeditor: Mark Hall
Layout and type: Terri Wright Design, www.terriwright.com
Cover design: Helmut Kraus, www.exclam.de
Cover photos: George Barr
Printer: Friesens Corporation, Altona, Canada

ISBN 978-1-933952-37-6

1st Edition
© 2009 George Barr
Rocky Nook, Inc.
26 West Mission Street, Ste 3
Santa Barbara, CA 93111-2432

www.rockynook.com

Library of Congress Cataloging-in-Publication Data
Barr, George, 1949-
From camera to computer : how to make fine photographs through examples, tips, and
techniques / George Barr. -- 1st ed.
 p. cm.
Includes bibliographical references and index.
ISBN 978-1-933952-37-6 (alk. paper)
1. Photography--Technique. 2. Photography--Digital techniques. 3. Example. 4. Composition (Photography) I. Title.
TR146.B3175 2009
771--dc22
 2009030028

Distributed by O'Reilly Media
1005 Gravenstein Highway North
Sebastopol, CA 95472

Printed in Canada. This book is printed on acid-free paper.

Unless otherwise noted, all photographs and illustrations are by the author.

Without the undying support of my trouper wife Isabelle Fox-Barr, this book would not have come to fruition. You'd think that writing the book would be the hard part, but truly, when you stop writing you are only one third of the way through the process, and I have not been "there" to do my share for more than a year now. Throughout, she has encouraged me without a hint of frustration or criticism, so I cannot thank her enough.

This is my second book with Rocky Nook and specifically with my editor Joan Dixon, who has been absolutely tremendous; in her enthusiasm when mine lagged, in patiently listening when yet again I came up with one of the all too many changes I wanted, and in her editorial skills of taking the rough edges from my prose.

I'd like to also thank Andy Ilachinski, fellow photographer, who was kind enough to proof chapters for me and who offered several suggestions which have materially improved the book.

To you, the reader, we share a wonderful pastime, an outlet for our creativity, a challenge to our intellect, and not incidentally, an activity that is a whole lot of fun. I wish you the best of times and a bundle of wonderful images.

Table of Contents

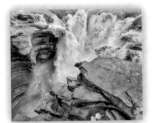
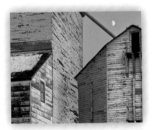

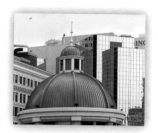

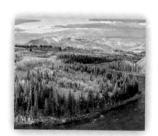
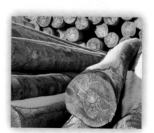

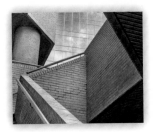

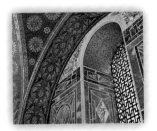
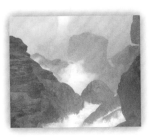

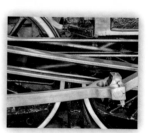

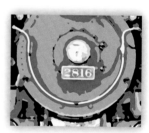

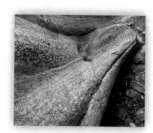

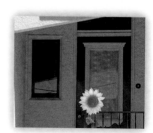

Introduction

I wrote this book for several reasons. First and foremost, I wanted to provide a book of real world examples from the point of view of a fine art photographer instead of a commercial shooter. It is my impression that a lot of photographers still struggle with working the scene and even coming up with ideas on what to photograph. Even more photographers struggle with what to do with editing rather than how to do the editing. Many are comfortable with fixing problems with an image, but are sublimely unaware of just how much further you can take an image beyond basic fixing, to add light and life to it.

In an ideal world, I'd go along with you as you photograph your favorite subjects, lean over your shoulder, peer through your viewfinder, discuss with you how you are handling the edges of the image, comment on the lighting, and suggest better angles. Since I cannot do that, I have written in detail the steps, problems, and solutions I go through to make my images.

Now, my images aren't your images, but in this book I have made an effort to include broad subject matter, including a chapter on travel and another on people—subjects I rarely photographed until recently. Some chapters show you digital proof sheets so you get an idea of the things I try as I work toward the best possible image. I discuss what's going through my mind as I look at the scene. In one chapter, I supply a series of image pairs from the same scene and discuss the strengths and weaknesses of each image. I'm pretty forthcoming on my mistakes in the hope that you will learn from them, and then you'll have to find your own mistakes to make. There can't be that many mistakes left to be made!

Throughout the book, and usually where the issues first come up, I have written about stitching, focus blending, high -dynamic range (HDR), sharpening, and other technical issues. I have provided some image crops to show you the problems of noise in shadows and the effect of local contrast enhancement. Since I frequently use Akvis Enhancer, which is a plugin for Photoshop to increase local contrast, I discuss both its strengths and weaknesses and illustrate its effects.

Many photographic books, especially ones that discuss Photoshop, are written by commercial photographers. They come at image editing from an entirely different slant than would a hobbyist, serious amateur, or fine art photographer. The commercial photographer has hundreds of images to adjust and a tight deadline to meet, often with only minor variations between images. If the commercial photographer can come up with a "trick" to quickly and painlessly adjust an image, and, even better, if he can apply the trick to all of the images, then it is in his interest to do so. Time is money for the commercial photographer.

The fine art or hobbist-photographer typically approaches an image without deadlines. Images are each unique and the client is "myself". Almost always, we are working on a single image and the length of time it takes to get it right doesn't really enter into the equation, as long as we are making progress to improve the image. The fine art photographer or serious amateur is concerned only with quality, and if a trick produces a result that is

a whole lot easier while being almost as good, then that "almost" rules out the trick.

Another problem arises with the commercial photographer tricks, and that is their sheer volume. You can read about dozens, if not hundreds of tricks in just one book. How you could be expected to remember, never mind become expert at these tricks, is a significant issue. In this book you won't learn hundreds of tricks, and certainly none that will make your images "almost" as good. What I will show you are tricks and techniques that can be applied to many kinds of images so you can use them frequently and become skilled in their use. I do my image editing with a very small set of tools that do an excellent job of improving images. Most certainly, there are other ways to get the effects I aim for, and this book is not a review of all the possible methods of editing. Rather, it shows you the tools I use on a daily basis on my images. If you like the images I make, and want to know how I make them, then this book will help you. Even if my images are not to your taste, you can still learn to improve your own images to make a strong statement.

An issue that I feel strongly about is that when I make a photograph, it is not intended as a literal translation of what I saw. Instead, it is about what I felt or even what I thought I could do with the subject. Everything I do is geared toward the fine art print. With my background in black and white photography, it was always natural to enhance images with a bit of dodging here, burning there, and eventually bleaching. It seemed only natural to extend these same techniques first to the digital world and then to color. I will show you how far you can take an image to make that fine print. This may seem odd when one of the common faults of novices is to produce garish color, overdo local contrast, and generally produce an image

that is hard on the eye, while I would like to think that most of my images look natural and don't strain credibility.

Some chapters of this book discuss only a single image—either how I captured it or the steps I took in editing it. Other chapters discuss a series of images and concentrate on the issues of finding and recording the images.

Almost all the images in this book are recent, and very few were in *Take Your Photography to the Next Level*, my previous book published by Rocky Nook. All the images, except those from San Francisco and Europe, were taken within a 3-hour drive of my house. In fact, half the chapters feature images taken within 30 minutes from my door. Almost every image could have been taken with the most basic DSLR with a couple of kit lenses, and maybe a close up lens or extension tube. I do have good equipment, but that has more to do with being able to make really big prints that customers sometimes require than it does with being able to capture the image in the first place.

My main camera for the last three years is my Canon 1Ds Mark II which I have now supplemented with a Canon 5D2. I travel with a Canon 40D. I would happily use Nikon equipment, except that Canon was the only practical choice for me a few years ago. Now, with a decent collection of lenses, I am not about to start over.

Consider the wonderful images of Harold Mante who loves to show off his latest "fancy" equipment to his students—a 20 year old Minolta in which he continues to very successfully use slide film. Harold has several wonderful books to his name.

Most of my images are manually focused (albeit with focus confirmation). I use a tripod with mirror lock-up and cable release for all but a handful of images. Lately, with the 5D2,

I routinely use Live View (which automatically pops up the mirror and eliminates the shutter opening). I use a 4-year-old G5 Mac and 20-inch LCD screen for my editing. I own a variety of printers, most recently an Epson 3800. I print on Moab Entrada bright white or Harman FBAL gloss papers, the latter more and more.

A lot of photographers, some of them famous, give the impression that most images can be managed with global corrections within Adobe Camera Raw or Lightroom. These are adjustments that apply to the entire image, say, color correction or contrast adjustment. It is interesting that Lightoom now has some of the local adjustment abilities that the same people claimed they rarely needed. I hope that in this book I will convince you of both the power and the suitability of local adjustments to parts of an image as a very effective work-flow for making the fine print.

With Lightroom and Camera Raw now capable of making local corrections, you may wonder (quite reasonably) if you really need Photoshop at all. My feeling is that Lightroom and Camera Raw are ideal for making a few basic corrections, but are far from ideal when making hundreds of corrections and improve-ments to an image, as I typically do with my photographs. I will certainly continue to use Photoshop for my local editing and suggest that if you are interested in the best tools for image editing, that you do too.

Some warnings: This book does not discuss printing. You will need other resources to go from your edited image on screen to make a print that does justice to both your photog-raphy and your editing. Although I mention the equipment I use, I do not discuss relative merits of brands and models of cameras and lenses.

I will have succeeded with this book if, when you go out photographing in the future, you think about some of the things I have shown here, perhaps modifying your strategies and techniques based on my ideas; and, most importantly, if my advice results in greater satisfaction with your art and craft. The ideas presented in this book have given me a great deal of enjoyment, satisfaction, and good success. I see no reason for this not to rub off on you.

GEORGE BARR, 2009
www.georgebarr.com

Notes On Using This Book

First and foremost, this is not a "How To Use Photoshop" book. If you aren't familiar with basic image editing in Photoshop and the concepts of adjustment layers and masking, you are going to struggle reading much of this book. For those who are not conversant with Photoshop use, I have provided a "Photoshop Primer" as an appendix at the end of the book. This appendix explains those parts of Photoshop that I normally use and ignores the many that I rarely or never use, thus simplifying this huge and sophisticated piece of software.

If you find that you need more help than is provided in the "Photoshop Primer" appendix, then you probably want to purchase one of the many good books specifically written to explain Photoshop. In addition, there are classes, video tutorials, and tips on the Internet to help expand your use of Photoshop.

In addition to Photoshop, I use Photoshop plug-ins and standalone products to help my workflow, specifically Akvis Enhancer, Photomatix, Photokit Sharpener, and some of the tools available from Outback Photo for detail enhancement and local contrast control. For assistance with the whole issue of high dynamic range (HDR) photography, I highly recommend the website www.outbackphoto. com. In addition, I use Helicon Focus for focus blending and PTGui for stitching.

I have tried to maintain some conventions in the book. Most chapter titles refer to a specific image or project, but I sometimes include various images in a single chapter to illustrate a point I'm making. Each chapter starts with a very brief description of the concepts discussed within.

Throughout this book I offer tips and suggestions, which you'll find in the highlighted text boxes, making them easy to spot. Simply flipping through these alone will give you a mini course in photography.

Images and illustrations have a brief description and you can learn a fair amount by just looking at the various images in sequence, but I have tried to avoid a lot of duplication with the text and kept the image descriptions short.

I have uploaded a number of images to my website to fit 1000 pixels wide by 800 high. They are located on my website in this book's section; you can find them by chapter and figure number. You may download them and experiment with your own editing or cropping. You can put the images in layers into Photoshop and turn layers on and off to see the effects of the editing steps more clearly.

I make my images available to you with the understanding that you will use them solely for your own educational purposes. The images are not to be shared, posted to the web, or printed for any purpose other than for your own education. I own the copyright to all these images and have permission from all of the people who let me photograph them for my use.

Should my readers discover any errors or omissions in this book, please let me know and I will post them to my website as well. Unfortunately, an entire list of points went missing from my first book and it was only when a Chinese non-photographer translator

thought it odd that nothing followed after announcing a list of points that we realized the error. I hadn't noticed it, the editor didn't either, nor the German translator, nor for that matter the first 7,000 readers of the book. I was most impressed with this interpreter. Here's hoping any list of corrections to this book is a small one.

This book has been written from the point of view of a Macintosh computer user, because that's what I use, and many Photoshop users also work on a Mac. If you are a Windows user, it is not difficult to switch from Command-Letter to Control-Letter. Photoshop is set up to operate almost identically on either system.

1 Athabasca

- *Doing what you must to get the image*
- *Correcting and improving a landscape*
- *Image editing using Curves*
- *Highlight dodging*
- *Selective color*
- *Threshold highlight protection*
- *Akvis Enhancer*

A Little Background on Athabasca Falls

Waterfalls are such an ingrained part of photographing the landscape. They feature on postcards and calendars and illustrate books. Most hobby photographers approach the subject early in their development. I discuss issues related to photographing famous subjects in chapter 14, "Waterfall", but in this chapter I'm going to share with you the steps I took to record this image and a lot more on editing it so it would reflect what I saw and felt while standing before the falls.

Athabasca Falls is a famous tourist stop south of the town of Jasper, in Jasper National Park, Alberta, Canada. There are viewpoints with railings and even a bridge below the falls so you can get to the other side for an even better view. Problem was, the railing was several feet from the edge and blocked the best view of the falls, at least photographically.

If you do a Google image search for Athabasca Falls, you will see a large collection of images, most of which include the river with the forest and mountains above, and make these magnificent falls look quite unimpressive. I knew immediately that I wanted to concentrate on the best part of the falls. In the past I made a very successful image while standing on the bridge below the falls, but on this occasion really liked what I could see of the falls from the higher viewing area. However, I would have to overcome the problems of the location.

The Image Capture

The image was captured by mounting my Canon 1Ds2 and 17- 40 mm lens on the end of my tripod, and then while holding (tightly!) the bottom of the tripod I rested it on the railing about two feet from the end. In this way I was able to extend the camera a good four feet past the railing, where I could see nothing of

▼ *Figure 1.1*

The day promised to be good when I went out to find this lovely frost pattern on the roof of my car – Image blend for depth of field.

what it was capturing, but hey, you do what you have to do.

I triggered each image using my plug in electrical cable release although the two or even 10-second self-timer would be an alternative in most cameras. It took several trials to get the framing I needed. I clamped the ball head, ran the camera out, checked that no one was leaning on the railing, and shot the picture. I then brought the camera back to myself and checked the LCD for the framing of the image. I had to guess how far to adjust the camera and tried again and again, until after several tries I was able to capture the image I had hoped for. Of course, one of the new cameras with a titling, swinging LCD screen would be wonderful in this kind of situation.

Know your camera and what its limits are in terms of resolution, depth of field , maximum f-stop. useable ISOs, shutter speed limitations for both handheld and other situations. Don't look them up—test them for yourself.

▼ **Figure 1.2**
Athabasca Falls – output from Adobe Camera Raw.

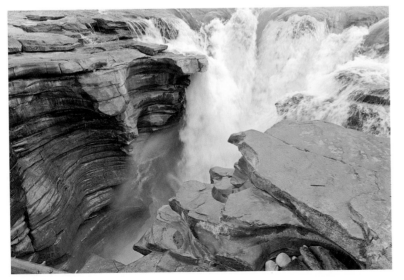

I captured this image at 29 mm focal length, f-10, 1/60 second at ISO 200 (figure 1.2). The water might have looked better at a slower speed, but I doubted I could hold the camera steadily enough while extending it so far beyond the railing. Basically all three settings were a compromise—adequate depth of field with a wide angle lens, short enough shutter speed (this wasn't an image stabilized lens), and a low enough ISO to make a good image while high enough to get that shutter speed to a reasonable semi-hand-holdable 1/60 second. With some of the newest cameras I would have happily gone to ISO 400, or even 800, but I knew I'd be lightening some shadows in the overhanging rocks. These areas were particularly dark, and on my camera, as good as it is, noise in these areas would be problematic

Advantages of RAW vs. JPEG

I always photograph in RAW format. With memory cards as inexpensive and large as they have become, memory limitations are not a reason to use JPEGs. About the only good reason to use the heavily compressed JPEG format is that, oddly, most cameras can convert to a JPEG very rapidly and result in only a small file to send to the memory card. RAW files are basically the data right from the sensor, with no manipulation at all, and should in theory be faster. However, the bottleneck of the process is writing to the memory card and the much larger file size of RAW images can slow things down or limit the number of images taken in a sequence. This has never been a problem for me but it can be for sports photographers who, in an effort to get the perfect shot, hold the shutter button down and fire off a dozen or more images in the knowledge that one will likely capture the absolute peak of action.

If RAW is slower, then why bother? JPEG actually does a remarkably good job of storing most of the image information in as little as one-tenth the file size. That said, it isn't perfect and there is a little bit more detail and higher quality in a RAW file. More important for me, RAW does not fiddle with the image in any way, letting me control things like sharpening, white balance, shadows, and highlights, all on my computer while viewed on a large screen.

Canon cameras are not renowned for their high quality JPEG images, but even Nikons and other brands can benefit from shooting RAW by using the Recovery slider in Adobe Camera Raw to recover lost highlights. With my Canon cameras, the Recovery slider does a stellar job reigning in unruly highlights, to the tune of a couple of f-stops worth compared to JPEG.

On the issue of which RAW processor to use, I have dabbled with other software—Raw Developer, Canon DPP, and C1—but each time, though in some areas they have advantages, in other areas I prefer what Adobe Camera Raw does and I have settled on it for all my work. For example, I had the impression that Raw Developer seemed to show more fine detail, though it turned out to be simply a grainy pattern on the image that appeared like real texture. I preferred the smoothness of Camera Raw that gave digital images the look of having been photographed on a much larger format film camera.

Over time RAW image processors have all improved substantially. In one case I was able to double the size of print I could make just because of improvements in RAW processing and sharpening compared to three years previous. With JPEG files, you are stuck with today's technology forever and you don't know that a few years from now, you might well regret not being able to avail yourself of the latest RAW software improvements.

Figure 1.2 is the output from Camera Raw. While I could certainly have made it look better using the standard Camera Raw Adjustment sliders, the image as it is has one main thing going for it: detail—everywhere—the shadows are open, and the highlights are under control. Frankly, this is all I need from my Raw processor. I virtually always do further editing after the conversion in Camera Raw, so all I want is a file that I can work with in Photoshop, and the image in this example is perfect as a starting point.

Lightroom can do a lot, but the more powerful tools in Photoshop are better suited to the fine art image, while Lightroom is ideal for the "in a hurry" commercial studio.

Editing the Image

The image may have all the detail it needs but it sure has a number of problems. The water is too washed out (Can you say that about water?), and the rocks on the left and right aren't the same hue; the ones on the left having a distinct yellow/green tinge that I don't like. That flat rock on the right sure is anemic. There's a log in the bottom left that has to go. A stick, or something is sitting on the flat rock on the right and something green projects into the bottom right corner. And that's just for starters.

My first task is to correct the left side of the image to remove the seasick look of the rocks. I certainly wasn't aware of that color as I stood there but it doesn't look right on screen. I could use a Color Balance Adjustment Layer, or Curves, perhaps Hue/Saturation or any one

of a number of other methods to improve the color on the left.

I chose to use the Selective Color Adjustment Layer because I thought it would be simple and effective, while doing the least damage to other areas of the image. Although I wanted the yellow/green out, I didn't want to turn the whole area pink, which is what a Color Balance Adjustment Layer would have done. I knew the problem was a predominance of yellow/green in the rock, so it seemed reasonable to choose to change the yellow and to reduce the cyan component. I could have increased the magenta of the yellows, but I wanted less green, not more red. Of course, the Adjustment Layer is masked so the effect is only applied to the relevant rocks. Result: perfect.

Next, I decided to tackle the detail in the water. I could use the Burn tool on it, but I prefer to leave burning and dodging for near the end of my workflow, so I chose to start with a simple Curves Adjustment Layer. Using

burn and dodge requires many strokes of the brush, each one taking up one "undo" in the history and rapidly using them all up. The only practical way to use burn and dodge would be to duplicate the image and work on the copy, but even with this method there are problems that I address in a future chapter.

It is important for me to use an Adjustment Layer for the editing. It means that at any point prior to flattening the image I can go back to adjust something. It also means that I can reduce the effect of a layer by turning down the opacity of that layer (I'll show you how later). Combined with using masks for each layer to control both where and how much of the layers effect comes through, I have a very powerful tool for modifying an image.

Figure 1.4 shows the curve that I used. The effect makes the water look way too dark, but it does a lovely job of bringing out the detail in the white water. Also, I happen to know that near the end of the editing process I can easily fix the darkness of the water and make that foam sparkle.

▼ **Figure 1.3**
Green tinge to rocks on left removed with Selective Color Adjustment Layer, color yellow, reduce cyan slider.

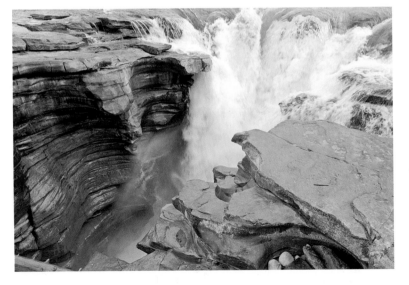

> *When creating an effect with an Adjustment Layer, it often pays to take the effect too far, then use masking or even the opacity slider of the layer to tone down the effect.*

I will be masking the curve so it only applies to the water, but there's no point in creating headaches for myself by having the shadows so dark that I have to spend hours getting the masking just right. I therefore level off the curve (figure 1.4) in the lower darker parts of the image rather than using a straight line down. Note, that the water consists of very light to medium tones and is thus not affected

by the darker parts of the curve. By making a curve that doesn't cause big problems for adjacent areas, you make things easier for yourself when it comes to painting into the mask. For example, if you want to darken the water but not the rocks and you don't want to spend hours fiddling with the edge between the two, creating a curve that will change the water without creating much change in the rock will save time and make the job of masking easier.

Next, I want to increase overall contrast in that flat rock area on the right. Clearly, this is a call for another Curves Adjustment Layer. An S-shaped curve increases contrast.

The steepest part of the S-curve is where the contrast is increased, so move the steepest part to the left or right depending on whether you want to boost the contrast in the darker or lighter parts of the image.

▲ **Figure 1.4**
Curve Adjustment Layer to darken the white water.

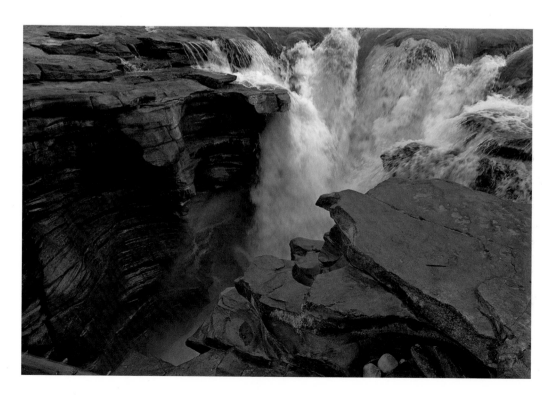

◀ **Figure 1.5**
Darken water curve applied everywhere.

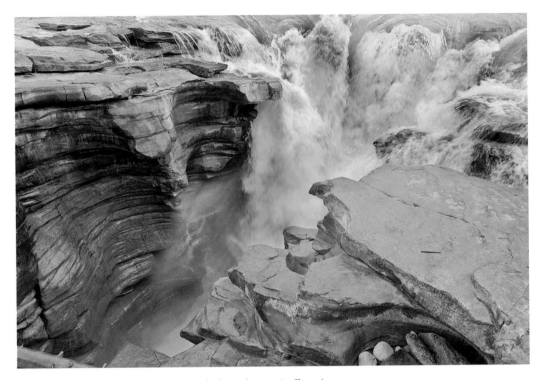

▲ *Figure 1.6* Darken water curve now masked so only water is affected.

It is possible to change blending mode from normal to some other blending mode, for example, to increase contrast and have it work across an image, thus saving time, but I prefer to be the one calling the shots, rather than some formula built into Photoshop for over-laying, multiplying, darkening, or whatever. Blending modes refers to the way that one layer affects the layers below it. For example, if you switch from normal blending to lighten, only those pixels that are lightened by the top layers effect are changed. Those that would have been darkened are left "as is". There are more than a dozen blending modes other than normal, each having powerful effects on the image, but you cannot control how the modes affect the image other than to change to a different blend. There is no subtlety, no fine control, other than to have a little layer effect, or a lot. More blending mode choices would just be confusing.

Many books show all manner of tricks to create selections that can then be adjusted. So why is it that I choose to "hand paint" masks instead? Frankly, it is both easier and better. It is easier because remembering the exact steps to create a particular type of selection is problematic, whether it is based on color or brightness, a particular channel, or some other aspect. It is easier because automatic selections can easily select more or less than what you would have most likely wanted, or leave telltale edges. If you are photographing a white wedding dress against a bright red background, it's pretty easy to make a selection for just the dress. But when working on one particular tree against a background of a forest, it's a lot harder.

You can add a mask using the icons at the bottom of the layers palette. When a layer without a mask is highlighted (i.e., the active layer) the icon second from the left at the bottom of the layers palette (the circle within a rectangle) becomes a tool to add a mask. If you hold down the option key first, you get a black mask, otherwise it's a white one.

To adjust an image, make sure the mask is selected (has a rectangle around it). A white mask means the Adjustment Layer applies to the entire image, a black one will not be applied anywhere. You can then paint into the mask with black or white to change exactly where the layer effect will be applied. You will still see the image on screen but any painting over the image with your brush will affect the mask, not the image.

In theory you could paint into the mask with grays or even colors (color has no effect on a mask), but it's better to only do your painting with either pure black or pure white and use the opacity slider of the paint brush to control just how much of the black or white is applied. When you apply a second stroke of 10% white to a black mask, you get 80% black instead of 90% as you had after the first stroke (remember the brush was applying 10% opacity white).

For example, if you have a color image and you want everything black and white except, say, the child in the middle. In this case, it might be easiest to add the Black & White Adjustment Layer that will then take effect over the entire image. When you add an Adjustment layer via the layers palette, it automatically comes with a white mask and the mask rather than the image is selected (the icon is framed). Interestingly, if you add an Adjustment layer via the Layers menu, there is no mask automatically added. With the mask present and selected I can use a paintbrush over the image,

but the paint actually goes to the mask. A black brush applied over the child will bring back the color. A black brush with only 10% opacity will bring back a little of the color since painting 10% black into a white mask makes it 90% white or light gray. Almost all of the black and white conversion applies, but not quite all—a little color will "leak through".

You can paint white into a black mask so that the layer's effect is applied only where you paint the white; or you can apply black paint onto a white mask so only where you paint, the layer effect will be reduced or eliminated (depending on the opacity of the black).

If this is new to you, at this point you are probably convinced that using masks and painting into them is anything but easy and you're ready to go back to one of those books written by a commercial photographer. But remember, this concept of mask painting can be used for all Adjustment Layers. It is the only trick you really need. Hang in there, and if need be, read the "Photoshop Primer" at the end of this book. Your persistence will be rewarded.

Black in a mask means the Adjustment Layer has no effect, white causes the full effect, and tones in between result in the adjustment layer having some effect. The lighter the gray the greater the effect.

As an example of how easy it is to paint into masks, I was teaching editing at a workshop in San Francisco and lacking a mouse with my laptop, did the entire editing with my index finger on the laptop's track pad. That's how imprecise you can be. It doesn't take long to learn to paint an area and, because you are only painting into the mask. Using

▶ **Figure 1.7**
Curve to increase contrast in the flat rock on the right.

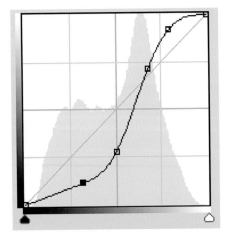

the X key, you can change the color of your paintbrush to the opposite extreme (white if it was black, etc.), and you can undo what you did where you "slopped" over the edges of something else. The smaller the brush the more accurately you can control where the effects are applied. Brush size is controlled by the rectangular bracket keys. You can invert the color of your brush via the X key.

Sometimes it pays to slop the brush effect well beyond what you want changed, and then type just plain X to invert the colors and paint out the areas you didn't want changed. A classic example of this is a triangular area in which it is awkward to continuously reduce the width of the brush to get right into the corner of the triangle. It is much faster to slop the paint on and then undo the spill by switching from white to black and painting along the edges outside the triangle.

Getting back to the image and the problem with the water. I created a curve (figure 1.7) that added contrast to the flat rock but it darkened much of it way too far. I then used command-I to invert the white mask to black, which means that the layer didn't apply to any of the image. I could then use a soft brush to paint white into the mask, using reduced opacity (anything from 10-50%). The layer effect started to build up in the areas I painted. Multiple strokes would increase the opacity, so often I just set it to around 20%, and apply multiple strokes as needed to further lighten the mask and thereby increase the effect of the Adjustment Layer. That is how I got the mask in figure 1.8.

For further information on the differences between fine art editing and commercial editing, reread the Introduction to this book. (You did read it, right?)

At this point we're ready to clone and crop. After that it's a matter of going over the image

▲ **Figure 1.8** Mask for the Curve Adjustment Layer in figure 1.7.

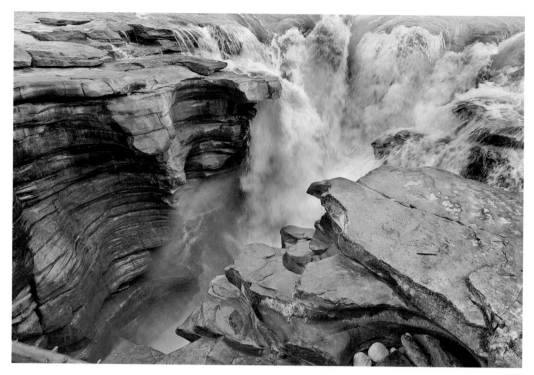

▲ *Figure 1.9* The masked increase contrast Curve applied to the flat rock on the right.

area by area and making small adjustments that will improve the image.

Cropping this image wasn't an easy decision. Truth is the rocks on the far left are nice. They are a continuation of the rocks closer to the middle and deserve to be included, reinforcing that part of the image. Problem is, they come with a price and that is the pesky log in the bottom left corner.

I could crop the bottom of the image but I quite like that little curve of small stones on the bottom right and don't want to lose any of that area. In theory, I could clone out the log but since the part I'd have to add back is not something simple like the water but actual rock, it would take some effort and might be noticeable after the fact. On the whole, I don't mind small cheats, but I avoid big ones like this.

> *It doesn't matter how good the part of the image is, if it compromises the image as a whole, it has to go. Be ruthless!*

It occurs to me that in losing some of the rock on the left, the water becomes an even more prominent part of the image, which is what I wanted to emphasize over all else.

I discuss cloning in a later chapter, both the ethics and the techniques, but suffice it to say, an errant twig or leaf is ideally suited to be cloned out of an image. And I was able to fix the bottom right corner and the twig lying on the flat rock with no difficulty.

I haven't quite given enough detail to the water, so I added another Curves Adjustment Layer to further darken it. I could go back and edit the previous darkening curve, say by

altering the curve (if I haven't flattened the image at some point), but I would run the risk that to fix one area of the water, I could spoil another, so it is better to add a second similar layer. I want to brighten those small rocks on the bottom right that sit in the curve of the rock caused by a back eddy millennia ago, so I used a lightening curve which nicely opened up the area.

Now it's time to make final adjustments with the Dodge Highlights from the tool bar on a duplicate of the image. I do this by first flattening the many layers (Layers/Flatten Image) and then duplicating the image by dragging the image layer to the icon second from the right at the bottom of the layers palette (figure

Figure 1.10
Duplicate Layer Icon located at the bottom of the Layers palette, second from right.

1.10). By the way, Photoshop doesn't come with a keystroke shortcut for flattening the image, but it does allow you to create you own keystroke shortcuts. I converted the F13 key to flatten image (Edit/Keystroke Shortcuts). I have also added shortcuts for several other tasks that would take longer via menu/submenu.

The idea behind duplicating the image and working on the copy layer is so I can edit to my heart's content but can always mask out anything that goes "over the top".

Photoshop has a multiple level undo capability. This is very nice, but it does take a lot of memory to be able to recall what happened 25 steps ago. With the Dodging tool, in particular, I use a very weak effect with multiple applications to get just the effect I want. That means dozens of brush strokes, each accounting for

one of those undos. Therefore, it is almost a guarantee that you will run out of undos and have to find another way to back track, which the duplicate image layer provides in spades by letting you reduce the changes in any area of the image by painting the mask darker in that spot. Since you can do this as many times as you like, the limit to the number of undo's does not apply.

I find that using the Dodge Highlights tool is like turning on the sun; the image just shines. I have discovered that dodging repetitively tends to damage the image file, first by driving some pixels to pure white, but also by accumulating small errors. It would appear that while Curves uses floating-point arithmetic, Dodging does not and the errors of rounding up or down can eventually lead to some very odd-looking areas of the image. To be fair this was a bigger problem in the days of 8-bit files. Using Curves does not accumulate damage in this way and you can add as many Curves Adjustment Layers as you like; thus the strategy to leave Dodge Highlights to the last.

Since dodging can drive pixels to pure white from whence they may not be retrieved, I want to share a trick for getting those highlights really light without driving them to pure white. First, add a Threshold layer on top of all your current layers. Set the threshold to around 250 (pure white being 255). Next, set the layer opacity so you can see a little of the underlying image through the threshold. Finally, if you set all of the above as an action, or, even better, as a keyboard shortcut for an action, you will have a powerful tool for editing your highlights. (Oh, and you can do the same for shadows, too.)

The Threshold Adjustment Layer shows only the pixels that are brighter than the level you set for it, in this case 250. The remaining

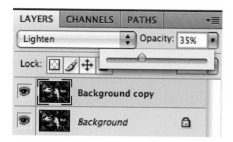

▲ **Figure 1.11**
Layers palette opacity slider – set to reduce the opacity of selected layer to 35% of full effect.

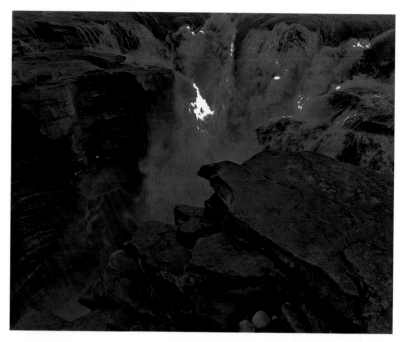

▲ **Figure 1.12**
Threshold Adjustment applied to the image, showing only those pixels brighter than 250 (on a 0-255 scale).

pixels are pure black (not having reached threshold). Like all Adjustment Layers though, you can reduce the effectiveness of the layer by reducing the layer opacity. As you click to the right of "opacity", a slider (figure 1.11) appears that lets you control just how much of the effect you want. In this case, by knocking back the effect to around 90%, it allows 10% of the original image to peek through the black, so you know where you are.

Now you dodge the copy image which sits below the threshold layer (by clicking on that layer to make it the active one), and as highlights reach 250 they suddenly show bright against the rather dim image. Should the area showing bright be too wide, then you overdid it and will likely end up with a large white blob in the print. You can simply undo the last brushstroke of the Dodge Highlights brush. By the way, I usually set the opacity of this dodging tool to around 5% since I want subtlety. This is done by using the slider at the top of the screen or more handily by quickly typing in "zero five" (typing anything from one through zero sets opacity to 10–100%).

Now and then I turn off the threshold layer to see the overall effect (the little eye symbol to the left of the layer). If I am unhappy with

something I did 25 brush strokes ago (further back than history records in my Photoshop preferences) then I can mask the overdone area in the duplicate image layer by adding a white mask to the duplicate image layer, and then painting black into part(s) of it to eliminate or reduce the effect of the dodging.

In figure 1.12 you see what things look like with the threshold layer activated and some dodging having been done. In fact, you can see that the middle area was likely overdone and should be fixed via the masking described above. A large chunk of image was driven above 250. This might be correct, but most often it means I have gone too far.

The actual number you use (250 or whatever you choose) is a function of your printer and its ability to separate very light from pure white. The better it can do this, the closer to 255 you can place your setting.

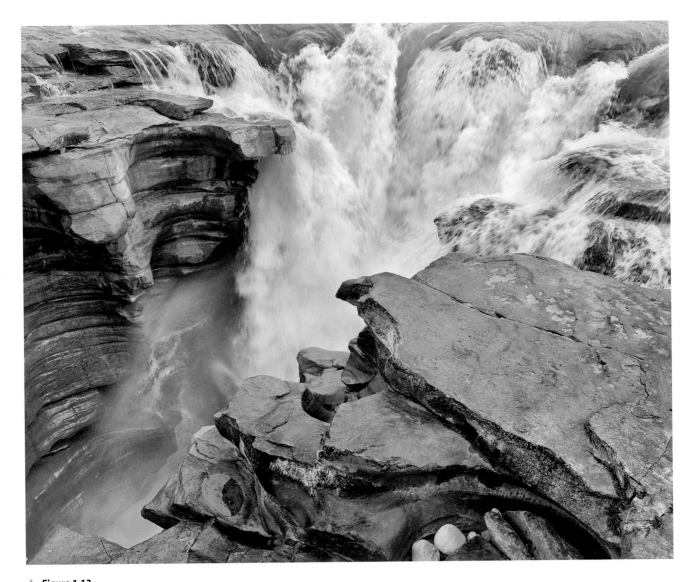

▲ *Figure 1.13*

After image cropping – loss of some nice rock on the left but water now emphasized and problematic log in bottom left gone.

Figure 1.13 shows the results of the dodging and various other minor changes. Note the increased mist through dodging and the power of the highlights in the water. The green in the water is stronger too. That's because after darkening the water the second time, I increased the contrast in the water. Anytime you increase contrast, you also increase saturation (unless you use "luminosity" blending instead of "normal"). Of course the effect was masked so it only affected the water.

Notice that I have cropped the left side of the image and my log "problem" is solved.

At this point the image is looking pretty darn good. But my previous experience with Akvis Enhancer tells me I can improve it even further via this Photoshop plug-in (figure 1.14). I discuss Akvis Enhancer in more detail later in the book but suffice it to say it brightens images, opens shadows, and improves local contrast (bringing out textures and subtle details).

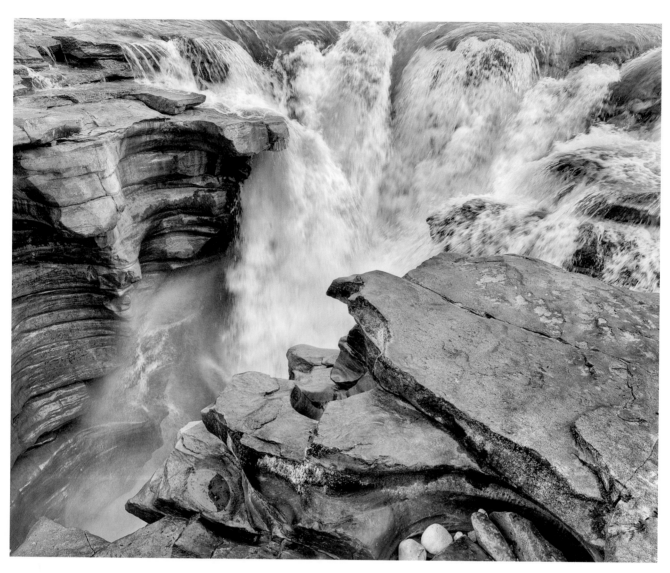

▲ *Figure 1.14* Effect of
Akvis Enhancer plug-in on
image detail and shadows.

Interestingly, for this chapter, I had planned to use the original image file I previously spent hours on, but I liked the new version I "whipped up" just so I could capture some of the settings, therefore it is the new version you see here as the final image. This is truly the full sequence from start to finish, all done in a couple of hours, complete with writing and layout work.

A few further minor adjustments to tone down saturation in some areas of the rock and I'm finally happy with the result.

Is this image better than standing at the falls? I think not, but I like the image for itself and it shows the falls at their best. Once again you can do a Google image search for Athabasca Falls to see how others have photographed the scene.

Thoughts On the Image

My editing is more about hard work and perseverance than it is about quick and easy tricks. I used a limited number of tools (Curves, Dodge Highlights, Hue/Saturation, and Selective Color) to do the editing. These are pretty much the same tools I used for almost all the images in this book. The point is that I get really familiar with what these tools can and can't do, where they excel, and also where they are problematic.

The image as it was straight from the RAW processor is miles away from my experience (what I saw and what I felt) while standing at the falls. The final result of the image editing goes a long way to capturing that feeling—of power and majesty, of beauty and wonder.

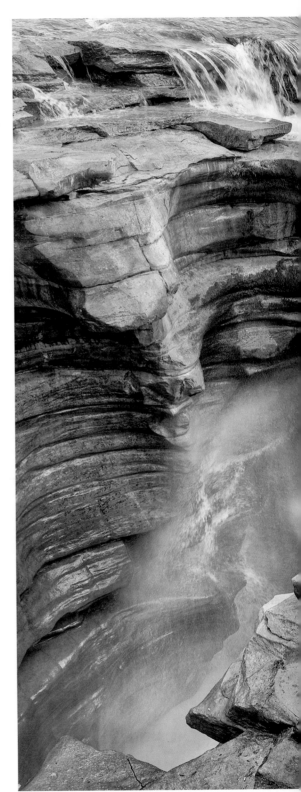

▶ **Figure 1.15** Athabasca Falls – the final image – color toned down a bit, some areas darkened.

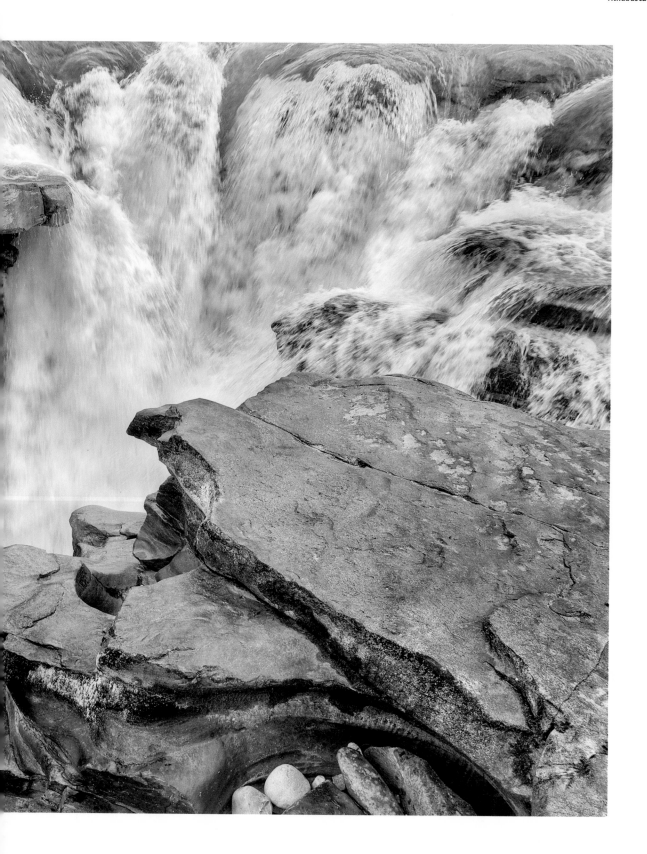

2 Bluffs and Bush

- Bringing out texture
- Whether to stay with color or switch to black and white
- Converting to black and white
- Erasing skid marks
- Comparison of an image with and without Akvis Enhancer

My Approach to the Image

I love the Badlands of Alberta and get back there to photograph at least once a year. While the whole area is fascinating and there are beautiful details everywhere, on this visit I was looking for something a bit more around which I could hang an image. The first things I noticed were the cave and the silvery green bush. From that moment, I began looking for a way to present these two objects in a strong composition.

The large, triangular shaped rock nicely defined the left hand edge of the image, and the darker rock in the foreground formed a base to the image. However, the question remained whether I could make a definite edge to the right side of the image. As usual, I didn't include the sky, preferring not to distract the viewer from the landscape forms and not wanting the composition to be divided by a horizon line.

This image is included in Chapter 18 in which it is compared to an image of the same area taken the next morning as the sun was coming up. In it I address the issue of lighting but here I want to concentrate on image processing.

Taken in the evening, the softly lit image, which I am especially fond of and is the focus of this chapter, was shot with a Canon 10D, using stitching to enable the making of large prints. The essence of stitching is to break a scene into a series of overlapping photographs that are then combined with special stitching software (or the stitching facilities in Photoshop). My preference is to use dedicated software, as I have found with experience that Photoshop will commonly create stitching artifacts—little lines that you don't see until you have been editing the image for an hour and then have to fix—or even worse, actual misalignment problems that result in having to go all the way back to the beginning. I use PTGui and it continues to do a superb job of stitching my images together.

Stitching is useful when otherwise you would have to throw away pixels by cropping. Stitching is also useful when you know you want to make really big prints or panoramic images.

Good printers and young eyes can take advantage of 360 pixels per inch of real resolution. This means that if you want a 20-inch wide print, you are going to need 20 x 360 = 7200 pixels in the longer dimension. In 2009 this is the domain of $40,000 medium format back cameras, keeping most of us mere mortals happily and inexpensively stitching.

Note that many wonderful images have been made with fewer pixels per inch. But resolution, like beauty, is in the eye of the beholder and even then, some subjects can enlarge better than others. Fine landscapes with grass and leaves do not reproduce well in large prints, while sports and architectural subject do much better. Oddly, rocks tend to enlarge fairly well, the artifacts of the image somewhat resembling rock texture anyway.

Stitching and Panoramic Image Basics

Now, the basic idea behind using stitching is that you take several photos of a scene using a

longer focal length lens to "magnify" each part of the scene, and then you combine them for a resultant image that has more pixels and even more importantly, more detail than you would have had without stitching. Some have the idea that stitching isn't any different from upsizing an image in Photoshop directly in the printer driver or with dedicated software like Genuine Fractals. Truth is, upsizing adds no new information. But photographing parts of the image with a longer lens does add data—rather like checking out a scene with binoculars—you can see more detail, albeit one small part at a time.

It is possible to use stitching with rows and columns, though with 10 megapixel cameras and up, why would you want to? You can already make 16 x 20 prints that are as sharp as a tack and can withstand a nose-on-print inspection using the much simpler single row stitch.

A 10-megapixel camera has a long dimension of 3873 pixels. If you then take that as the height of a horizontal stitch (swinging the camera horizontally while the camera is in the vertical position), you get 3873÷360 = 10.75 inches, or say 10 inches to allow for trimming. Thus, at the absolute highest standard (that only young people can see close enough to appreciate), you have a 10-inch high print, by however long you want it (that being controlled by the number of images in the stitch). At more realistic printing resolutions for large prints, you can print at 240 pixels per inch and make prints 16 inches high by as long as you want, all from a single row stitch. As prints this large can't even be appreciated from a foot away, never mind nose on print, this produces beautiful high-resolution prints that would satisfy anyone.

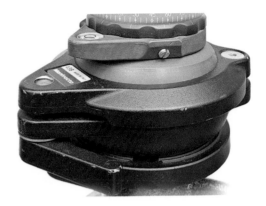

▲ **Figure 2.1**
Manfrotto Leveling Head on top of Gitzo tripod center column.

Single row stitching requires a minimum of equipment and is fast and easy.

First, you need a level tripod. You could stitch on a slant but aligning images is much easier when they are either in a vertical or horizontal column, and not somewhere in between. While in theory you could fiddle with the legs until the tripod is level, in practice it's much easier if you have a leveling base between the tripod and the head.

Everyone tests tripods out on the nice level floor at the camera store, then they go out and try to get it level when one leg balances on a rock, the second on a tuft of grass, and the third in the water—not at all the same experience.

I use a Gitzo tripod with a leveling base made by Manfrotto, which work well together. Gitzo does make a leveling head but it precludes the use of a rising center post. I prefer a ball head that is mounted on the leveling base, and I use the Arca Swiss type clamping system. With this side clamping

device I can use a short plate on the bottom of the camera, or even better an L-plate for bottom and side mounting, or for best stitching a long plate or rail which has another clamp on the back end of it.

My first long plate or rail for stitching was made of oak and the V-shaped grooves were cut on my table saw. It was strong and worked well. A Really Right Stuff lever clamp was both bolted and epoxy glued to the back end of it. Unfortunately, it went missing and I now use a commercial rail (they can be referred to by either name) from Really Right Stuff.

The use of a ball head and clamp that can grab the rail in various positions results in the ability to mount the camera behind the axis of rotation of the ball head base. You want this because to avoid parallax error in stitching, you need to rotate the camera around the lens rather than the lens around the camera, as would happen if you attached your head to the bottom of the camera. Parallax in stitching is the problem of something in the foreground moving against the background between shots because you didn't spin the rig around the point in the lens at which the light beams cross over. It is as if while you stood there looking at the scene you were to move your head sideways as you turn your head to scan the horizon; then a nearby branch would shift against the background. If you rotated your body with your eyes at the axis, then the branch wouldn't move. This shifting of near vs. far objects creates nightmares for stitching and thus all the fuss about how you rotate the camera. Of course, if everything is at infinity (more than 100 feet away), this is all academic, there are no near objects to shift against the background and it doesn't matter how you rotate the camera. With long lenses

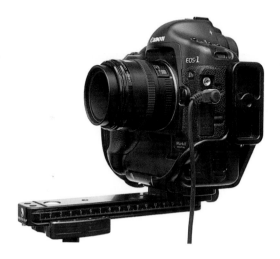

▲ *Figure 2.2*

Really Right Stuff rail and clamp for horizontal row stitching – enables rotating camera around lens.

that have tripod collars on the lens (and the camera hangs off the back of the lens), no special long plate is needed for anything other than really close images. But for wider lenses, I can use the long plate/clamp combination to adjust the position of the camera.

The point around which the camera lens combination should be rotated for best stitching is called the nodal point or entrance pupil. Unfortunately this is not marked on the lens, nor available in a table you can look up anywhere. Even worse, the nodal point changes position in zoom lenses, and it doesn't even move logically. For example, it can actually get closer to the camera body as you zoom to a longer focal length. Therefore, the only way to determine the position is to actually do a trial run.

You need your leveled tripod and head, the long plate, your camera and lens, and a couple of thin sticks at least three feet long.

One stick is stuck into the ground about 5 feet from the camera. Put the other stick in the ground about 20 feet from the camera, in the same direction from the tripod. Your camera is clamped to the rail (long plate) and you look through the viewfinder. Most likely, if you center the two sticks in the viewfinder, one is almost directly behind the other. If it isn't, move the tripod so it is. Now swing your camera so the two sticks get closer to the left and right sides of the viewfinder. You will probably find that the two sticks move apart horizontally so you can now see both of them.

Most ball heads contain a separate control for rotation of the whole ball head which is what will allow you to swing the camera horizontally. If your ball head does not have a separate control for rotation, then you will just have to do the best you can to keep camera and rail horizontal as you rotate back and forth. If you plan to do much stitching, you would be well advised to purchase a ball head that does have a base rotation control.

You need to keep the camera horizontal for this test, therefore the sticks have to be tall enough so you don't have to aim down (or up); but to avoid the sticks swinging in the breeze, it is probably best to keep the tripod relatively low—say less than 3 feet off the ground.

By the way, live view with magnification makes this test even easier to perform. Either way, you experimentally move the rail back or forth on the tripod head so the rotation point is closer or further from the camera body. You are either going to make things better (the sticks don't appear to move apart as much as you rotate the camera back and forth to the edges of the viewfinder), or worse (they appear to move apart as you swing to the sides). If you made things worse, you should have

moved the rail the other direction. You simply keep moving the rail until you minimize the movement of the two sticks against each other when near the edge of the viewfinder. Make a note of where the rail is clamped in the head—perhaps using a felt pen to mark this position on the rail. You have found the nodal point (the position on the lens and rail that is directly above the axis of rotation of the tripod head)!

If you are testing a zoom, you are going to have to start at one end of the zoom range and repeat the test several times as you zoom to the other end of the range. I kept a record of all these distances and then made up a drawing to 1:1 scale with these positions marked. I printed this to size and then cut and glued this piece of paper right onto the rail, with settings for each lens and each focal length.

To actually make a series of images for stitching, use a viewing aid such as a cardboard rectangle with suitable hole cut out of it to match the sensor shape, a compact point-and-shoot digital camera with a good sized LCD screen, or use a shorter lens on the stitching camera until you know what you want to photograph—the top, bottom, left, and right. A simple way to do to this is to first frame a horizontal image with the camera positioned horizontally, but when it comes time to stitch, switch the camera to vertical, zoom longer so the top and bottom match the original framing, and take a series of images in a horizontal swing of the now aligned camera.

Panoramic images need left and right borders that work compositionally every bit as much as ordinary images—use your viewing rectangle or other tool to predetermine where you will start and stop stitching—and give yourself a little room on either end just in case.

Generally I overlap images by 30% but if I am using a wide-angle lens, then I'll go to 50%. Sure this wastes pixels, but technically you didn't pay for the extra ones, so what are you fussing about?

It is vital to not change focus or exposure between images; so do not use polarizing filters. Manual exposure and manual focus is the order of the day.

A square image needs 2 or 3 vertical images overlapped, and more are needed for horizontal images. A panoramic image might need 8 images overlapped. If you are up to 12 images overlapped, then you are going to end up with a print that is five times longer than it is high, or more, which rarely works so you might have to reconsider the framing of the photograph if you reach that many overlapped images.

One issue that comes up with panoramic images that are stitched is that, should the camera have to be aimed up or down, the aligned images of the stitch form an arc (see figure 2.3). There are two ways to deal with this. Most stitching applications have a "horizon" and the images can be placed above or below it and usually this will result in the images being closer to a straight line—something that will facilitate cropping and framing. The only problem is that if you stitch half a dozen images, you are looking at a pretty big file. If you then "waste" some of

the image real estate to place the images well above or below the horizon, you end up with empty space taking up most of the pixels and you'll have huge files—at least until you crop the image in Photoshop. Sometimes even moving the images relative to the horizon won't fix the curvature.

If photographing architecture or other rectangular objects which need to retain their shapes and proportions, keeping the base of the tripod head horizontal is essential, otherwise you can sometimes tilt the base so that the stitching covers the areas you want —just don't expect trees to be vertical.

Editing the Image

When stitching does place the images in an arc, Photoshop comes to the rescue with Edit/Transform/Warp. In figure 2.3 you can see the image as it is stitched and before warping. You can already see the lines that Warp applies to the image for you to stretch it. You see the result of the stretch in figure 2.4.

Wide-angle zooms are prone to barrel distortion, an aberration in which straight lines appear curved. Lines bulge outward in the middle of each side of the image, giving the subject of the image a bloated appearance. Photographing a rectangular object centered in the viewfinder (e.g., a building) results in outward distortion of the middles of the sides of the rectangle relative to the corners. There are ways to correct this distortion if it is simple, but in order to minimize this distortion, lens makers actually complicate the barrel distortion so that correcting the lines back to straight results in wavy lines instead of curved ones. The same Edit/Transform/Warp can be used to fix these wavy lines.

▶ *Figure 2.3*
Stitched image showing arc of the stitched images which will require cropping if we don't stretch the image.

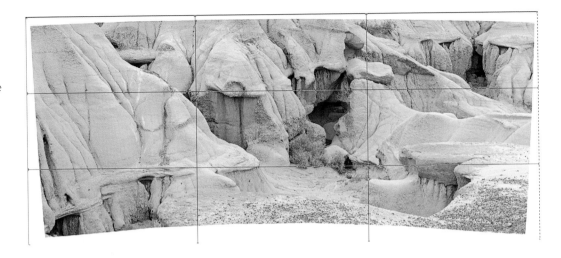

▶ *Figure 2.4*
The result of stretching the image using Edit/Transform/Warp.

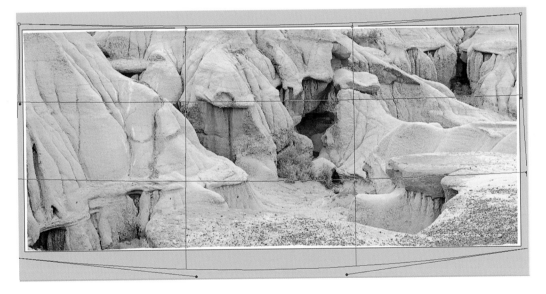

When I originally made this image, Akvis Enhancer was not available. Last year I decided to re-edit the image to see what this Photoshop plug-in could do for the image, and you see the result in figure 2.5.

I normally apply Enhancer at the end of my editing, but in this case I wanted to see what it could add to the image early in the process. Try using Avis Enhancer both ways, early and late in the editing and see which you prefer. Although purely subjective, my sense is that the closer the image is to right before you apply the filter, the better the results. The earlier you apply it, the less work you might actually need to do afterwards. But, as with so many things, it's a personal choice.

When offered the choice of better vs. easier, the serious fine art photographer chooses better every time.

Unfortunately, this Badlands location is well traveled by hikers, campers, and visitors who have caused skid marks down the bluffs. They (the skid marks, not the hikers) are especially

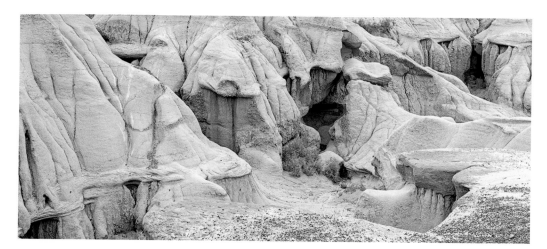

◀ *Figure 2.5*
Image after applying Akvis
Enhancer plug-in to en-
hance texture in the bluffs.

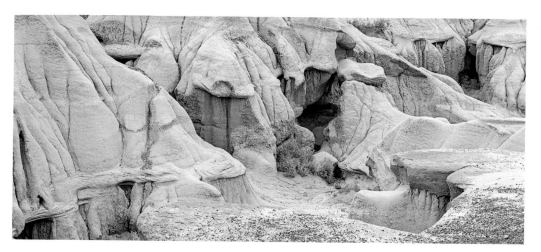

◀ *Figure 2.6*
Clone and Healing Brush
tools used to remove skid
marks on bluffs.

obvious on the left hand side of the image (the light vertical "scratches" about an inch from the left side of image). I am not above cloning out these manmade effects, and in figure 2.6 you see the result of the "cleanup" which was done using a combination (not at the same time) of the Healing Brush tool and the Cloning tool. This work is not difficult, just painstaking; and invariably, after you are finished (and usually after you print) you will find one more skid mark that has to be removed.

The Clone tool copies the pixels from one location and applies them to another. You capture the area to be copied by using the option key and clicking on the appropriate area. Then as you click and hold the mouse, you apply those pixels to the receiving area. As you move the mouse, the area to be copied moves in unison, so in choosing the area to be copied, you need to be sure you don't accidentally copy something totally different, or even worse, copy the edge of the print into the middle of the new area.

As cloning exactly copies the original, you may find the area you picked doesn't match the new surroundings (darker or lighter). It will take practice to select good copying material. In Photoshop CS4, you are now able to see the area to be copied in the middle of the brush shape where the pixels are to be applied. This makes copying things such as lines much easier than in

earlier versions. That change alone is probably worth the price of the upgrade to CS4.

The advantage (and curse) of the Healing Brush tool is that all you need to copy is a matching texture. Don't worry about the brightness; it isn't critical. You then apply the matching texture to the appropriate area and the software automatically blends it into the receiving area. This makes things like blemishes on a face or dust spots in a scanned image easy to fix. The only catch is that if the receiving area is near something of different brightness, then the auto blending tends not to work and you have to go back to cloning. Otherwise the Healing Brush tool is like magic. In earlier Photoshop versions, the blends weren't very

▲ *Figure 2.7*
Adjustment Curve to darken parts of the bluff and further enhance texture.

▶ *Figure 2.8*
Effect of the curve of figure 2.7 on the whole image.

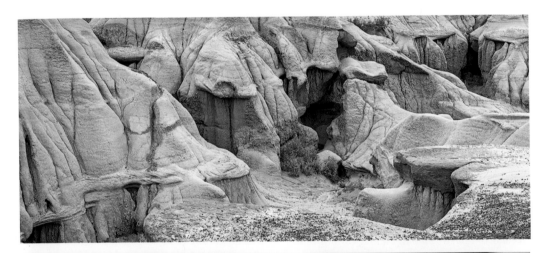

▶ *Figure 2.9*
Mask for curve of figure 2.7.

smooth and could be seen in large prints. But in CS4, this too has been fixed. I used a combination of both tools for erasing the hikers' tracks.

Cloning out parts of the image that were not there originally (a pop can or errant stick) is considered legitimate by most, but not all photographers. You will form your own opinions on what's legitimate and what's not.

Next I want to bring out texture further by selectively darkening areas of the image. I use the curve in figure 2.7 and you see the effect of that curve applied to the whole image in figure 2.8. In figure 2.9, you see the mask I painted into it to cause the curve to only apply to the lighter areas of the image, and then in figure 2.10 you see the effect on the image of applying the mask (i.e., only using the curve in selected areas).

I created some more Curves Adjustment layers to make these corrections and then finally used my Dodge Highlights brush to add highlights to the bluffs, giving the image more three-dimensionality. (See chapter 1 for details on dodging highlights.)

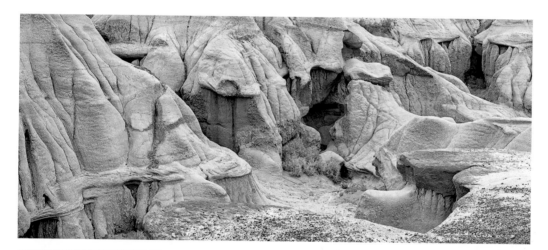

◄ **Figure 2.10**
The masked effect of curve of figure 2.7, selectively darkening parts of the bluffs and increasing texture.

▼ **Figure 2.11**
Final color image, after further adjustments – more work would be done if I were staying in color.

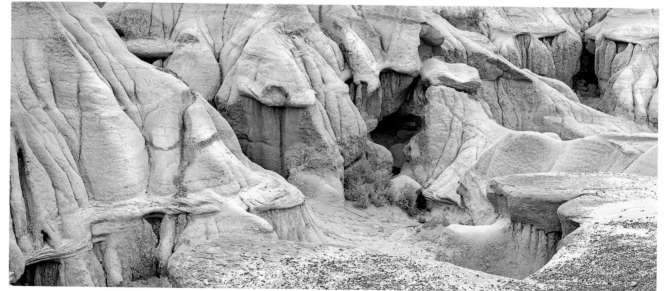

It is time to convert this image to black and white. In fact, this is an image that I happen to like both in color and black and white and quite happily sell both versions.

Why You Might Want to Consider Black and White

The vast majority of serious photographers shoot either for color or black and white, but they don't tend to switch back and forth. Even those who do, like Huntington Witherill, do so only at the end of a project or even less often. If you are already a confirmed black and white photographer, you may wish to consider the following points to see if, in fact, your black and white images take maximum advantage of the medium. For those of you who have at most dabbled in black and white and don't use it for your serious photography, well, here is an introduction to the whys and wherefores of monochrome.

Traditionally, there were practical reasons for black and white. It simplified home-based film processing and printmaking. The greater dynamic range of black and white film (which is still true compared to digital), price, availability, and so on all contributed to its success.

In a digital world, most of these arguments don't hold up. In fact, the digital world had good color prints long before we had good black and white. While every so often someone raises the idea of a monochrome sensor, except for a brief, early period when Kodak made cameras with black and white sensors, there has never been a sufficient market for a manufacturer to take up the gauntlet. As pixel counts go higher, the need for monochrome sensors gets even less important.

We live in a color world and nowadays it is an extra step to suck out the color from an image. There's no doubt that it takes skill to "see" what will work in black and white; a skill younger photographers have never had to develop.

On the other hand, there are tools now to make it easier to work in black and white. You can use a pocket digital point and shoot camera as a viewing device—something like the Panasonic TZ5 or its recent replacement the ZS3, with it's various ratio framing from 3:4 to 16:9. With these devices you can set the LCD to display in black and white, and with a 10-12X zoom and a lovely 3-inch high resolution LCD to see potential images, this makes a very nice viewing device (and not a bad camera either). No longer do you need to squint through a brown filter, which never did take red out of the viewing, though it was fairly good at judging green and blue and thus handy for landscapes.

You can set your DSLR to shoot black and white, and this is what will show on the LCD. But if you're shooting in RAW format (and why wouldn't you?), then the image is still recorded in color.

You might ask why that's a good thing. A few times in this book, I convert images to black and white in Photoshop and take advantage of the digital filtering capability which is far better than any filter you could have hung in front of your lens, excluding polarizing filters. Want to darken the sky while at the same time lightening the trees? No problem. Just go to the color sliders that accompany the Black & White Conversion Adjustment layer and move the blue slider left to darken the sky and he green slider to the right to lighten the trees.

All of the above makes it easy to use black and white, but it doesn't fully explain why

you might want to go mono. Below are some thoughts on why you might want black and white:

1. Some subjects don't work in color. The colors stick out like a sore thumb, clash, or are too similar. The scene might work in black and white.

2. Being good at both black and white and color doubles your opportunities for great images. How can that be a bad thing?

3. Colors may be pretty, but they distract from textures, highlights, and shadows that may be what you want to emphasize.

4. There is a glow to a great black and white print that rarely happens in color.

5. Black and white is further removed from reality and so images tend to be less "post card" and "wish you were here" type images.

6. Being further removed from reality, there is more freedom to manipulate images. There is an expectation that color images should not be unreal, unless they are so unreal as to not associate at all with the real world. No such problem in black and white. Chapter 4, the Fruit Bowl, is a good example of how far you can go in black and white, and yet still have the image accepted as "normal".

7. Black and white seems more artistic. I don't know if this is fair, whether it's simply because for the first 120 years of photography that was the only choice, or if it has to do with black and white being not associated with the real world, but it does seem true and you might as well take advantage of that prevailing view.

8. Color prints are often best in really large prints while the handheld 8.5 x 11 black and white is wonderful. The recent return of Lenswork folios illustrates the power and beauty of the small black and white image. It also points to the joy of holding a bare print in hand instead of looking at something behind glass.

9. Even in a digital world, black and white prints are going to last longer than color.

10. With the recent development of really good semi gloss baryta papers, black and white images may not look like silver prints, but they have their own beauty which can exceed that of a darkroom made print.

11. There's an intellectual and artistic challenge to working in black and white—rather like stepping out with only one lens. Being challenged is a good thing; whether it's something you'd want to do every day is another matter.

12. With all that going for you, there is no excuse for not trying black and white. Everything about the fine black and white print still applies and there are many master photographers whose work you can study and learn from.

Black and white requires planning and appropriate composition to work well, and the best composition for black and white may differ from that of a color image. You are going to be more successful if:

1. *You can see the black and white composition at the scene.*
2. *You know what you can do with black and white tones to make them sing.*

As usual, I use the black and white conversion adjustment layer available in Photoshop CS3 and beyond.

There are many ways to achieve a black and white image but some work better than others. Oddly, if you simply take the brightness information of each color pixel and discard the color, you end up with rather dull images. This has to do with two equally bright colors not seeming equal to the human eye. You want a method that allows you some control over the relative brightness of each color while at the same time doing a decent job of conversion right out of the box—automatically.

I have been happily using the Black & White Adjustment Layer facility built right into Photoshop. But Andy Ilachinski, who has been kind enough to proof my chapters, suggested Silver Effex Pro from Nik Software as well. As a brief trial of Silver Effex, I took a standard conversion of a people picture and noted that when both were on auto settings the Nik image was a bit better than Photoshop. I then tested a landscape image and again Nik did a bit better. Now, it took me only a minute to adjust the sliders in the Photoshop Black & White Adjustment Layer to equal the Nik result, but if you want to make things easy for yourself and if you want suggestions for possible conversions, then Nik might just be worth the money. I probably won't invest in it since I work on the assumption that automatic is never as good as intelligent personal interference. I always like to play with the sliders in the Photoshop Adjustment Layer to see what settings make for the absolutely best image, but there's nothing wrong with having your black and white conversion software provide a better-looking result right from the start.

When converting to black and white you need to consider a few things when making adjustments to image tones. First, get a good separation of tones. The green bush in my image is a good example. If I pick the wrong slider setting the bush doesn't stand out, which it obviously did when it was silvery green against the beige bluffs. I could darken it, but things that are dark tend to seem to recede while light objects stand out and seem closer. I want the bush to stand out and be in front of the background bluffs, so lightening it is the way to go. Besides, I want to emphasize the silvery green nature of this particular plant.

Back to Editing the Image

I am wondering if I can use the red slider to separate the middle foreground rust colored rock from the background, since I see that in black and white it's hard to tell where the one ends and the other starts. I could rely on dodging and burning and curves, but if I can separate these elements via color-to-tone adjustments it could make the separation of the two objects better.

The rest of the image is close to neutral in color so I don't expect the sliders to do much here.

Figure 2.12 shows the sliders for the Black & White Conversion Adjustment Layer. I used the cyan curve to somewhat lighten the central bush and to darken the orange and reddish rocks on the right and in the middle foreground of the image. By this time the image is looking pretty good to my eyes, but it is not perfect (figure 2.13). There are a few harsh white areas that need a little burning in, some corners that are a bit weak, and I still don't like the separation of the middle foreground rock from what's behind it; it is too similar in tone (not a problem in the color version).

In figure 2.13 you see the original 2004 version of this image, while the final image shows the end result of the current interpretation.

They are quite different from each other. It's possible that some day I may pick the best from both versions to produce a third attempt. I have no doubt that over the next 20 years (should I be healthy) I will reinterpret this image yet again in some way as yet unimagined.

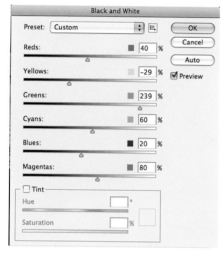

▲ **Figure 2.12**
Black And White Conversion Adjustment Layer sliders, set to enhance separation of foreground reddish rock and the blue/green bush in middle.

That's the nature of photography and personal development, and of mood and taste.

As to color or black and white, did you prefer the final color version or one of these two black and white images? In this particular image there weren't any strong colors in the color image to distract you, but in another image could you ignore something that was fluorescent orange and electric blue to see beyond the color and recognize a brilliant prospect for a black and white image?

The differences between the 2004 image (figure 2.13) and this year's image (figure 2.14) include more surface texture thanks to Akvis. I went to more trouble with the older image (figure 2.13) to highlight the edges of the bluffs, and the shadows are darker. In figure 2.14, the foreground rock is darker, but since the contrast in the bluffs behind is lower, it still doesn't stand out all that well. I'm already thinking of a third version, based on this year's but with a bit more work on the highlights and darkening some of the shadow areas. If I don't stop editing this chapter, I'll never settle on the ideal image.

▼ **Figure 2.13**
The final result of the 2004 editing process for "Bluffs and Bushes".

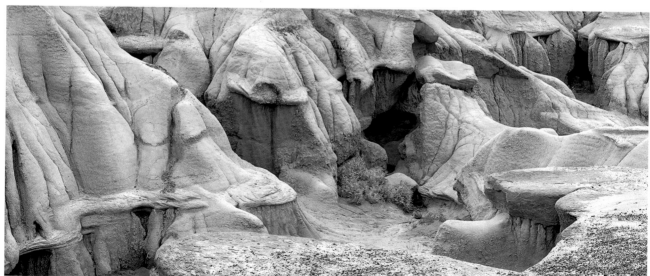

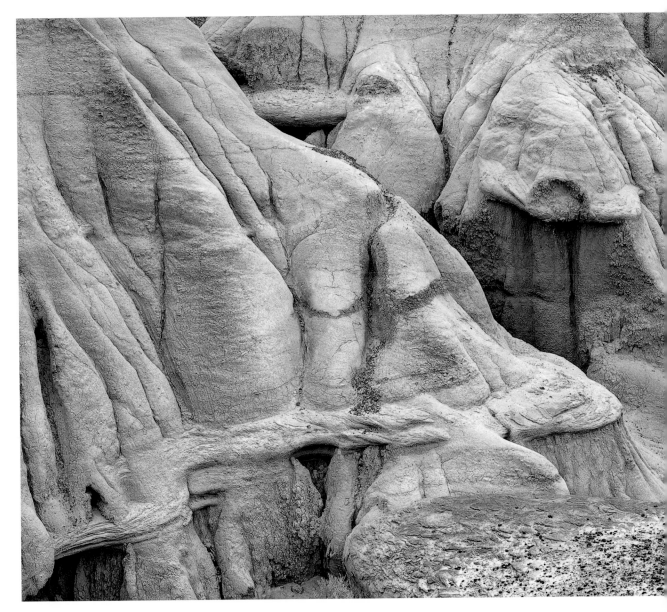

▲ *Figure 2.14*
The 2009 editing process completed – more texture, less highlighting of the bluffs.

Thoughts On the Image

I shot this photograph in 2004. It has remained a favorite since then. If I died tomorrow it is one of the images I'd like to be remembered for. It was published in *Black and White Photography* magazine and in *Lenswork*

Extended and it has sold well, so others apparently see in it some of the same things I do.

Do you have a set of images that you think are your best? Does anyone else know which ones they are, or how to find them? Are these prints set aside and protected and marked "my best work"? Do you look at your best work and

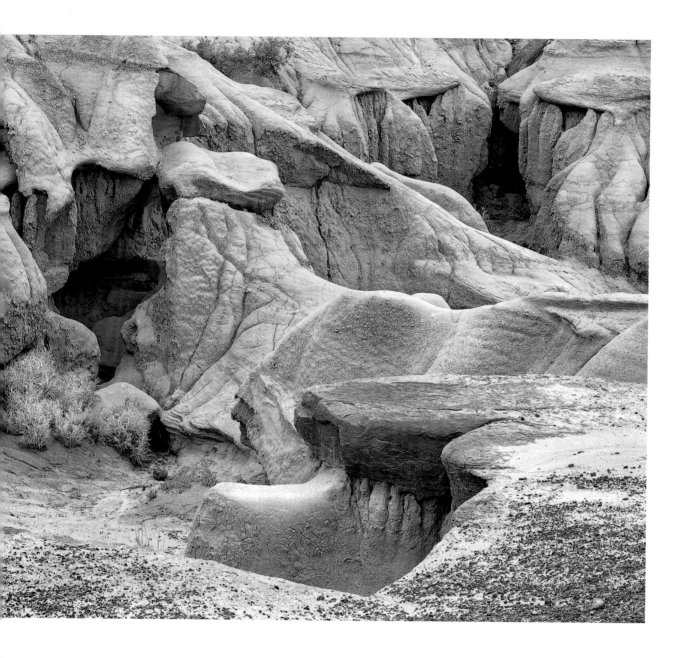

consider how it's different from your lesser
work? Knowing how and why it is superior to
your normal level of images can help you make
this become your new standard from which
you will take further steps forward.

3 Grain Elevator

- *Working the scene*
- *Use of separate exposures*
- *Applying perspective correction*
- *A talk about perfection*

My Approach to the Image and Working the Scene

Grain elevators are a classic, if not to say cliché subject in images of the prairies, but many have been blown up, knocked down, burned, or have simply collapsed from age, so when I was on a photo excursion with my friend Robin, we grabbed the chance to photograph these three elevators still standing (for now) near Calgary. As we drove up the three appeared to be overlapped, but as we got closer we could see each one individually. After we parked it seemed obvious to run back down the road until the three appeared to be overlapped again and photograph them using a long lens (figure 3.1). It isn't the long lens that makes the elevators appear almost the same size; it is their relative positions. From this vantage point, the farther you are from the first elevator, the smaller the distance between them appears. The long lens simply allows you to frame tightly on the subject. You could have used your widest lens and the elevators would still appear to be of similar size to each other, albeit a lot smaller on the print.

It is position that determines perspective and relationships, not the choice of lens. Focal length only controls size on the print and the framing of the shot.

▼ **Figure 3.1**
The view as we approached the elevators – not enough character, too much clutter, repetition not strong enough.

I had a pretty good idea from what I saw in the viewfinder that this was not going to be a great image. But photography is about doing what you can, and especially in the age of digital, if in doubt, photograph it anyway. That metal door in the bottom right sure bothered me and there was only one strong element to the image, the repetition of shapes and lines. Perhaps if four or five elevators had overlapped, or if some other element had been present, it could have been a better composition. Perhaps I should have moved to the right so that the overlap was greater, but the nearest elevator was the newest and had the least character so I suspect the idea was doomed from the start.

When you look at a scene, just standing there, through a viewing rectangle, on an LCD, or through the viewfinder, there is a mental inventory going on, listing the strengths and weaknesses to the possible image. There had to be something that made you first consider the image. But what other strengths can you discover—a repeating pattern or interesting shadows, the texture of peeling paint, or the way light plays on perfect skin? Now you need to look for other strengths that could include the way that you frame the subject and make use of the image edges, or lines that interact in an interesting way. Next you inventory the weaknesses of the image—out of focus foreground grasses are going to be a problem, telephone wires in the background, or whatever. Are there ways to minimize the negative? Next you see what you can do to maximize the strengths or even find new ones. Perhaps by moving to the right, three objects suddenly form an interesting relationship that wasn't even there before. You also have to see what can be done with the weaknesses—the grass can be bent over and kept out of view by your sweater, by moving left and back and using a longer lens I can eliminate those telephone wires, and so on. Some of the weaknesses may be manageable in the editing process—that bright red object won't be an issue in a black and white image, or the light colored log that distracts can be darkened.

Sometimes while on site I will even go so far as to consider how I might edit an image in my computer. I work through in my mind how I might bring this element up, make that other one recede, emphasize these aspects, and hide those. I might notice that there aren't good highlights on the main subject, but since the lighting is great everywhere else, I will already be planning to use the Dodge Highlights tool in editing to help the image. Even when I am away from my computer I am seldom taking photographs without knowing how the editing process can help the image.

Ansel Adams called this pre-visualization. I call it just plain practical. The image as framed has flaws, and I need to know if it's still worth taking. Can I work with this image?

When you aren't sure which of two framings/ compositions is better, shoot both and let the image editor (you) choose the better one.

The second attempt (figure 3.2) was shot from next to the first elevator. I took advantage of the shadows cast by it, and though it has some interesting shapes, I don't see a strong enough design for it to work, even with some judicious cropping. For one thing, the old buildings aren't all vertical, yet they aren't far enough off to make that a main element of the image. No, nice try, but not a keeper.

So I decided to wander round to the side with the railroad tracks and I captured the image in figure 3.3.

Note that I have corrected perspective in Photoshop using Edit/Free Transform (figure 3.4). Use command A to select all, Command T to go

◀ *Figure 3.2*
Some interesting structures but no order to the image.

◀ *Figure 3.3 (left)*
An interesting viewpoint but without something on the track, an old faded sign, or even a spout, the image doesn't work.

◀ *Figure 3.4 (right)*
Perspective corrected using Edit/Free Transform – the image then cropped so the rail comes to the bottom right corner.

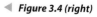

to free transform, Command key down and drag the corners as needed, hit Return to finalize the reshaping. I actually tried using Filter/Distort/ Lens Correction but it resulted in the top of the grain elevator being chopped off. Lens Correction has the advantage that you can rotate the image at the same time and also correct for pincushion flaws and barrel distortion, but in this case none was needed. There are times when I have had to use both Filter/Distort/Lens Correction and Edit/Free Transform on a single image to get exactly the correction I want.

In figure 3.5 you see the verticals corrected, but the width of the elevator is inadvertently increased. In figure 3.6 you see the canvas enlarged vertically to 120% and then the stretching is applied both to the top corners (to fix the verticals) and to the middle top to stretch the whole image vertically. Figure 3.7 shows the alternative method of using Filter/Distort/ Lens Correction, where, to avoid cropping the top, I had to resize the image downwards to 94%. I rotated the image 1 degree to the left and then used vertical distortion correction to fix the top of the building.

▼ *Figure 3.5*
Stretching the top of the image wider can make objects appear fatter than in reality

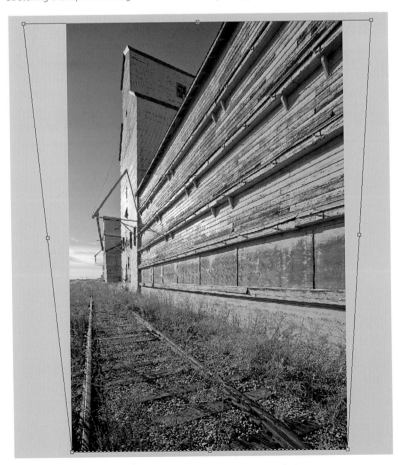

▼ *Figure 3.6*
You can stretch the image across the top to fix vertical lines but also stretch the entire image vertically to preserve the shape of the object.

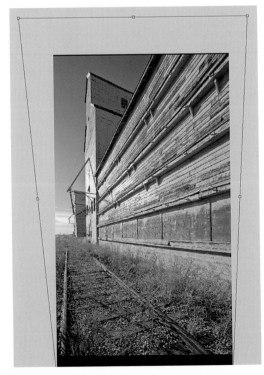

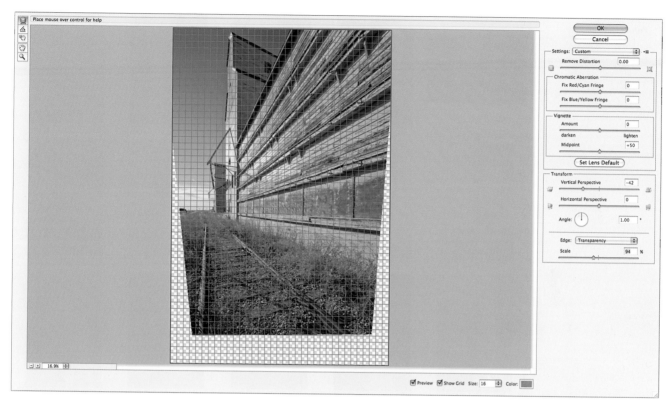

Figure 3.7

An alternate method is to use Filter/Distort/Lens Correction – but note the 94% scaling to prevent cropping the top of the building.

When using Edit/Free Transform to correct perspective distortion remember that if you only widen the top of the image, you end up stretching the subject wider without adding height, thus fundamentally changing its shape. Before doing the Edit/Free Transform, increase canvas size to allow for a vertical stretch at the same time.

I think this image is fair, but I have the feeling that it lacks something. For a start, there's nothing on the track—a grain car under the chute would have been good, or perhaps a series of cars on the track not seen in the foreground to the left.

It would have helped if the side of the elevator had a sign on it and perhaps some sort of piping on the near side of the storage bin. Oh, well, not much I could do about that. Still I had the feeling that I was making some progress.

My next step was to go back round the other side to see what could be done with the last elevator, which had an interesting if somewhat tilting octagonal storage bin next to it. Nothing seemed to work but I did realize that within about two hours the sun would be low on the horizon, lighting more of the side away from the track and possibly giving me an image I would like or, at least, could work with. It didn't take much persuading to head down the road with the idea of returning around 4:30 to try the elevators again.

The difference between OK and terrific may simply require different weather and lighting. If you have done the preliminary work for a future great image—then today was a really successful day—be satisfied.

▶ *Figure 3.8*
Contact sheet of images
from our return to the scene
later in the day.

Figure 3.8 shows a "contact sheet" of images taken after returning to the elevators later in the day. The light was much better with a hazy low sun coming through clouds, a deep blue sky, and the moon. A few images might have been okay, and some I even brought into Photoshop for a closer look, but none looked as good as image number 6707. It took advantage of the moon,

the blue shadows created by the dark sky, and the warm light of the low sun on other areas.

I did consider image number 6710 but as you can see in figure 3.9, while okay it doesn't have enough to offer.

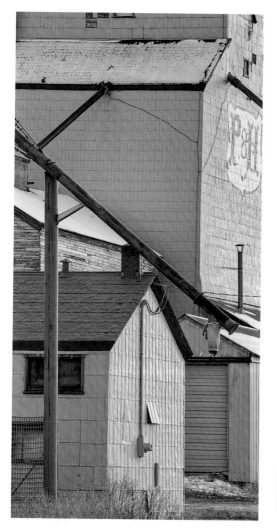

▲ *Figure 3.9*
Good use of lines but not enough of interest to make a strong image.

In my book, *Take Your Photography to the Next Level,* I wrote about working the scene. Many readers told me that they did not put much effort into improving what they first

saw in a scene. I'm hoping that the description here and in other chapters will give you an idea of what "working the scene" is really like. Sure, sometimes you walk into a scene and go "ah hah" and quickly fire off the perfect image, but wandering around, squatting down, and moving left and right are how you "get lucky". You consider whether the lighting of a scene might be better later, checking out the clouds, factoring in the wind, and pushing through thick bush hoping for a better angle.

I now had an interesting scene in the elevator, storage bin, and moon in between. It was time to consider how best to frame the image. Many people would have moved back or switched to a wider lens to include the top of the grain elevator, but as you may know if you have read my first book or checked my images on my website (www.georgebarr.com), I like to move in and fill the frame, and to include any sky at all is the exception.

When framing the image for perspective correction or for stitching (especially if the camera is aiming up or down), remember that you will lose some of the image on both the left and right sides. Make sure you have taken this into consideration in the case of perspective, and gone far enough left and right with stitching so you don't end up with part of your image chopped off—unless of course you like trapezoid shaped prints..

The ramp would frame the image on the bottom, the sky on top. Left and right, I only wanted to include as much elevator and bin as would strengthen the composition. I knew when photographing it that the moon would be overexposed compared to the main subject being lit by low sun partially obscured by cloud. A check on the LCD with the first

exposure confirmed this and it wasn't difficult to make a second exposure specifically for the moon, guessing the right exposure—1/30 sec. at f-16.

Perhaps I should have cheated and used a longer lens for the moon. After all, I was blending anyway and many photographers have done this before. Back in the days of film photographers would shoot the moon with a long lens at night, then rewind the film and shoot landscapes with a wider lens. There is a current landscape book out in which, I swear, the overall large format film image was taken with a wide angle lens, but the moon is quite large and had to have been shot with a long lens.

I'm not above this kind of "cheating" but somehow I felt it wasn't appropriate for this elevator image. Both the elevators and the moon were shot at 78 mm and only seconds apart; the only change was the shutter speed. Enlarging the moon so it shows better is one thing, adding a moon that wasn't there in the first place does seem a bit over the top. I'd be very disappointed to find out that Ansel Adams cheated on "Moon Over Half Dome".

The idea of capturing the octagonal storage bin and the shine on the side of the elevator between the two definitely appealed to me. It wasn't until I brought the image into Photoshop and corrected perspective that the strength of the design really hit me, along with its two-color palette of yellow and blue. The blue "planks" are in fact shiny metal reflecting blue sky. I didn't have to do anything other than a modest increase of the Vibrance slider in Adobe Camera Raw, which I later decided was a bit much so I toned it down.

Comments about this image are divided—half of those who have seen it just love it and have no issues. The other half ask if the color was real. The truth is not simple. In my film days, had I photographed this with Velvia, the color would likely have been the same and no one would have questioned it. In the age of digital imagery, however, they assume that the color has been added, that I cheated. In practice, the human eye adapts easily to color shifts so that we don't see open shade as being strongly blue, but both film and digital cameras do. In editing the image, the saturation of the colors were probably increased somewhat (see the proof sheet for the unedited appearance). What really happened here is that I took advantage of the nature of light and shadow, shade and sun. So, when I'm asked if the color is real, the answer is Yes!

Two updates—I was sending this image to my friend Andy along with this text for proofing and decided that the blue really was a bit strong so I toned it down before firing off the image. Andy mentioned that the image might be nice in black and white (even though its main strength is in the two colors—strong blue and pale yellow). Now, Andy is mostly into black and white so there's a bit of a bias there, but nonetheless, he has a good eye so off I went, and you know what, it works well in black and white too (figure 3.10). Now I have to figure out which I prefer, or do I?

The use of a simple color palette is extremely important in making strong images. Seldom do good images contain a full rainbow of colors. There are exceptions (besides rainbows, that is), but on the whole, a lot of great color images do very nicely, thank you, with only two colors, generally complementary to each other (i.e., at opposite sides of a color wheel). People naturally associate yellow and blue—just look at how often that combination is used in advertising—they know what makes people look.

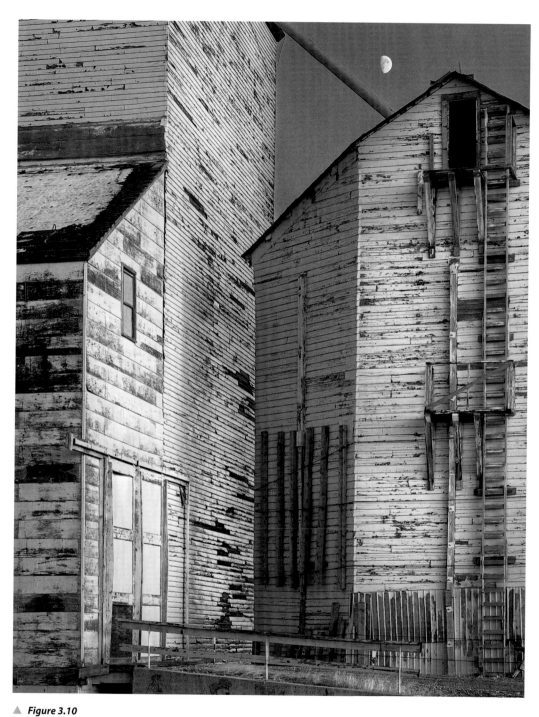

▲ *Figure 3.10*
Final image – the black and white version.

No image is perfect in every way—perfect subject, fantastic composition, incredible color, humor, or deep message. All images are simply the best they can be. Either they work or they don't, and agonizing over lack of perfection is a chump's game. Like the image? Then be satisfied. End of story.

The actual composition of the finished elevator image isn't very sophisticated; some vertical lines and a few incomplete diagonal ones with very little going on in the corners. On the other hand, the alternating vertical bands of dark and light work quite well, and in my opinion the colors are what make the image appealing. Would it have been a better image had there been a stronger composition with bold diagonals and more interesting shapes? Perhaps, but remember you can only work with what you have (still life excepted) and few images are perfect in every way. This was the best I could do on that particular occasion. They say that painters have to learn to let go and it is no different for photographers. Also, remember that a simple design forces you to examine other aspects of the image—tonalities and textures, for example.

Thoughts On the Image

Were I back at the Farmers Market selling my images, I have no doubt that this image would be a good seller because of the sentimental subject, the color, and the moon. I prefer images that are more strongly composed and rely less on color but that's personal preference, not advice. At least these days, you can place good images on your website and even if you are not famous, your friends and relatives and a few admirers can check out your work. Although I have taken more than 40 years to get to where I am, it isn't a given that you should be such a slow learner. Michael Levin (check out his wonderful work on the Internet) has been photographing for 5 years and in that time has become internationally known and respected. I had assumed he must have been an artist previously to have such a good eye. No, he ran a restaurant. There is hope!

▶ *Figure 3.11 (opposite)*
The final image in color.

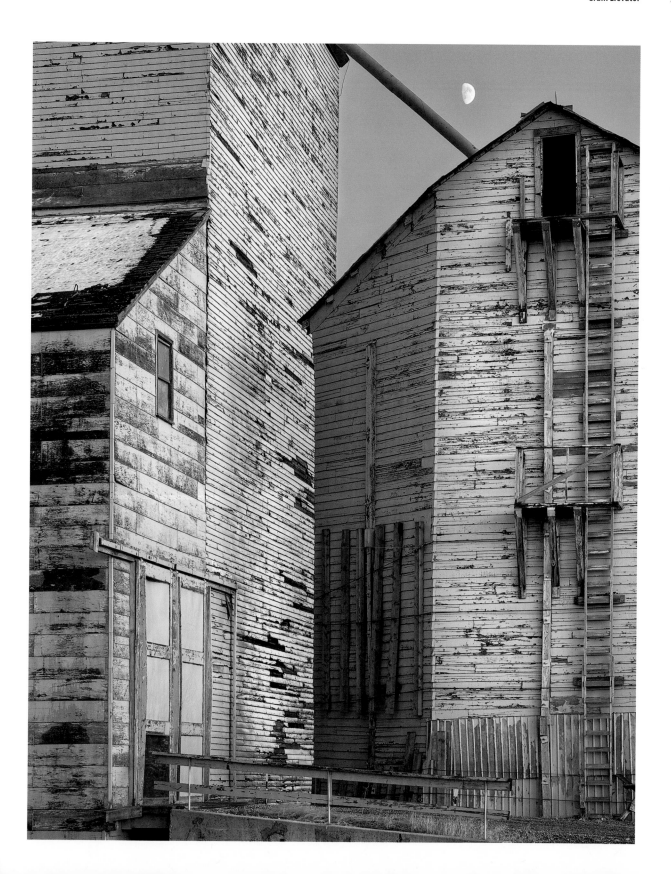

4 Fruit

- *Editing an image using multiple Curves*
- *Adding highlights via Dodge Highlights*
- *Removing noise with Gaussian Blur*
- *Increasing local contrast with Akvis Enhancer and other tools*

This simple but classic still life offers some good illustrations of editing technique. My goal was to produce a black and white image of rich, deep tones, glowing highlights, and strong composition. I was aiming for print quality along the lines of Edward Weston's Pepper # 30, even if I couldn't find suitably sexy fruit.

A trip to your local farmers market for some interesting looking veggies could be rewarding.

The photograph was made using a 90 mm tilt and shift lens so I could maintain sharpness from the closest apple at bottom to the apple at top that is further away, while still being able to blur the background. The alternative to this method would be to use focus blending with Helicon Focus or Photoshop CS4, which is addressed elsewhere in the book.

Figure 4.1 shows the original image without any manipulation as it came out of Camera Raw. The shadows are rather dark and the fruit is a bit dull. The first step is to control highlights and open up the shadows, using the Fill and Recovery sliders in Camera Raw as seen in figure 4.2. Figure 4.3 shows fairly standard

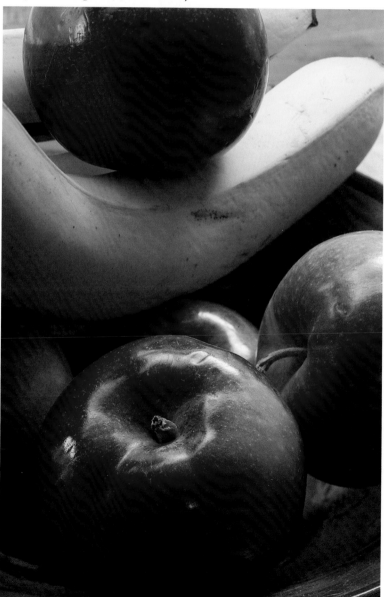

▶ *Figure 4.1*
The original Image as output from Adobe Camera Raw using default settings..

▶ **Figure 4.2**
Camera Raw Image Adjustments.

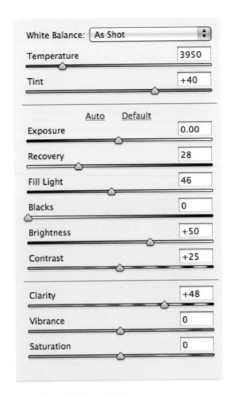

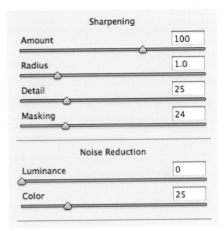

▲ **Figure 4.3**
Camera Raw Sharpening Settings...

▶ **Figure 4.4**
Image as output from
Camera Raw with the above
settings.

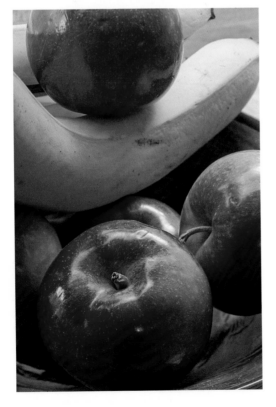

sharpening settings in Camera Raw so that I normally have some sharpening applied before I even see the image in Photoshop.

In figure 4.4 you can see the effect of the sliders. The highlights are controlled and the shadows are open, even if the image is a bit anemic, the fruit a bit bashed, and highlights need work. There are distractions in the image—the banana should reach the upper right corner and the bowl should extend to the bottom right corner.

My next step was to stretch the image using Edit/Free Transform so I could fix those problematic corners, albeit with the loss of some of the top apple.

I knew from the beginning that I'd be using Akvis Enhancer to increase local contrast and further open the shadows. I certainly like the overall effect. Other local contrast enhancing methods are available such as Photomatix, Photoshop's Unsharp Mask, and the filters, actions and scripts from Digital Outback Photo (DOP), all of them useful if in not quite the same ways.

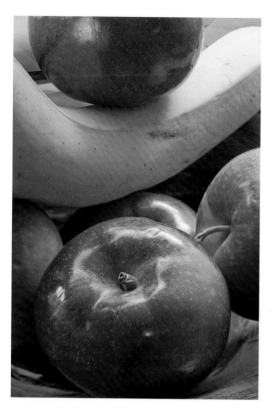

▲ *Figure 4.5*
Image stretched using Edit/Free Transform.

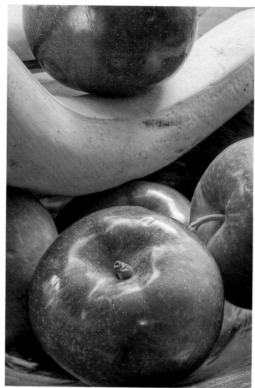

▲ *Figure 4.6*
Image after application of Akvis Enhancer.

The apples were not pristine, and up close there were many scratches, hairs, bashes, and blemishes that might show in a large print and had to be removed. I used a combination of the Clone and Healing Brush tools to do this.

At this point we have an image with some of the blemishes removed and tonality improved with Enhancer which opened shadows, controlled highlights, and increased local contrast all in a single step. You will find many references to Enhancer in this book, and while I don't use it in every image, I frequently use it at some point in the image processing just to see if it improves the image—it often does—especially if the effect is then toned down somewhat or applied only to parts of the image.

Enhancer is a powerful tool for improving images, both black and white and color. It brings out texture, brightens images, and does wonders for the darker parts of images. The effects on highlights are a bit more unpredictable, so you have to experiment to see the effect and whether it's one you want.

The ideal way to use Enhancer is to duplicate the image in a new layer, and then apply Enhancer to the new layer (Filter/Akvis/Akvis Enhancer). You can then use masking and layer opacity to control both where and how much of the effect you want. While I use Enhancer on most of my images, it is unusual for me to accept the full effect. Typically I set layer opacity to 30-50%, meaning that less than half of the filter's effect is kept. In addition, I don't necessarily want the effect everywhere. For example,

I sometimes avoid it for water and sky where it can remove the smoothness of the tones. That said, it can bring out waves and emphasize cloud structure. You just have to try the effect. It either improves the image or it doesn't and you can always throw away the extra layer. If, for some reason, you don't want to add another image layer (thereby using up memory), you can use the History tool to paint back the unenhanced image into the enhanced layer and control the opacity of the history brush as you paint to give you just as much enhancement to the image as needed where you need it.

Enhancer can be easy to take too far. I suggest you save your image just before applying the filter then do a Save As with a change to the name of the file so that with any future saves you won't lose everything you had done prior to the application of the filter. This way, when you find out you need to tone it back a bit further, or entirely throw it out, you can do so. Of course, this isn't an issue if you haven't flattened the file, but I find that saving many layered files is slow so I usually bite the bullet every so often and flatten the file before saving or going on to further editing. Be sure too that you have checked the effect of Enhancer on large prints—you could find yourself frustrated if the effect you have created only works on small files—another reason for toning down the full effect much of the time.

> *A good rule of thumb for Akvis Enhancer and other local contrast enhancing methods is to never apply more than 50% of the effect to an entire image and only use the full effect in selected areas, if at all.*

It's time now to do the black and white conversion. I was able to do this very nicely with the Black & White Adjustment Layer from the Layers Palette. I lightened the red slider (moved it to the right) until I had the apples where I liked them, then used the yellow slider until I had a good tone in the banana. I discovered that if I used the magenta slider, it had a dramatic effect on the specular reflections on the bottom apple. I did think to check to see if I had overdone it, and in fact I managed to clip those reflections unintentionally. I used my Threshold action to see the clipping and it was easy to go back to the Black & White Adjustment Layer and tone down the magenta adjustment (moving the slider back to the left a bit) until I had the look I wanted. The

▼ *Figure 4.7*
Use of Highlight Threshold Adjustment to show only those pixels lighter than 250 (on a scale of 0-255).

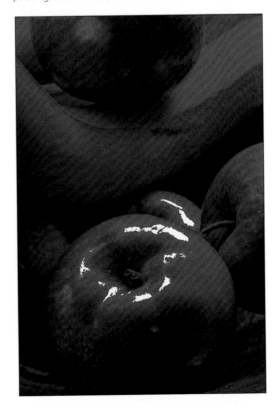

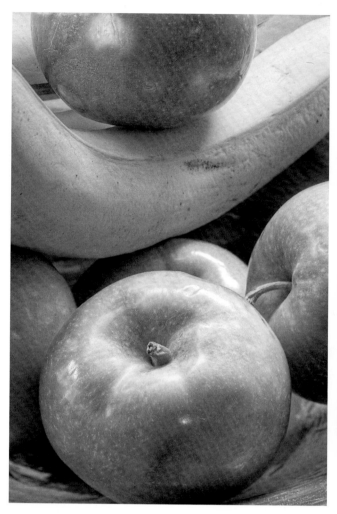

▲ *Figure 4.8*
Image as converted by the Photoshop Black & White
Conversion Adjustment Layer.

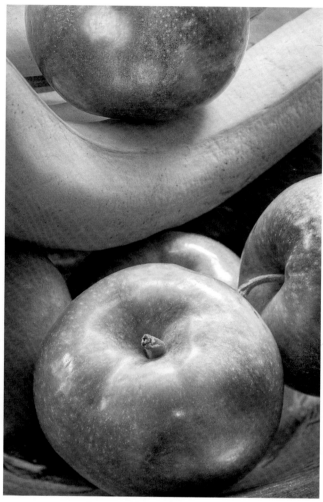

▲ *Figure 4.9*
The effect of several Curves to modify brightness and contrast in various
parts of the image.

appearance of the image with the Threshold
Adjustment in effect is seen in figure 4.7, while
you see the black and white result in figure 4.8.

It was now time to work on the various parts
of the image—lightening, darkening, and
adjusting contrast to suit. This was done with
a dozen or so Curves Adjustment Layers, each
masked to affect only the relevant part of the
image. The result is seen in figure 4.9.

I didn't know it but I was a long way from
getting the ideal image, even though it looked

okay at this point. I decided to use the Dodge
Highlights and Clone tools to bring out high-
lights, add other highlights where there were
none, and even transfer a few highlights.

I actually went back to the original image
(before the stretching) to retrieve a rather
nice highlight from the cropped part of the
top apple and move it to within the cropped
image. Photoshop allows you to open a
second copy of an image with different
Camera Raw settings if desired and then you

▶ *Figure 4.10*
After using Dodge High-
lights on the image.

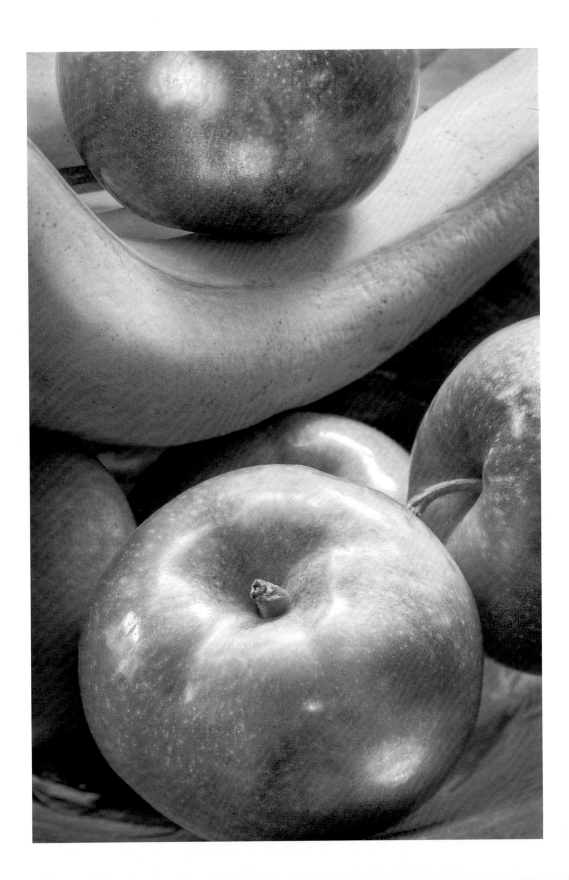

▲ **Figure 4.11**
Noise as seen in the lightened shadows.

▲ **Figure 4.12**
The same noise after applying a modest Filter/Blur/Gaussian Blur to it.

can copy part of that image by use of one of the selection tools and typing Command C for copy. You then flip back to the image you are working on and paste (Command V) the selected area as a new layer on top of the current set of layers. The copied area can then be dragged into position by using the move tool. In this case, the copied area was in color so I added a Black & White Conversion Layer and used Layer/Merge Down to cause the copied image layer second from the top to become a black and white layer. I then black masked the copied layer (via option click on the circle and rectangle layer icon at the bottom of the layers palette) and then painted in white to the mask to apply the highlight—and only the highlight—to the underlying images. Tricky? Yes. Cheating? Well, a little. The highlight was already on the apple; I just moved it a bit.

The Dodge Highlights tool does a terrific job at adding highlights where there didn't seem to be any, and you see the results of all this effort in figure 4.10.

The image was getting close to what I wanted, but I noted that after using the Camera Raw Fill slider, the Clarity slider, then Enhancer, and finally the lighten reds in Black & White Adjustment layer, considerable noise was showing up in the darker parts of the apples and especially in the dark areas between the fruit. I decided that a careful use of Gaussian Blur Filter would help here. I duplicated the image, blurred the copy, masked to black, and then painted the mask to blur as needed. It worked very nicely as can be seen by the two crops (figures 4.11 and 4.12) shown here, which I have lightened further to show the noise better, then blurred

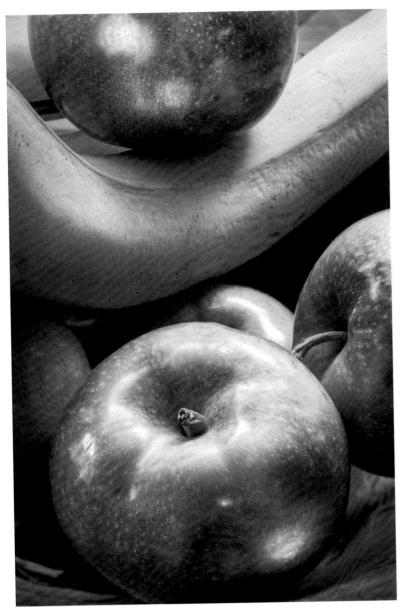

▲ *Figure 4.13*
A first attempt at darkening the image.

away via this technique. Obviously this would not work when you need extreme detail in the darker areas, but fortunately I don't need it in this case.

I have been watching the latest video from Luminous Landscape, this one on using Camera Raw 5 with Photoshop CS4. I disagree with much of the local editing in Camera Raw that they espouse, but the idea for reducing noise by moving the Clarity Slider to the left and eliminating sharpening locally to smooth the shadows rather than using Gaussian Blur is quite intriguing.

By this time I realized I needed to darken the image some more and I did this in several steps. Figure 4.13 shows an early step, but the image is too harsh. I can either do more work to correct the harshness or redo the darkening. I chose the latter and you see the result in figure 4.14. All I did was use the Layer 5 Opacity slider for the darken curve to reduce the effect from 100% (full application of the curve) to 40%.

This was not my first attempt at documenting the editing process for this image. I had previously written a blog entry illustrating the steps taken. For the book, however, I needed higher resolution images and it was easier to start over, and, therefore, the editing steps are not the same. In both efforts, I simply took the steps that seemed right at the time and not surprisingly there are many ways to get where you are going in Photoshop. Although the steps aren't in the same sequence, the editing followed roughly similar steps and the results don't vary a lot.

Like all books, this one has required much rewriting, and as I now work on the editing of the book (quite a while after my original writing was done), I have decided that what

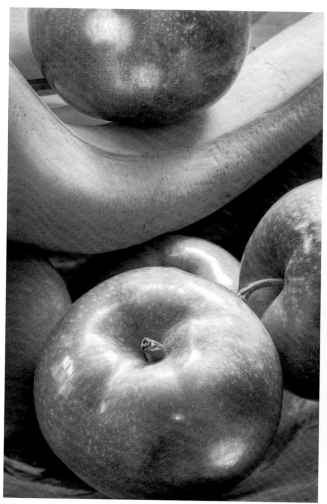

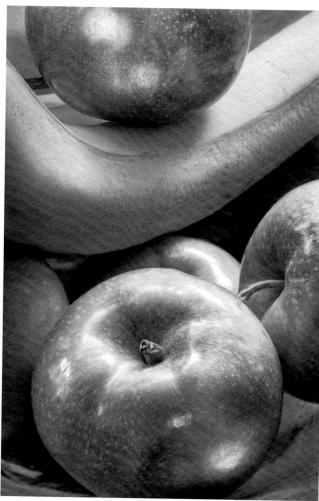

▲ *Figure 4.14*
The result of using the Layer Opacity slider to reduce the layer effect to 40%.

▲ *Figure 4.15*
A previous "end" to the editing process, but as you can see, there really is no end to editing.

was to be the final image is still not bold enough. Therefore, I added a darken Curve, and what you see now in the final position is the new darkened version. In figure 4.15 you see how the editing of this image was going to end. Figure 4.16 is the new final image.

Thoughts On the Image

Fruit bowl pictures are dime-a-dozen, and frankly, there's nothing spectacular about this one. On the other hand, it was very satisfying to take an ordinary color image and convert it into a black and white print that satisfies me on several levels. The skills learned in editing this image will come in handy in the future. Learning to move objects around (I arranged the fruit) is preliminary to doing still lifes in which all the objects have been placed by the photographer, rather than capturing a scene without intervention. Despite seeing very little of the bowl, it makes a good background for the image and underscores why you should give careful consideration to what's behind the scene.

Even if you aren't into photographing fruit and vegetables or other still life images, you could do a lot worse than try it. First, you might get to like it, and second, the skills you sharpen in the effort will pay dividends to the rest of your photography

And this is the final result of
the editing, for now.

5 Sculpture and Architecture

- ■ ■ *How to put some of yourself into images of objects that were originally designed as art or architecture*
- ■ ■ *Why you might want to photograph art anyway*
- ■ ■ *Some of the fine points of composing images*

My Approach to Photographing a Sculpture

The other weekend I tired of cleaning and repairing around the house. I even tired of reading, yet had no photographic projects in the works, so I headed downtown for a bit of a ramble. Amongst several potential subjects, I came upon an intriguing sculpture/wind-break at the end of my walk (figure 5.1). It is several stories high and can be seen for blocks. I started shooting it from some distance away with my zoom at its longest setting. I gradually approached, taking more images until I was under one half of the sculpture, the remainder on the other side of an aerial crosswalk.

I made a number of images as I looked up at the sculpture. I tried playing the sculpture off against its reflection in a building, and I even tried concentrating just on the reflection. None of the images were especially satisfying, however, and I knew I was "just trying". Eventually I decided to wander on and to my surprise discovered that more of the sculpture was to be found on the other side of the aerial walkway. Not only that, there were some sunlit buildings and some building faces lit by reflections from those sunlit buildings. Now I was really starting to get interested.

> When photographing architecture and sculpture, the more of "you" that you can put into the picture and the less it looks like a "wish you were here" snapshot the better.

I tried a number of compositions. I couldn't tell from just looking up where the best composition would be and I always find it difficult to compare compositions by memory—was it better over there or here? In a digital world, it's frankly simplest to shoot both if you have the time. In theory you could compare on the LCD but even that is challenging, and since the image is already recorded anyway, it hardly matters.

Figure 5.1 is the proof sheet from the shoot, so that you can see how I progressed. At a glance many of the compositions look similar, but I tried assorted focal lengths and minor crop variations on my 18-55IS on the Canon 40D. In the end, the widest shots were the best. I was trying to make interesting patterns and lines out of the sculpture while using the buildings in the background. I tried having important points meet, or cross, to see which was better. On the whole I find that lines should either go to the corner or stay well away,

▶ *Figure 5.1*
Contact sheet from
downtown shoot.

avoiding close to the corner In the central part of an image, subject matter that overlaps one part in front of the other is often best shown when the objects overlap by a substantial amount rather than showing them just barely touching (unless the thing the object touches is a shadow)—somehow that works better.

Note the overlap of the grid in the upper left corner in figure 5.2, with the blue building in the background. Somehow it would have been too clever to have the two corners exactly touch. Also, the grid half way down the left border of the image doesn't quite touch the largest grid referred to in the previous sentence. It's quite possible that what I'm describing here is personal taste rather than compositional advice. What you need to do is try it several different ways and see which one you like. Perhaps we would all agree that one way is strongest, but it is just as possible that you may have entirely different taste and prefer those corners to perfectly touch. Don't guess. Test!

As I was shooting, a trio of photographers came by and each took several pictures, then they had a group look at their LCDs, and before I was finished they were gone. Now, it could be that they got significantly better pictures than I did—it could be that they zeroed in on the one ideal image (though I noticed they never went near the spot I shot from for my chosen image). It's possible, but somehow I doubt it. They didn't move around much, seemed to shoot from wherever their feet were planted, simply rotating to find something else to photograph, and were done within less than five minutes.

I harp on Pepper #30 by Edward Weston because it illustrates many points, not the least of which is that it's a wonderful photograph. My point here is that had Edward quit at Pepper #29, he would have missed out on a magnificent photograph. Edward did show and publish other pepper images but none have come close to #30. I can't help but feel that these fellows quit after Pepper #3.

The whole question of whether it's photographic art to photograph someone else's

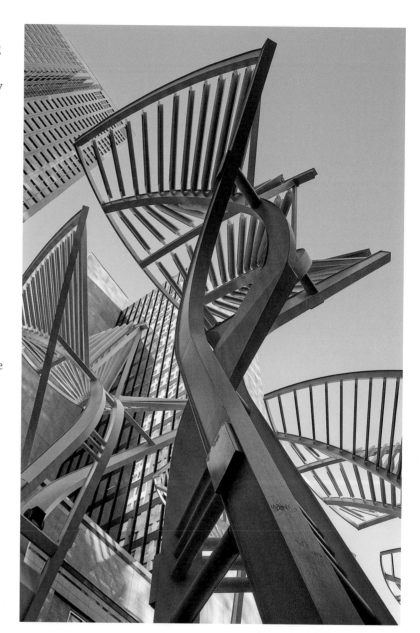

▲ **Figure 5.2**
Windbreak/Sculpture in downtown Calgary.

sculpture makes for an interesting debate. By extension we could include architecture in this discussion. Of course, taken to its absurd conclusion, only still life photographs of objects made by the photographer would be legitimate. Nudes would have to credit the model for providing the body, sports photographers the coach who set up the play, and so on.

Figure 5.3 shows a pretty straight, albeit cropped picture of "The Famous Five", a group of women who brought the vote to women in Canada. The sculptor is Barbara Paterson. Really, this is pretty much a record shot and

▼ **Figure 5.3**
Pretty much a straight recording of sculpture.

▼ **Figure 5.4**
At least in this face, the lighting is an important part of the image, but is that enough to justify "owning" this image?

I wouldn't normally show it, other than to make a point that everything in the image was created by the sculptor.

Of course, the difference in photographing sculpture is that the object photographed has only one purpose, which is as a piece of art, and somehow it seems like ripping off the sculptor to not only make images of the sculpture, but then to show them or even submit them for publication or to a contest. At what point do you admit that there is more of the sculptor than the photographer in the image and stop laying claim to the final image?

Figure 5.4 shows a narrow strip of a head sculpture in downtown Calgary. I have eliminated all extraneous detail and edges, and caught just the pop eyes, Roman nose, and incredible lips, at just the right time to light them. I would say that it has a bit more of me in the image, but still owes almost everything to the sculptor.

It's a pity that this discussion is even necessary since photographing sculpture can be fun, challenging, and quite rewarding, resulting in images for which the photographer can take at least some credit: for the lighting, positioning of the camera, the framing of the image, and of course for how the image is edited to make a final print.

Until recently, the only way that I have been able to enjoy the wonderful work of the architect Frank Gehry is through photographs. Had the photographers of these images considered it beneath them to "copy" someone else's art work, I would not have enjoyed these buildings, especially the Guggenheim Bilbao and Walt Disney Theatre in Los Angeles. One photographer even had a series of images of the theatre published in Lenswork. Clearly, Brooks Jenson, the editor, feels that the photographs are worthy in themselves. Figure

5.5 shows a Gehry building in Dusseldorf, photographed by me from the river.

So what happens when you make an image of someone photographing sculpture? That is exactly what I did in Cologne, Germany while on holiday. Clearly, I can lay claim to the image, and while it's hardly high art it is amusing and there's nothing wrong with photographs being entertaining. The wonderful photographer

▼ *Figure 5.5*
Frank Gehry building in Dusseldorf, Germany, as shot from the Rhine.

▲ *Figure 5.6*
Perhaps a photograph of the photographer might be a more interesting subject.

I suspect that the more you use your camera position and choice of background and lighting and so on, the more personal the image becomes and, I suppose, the more credit you can take for the image. As there's no cutoff that makes any sense, it really comes down to whether making images of others' artwork pleases you and whether you feel that your image of the art acts as more than a record-keeping photograph.

In terms of challenge (i.e., the satisfaction of solving a puzzle), photographing sculpture and architecture offers plenty of scope. Think of it this way—you could criticize any painter who paints what he sees, on the grounds that he didn't come up with the composition himself—thus condemning all traditional painting as mere copying of the real world and only abstract painting as worthy of being called true art. Clearly this is getting a bit silly, so perhaps the answer is to photograph sculpture and architecture if you want and avoid getting into the whole "Is it art?" discussion.

Right, so you are intrigued by my repeated mention of the challenge and to hell with whether it's art. Is there anything you can do to help the process of photographing the work of others, whether sculpture or architecture? Here are some suggestions for making successful images of which you can feel proud:

1. Try choosing a viewpoint that is different from what the normal passerby would see.

2. Consider photographing a part of the sculpture or building, emphasizing very strong composition in the image—no room here for sloppy framing. In moving in, you reduce the identification with the original sculpture. You might, in fact, move in extremely close to reveal details not normally seen.

Elliott Erwitt has made a career of photographing interesting juxtapositions. For years, his sharp eye has brought a smile to many a face. Come to think of it, an entire portfolio, or even a book, on people while photographing could be quite entertaining.

3. Think about what's different now that the building or object is in its final position vs. the studio where it was designed/built. This may mean making use of other buildings, water, trees, and especially lighting to "make" your image.

4. Take advantage of weather and weathering which can significantly change an artwork

5. It is your interpretation of the sculpture that matters. If you have ever had a chance to hear someone else interpret your images, you will be aware viewers often have quite different ideas about your motivations, intentions, feelings, and associations with the image. Thus, it is quite possible to bring a unique viewpoint (both literally and metaphysically) to your photograph(s) of a sculpture.

6. If your image looks like it would make a good picture for an auction catalogue, you probably have work to do.

My friend Robin and I were on our way to a shoot when we came across this typical country church. It was an ordinary building and it took some time to line up the right framing for a strong composition. I especially like those flowers in the frosted window. It's surprising how often one little touch turns an ordinary photograph into a good one. Note that the angled roof just touches the side of the tower (upper middle of the image). Filtering the sky was a piece of cake using the color sliders in the Black & White Conversion Layer—more a matter of deciding what I wanted than what I could do. I could have dialed in anything from white to black. Making the white walls glow without washing out entirely is a little tricky, being made all the easier by the Threshold Adjustment previously touched on chapter 1.

▲ *Figure 5.7*
Classic country church in southern Alberta – carefully composed and with flowers in the window.

Figure 5.8 shows some of the architecture of downtown Calgary. Two images from this location on top of a no longer existing parking garage made it into my book, *Take Your Photography To The Next Level* ("billboard" and "window reflection"). In this case I'm showing the eclectic architecture built over many years.

▲ *Figure 5.8*
A hodge podge of
architectural styles and
eras but forming a
harmonious composition.

Considerable effort went into composing the buildings in the shot even though I was limited to the area of the top floor of the garage. The way that one building ends and the next starts, the placement of the flag and dome, the soft lighting, and lots of detail all contribute to a successful image. Note the placement of those ducts in the beige and cream building—that's not luck, that's me wandering around for some time to find the absolutely best position. Is it important to the image—only in a small way—but sometimes images work not because they hit you over the head, but because you can come back to them and find other little things that are right about them. In hindsight a better sky would have been nice, but perhaps distracting. I do wish the bird had been close enough to not look like some flaw in the image, but I leave it in since in large prints it is recognizable for what it is.

Thoughts On the Images

Photographing architecture and sculpture is a
bit like solving those chess puzzles in the back of
the newspaper. It can be every bit as challenging
and rewarding as playing an entire game. No,
they aren't going to name the moves after you,
but it comes to a satisfying conclusion. The ar-
chitect or sculptor simply started you on the
path. How much further down the path you go
after you leave them behind is where the art in
the photography comes into play.

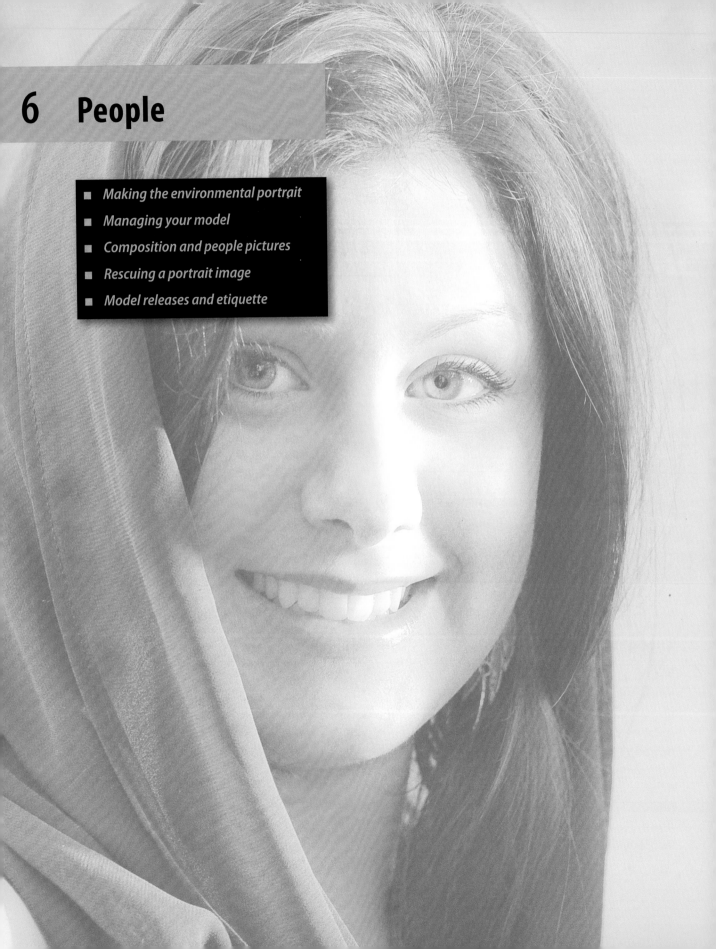

6 People

- Making the environmental portrait
- Managing your model
- Composition and people pictures
- Rescuing a portrait image
- Model releases and etiquette

'm not normally a people photographer but, in fact, the skills you learn in landscape photography still apply. Composition remains important, lighting is critical, but you have to add the element of capturing your subject in a way that says something about them. We all know of the artificial "smile for the camera" grins on many family snapshots that look pretty awful and don't give you any feeling for the person.

People photography in general and portrait photography in particular is one of the classic subjects in photography and some of the best works rank up there with the greatest images in the history of photography. I am especially fond of the work of Arnold Newman but there are many others who have contributed greatly to this genre. Photographers like Yousuf Karsh, Bill Brandt, Edward Weston, and even Ansel Adams all have images of people that are worth exploring. In this chapter I present a collection of people images I have made over the years along with some points they help illustrate.

Figure 6.1 shows a rugby picture circa 1968. Technically the image is lacking—not super sharp, especially by today's standards—but it does nicely show peak action. The image is well composed and you do get a sense of the intensity of the game, the finger digging into the thigh, the look of concentration and determination in the ball carrier (though it looks like he's about to lose it). These qualities far outweigh the technical problems—sure it's grainy, and yes, the face is blurred with movement, but it's the feeling in the image that counts.

As someone who rarely photographs sports anymore, I can only suggest that you spend a lot of time practicing before any important event. I remember the late Fred Picker writing about African safaris and suggesting that you visit a local farm and practice on the local "wildlife" (cows and horses) before heading for the African bush. High school sports can be practiced for the time you are invited to photograph the Super Bowl or FA Cup Final.

Sports images are about telling a story as clearly as possible. Do your images inform or explain?

▼ *Figure 6.1*
My one sports picture from back in my university days.

We tried a number of routine poses so at least I'd have something to fall back on, but not surprisingly they really didn't do much for me. I decided to copy Richard Avedon and have the girls jump, and that sort of worked. Then I hit on having them twirl round and was able to catch Emily (figure 6.2) in a nice composition. Her dress was flaring out and framing the bottom of the picture, and I had Emily the most relaxed yet as she concentrated on twirling rather than looking pretty. Her normally slim figure and pale skin worked wonderfully well with the low-lit, soft evening sun. I did cheat a bit—the background wasn't blurred enough so I used Filter/Blur/Gaussian Blur to soften the background in a copy of the image as a separate layer. Otherwise not much needed to be done. Emily was delighted with the result and that's all that matters.

Giving the subject something to do can really loosen up a shoot. Even if it doesn't make a good image, the model will be more relaxed afterwards.

The next "environmental" portrait (figure 6.3) is of my friend Neil, a fellow model railroader, a sometimes chronicler of human foibles, and an essayist. We were visiting an outdoor 7.5-inch railway (big enough to ride on) and Neil was relaxing at the station. I was carrying my Panasonic FZ50, a megazoom consumer digital camera. From a hillock some distance away, I was able to capture Neil without him noticing me, so he was quite relaxed.

It is essential that the models be comfortable. And the less pose there is about what they are doing the better.

I like the window framing Neil, the writings in his hand (sheer luck), and the other hand resting on his knee. In so many portraits, the

▲ *Figure 6.2*
A grad night picture, trying for something more than the usual stiff portraits

I was asked to photograph the daughters of friends who were heading off to grad night—all decked out in their new gowns. I did my best to make the girls feel relaxed. (Frankly I think they were more relaxed than I was—this was a one-off project and I didn't want to blow it in front of the neighbors. Besides, I didn't want to disappoint the girls.)

▲ *Figure 6.3*

An important goal of a portrait photograph is to tell a story about the person, although that message may only be known to the sitter, family, and friends.

▲ *Figure 6.4*

A casual and quickie shot just before playing tennis, but taking advantage of the light and using an unusual and surprisingly effective viewpoint.

model doesn't know what to do with his hands and often needs help placing them. Neil is leaning to the right and that's the darker side of the image, a combination that seems to work well.

Choose a background that suits the subject.

Just last night, a fellow photographer and physician brought me some prints from a project he is doing, photographing doctors at their hobbies. He was good enough to bring several prints of me. It was very clear to me, and later in the evening to my wife, that the best images were the ones in which I wasn't posed. Of course I'm not an actor. Models get paid big bucks not because they are good looking—those are dime a dozen—they get the big bucks because they can really get it on for the camera and switch from sexy to demure as required.

Bill and I were about to play tennis, but I had just purchased the Panasonic FZ50 and wanted to show it to Bill. It was early evening, the late sun shining. I decided to snap a picture of Bill, not expecting much. The background was terrible—bare trees or houses—so I did the obvious; I got down on my knees and used

the blue sky as a plain background (figure 6.4). Somewhat to my surprise the camera did a superb job of capturing both the sunlit and shaded parts of the face, and Bill didn't feel a lot of pressure (after all, I was just goofing around). The concentric loops of the sweatshirt nicely frame the bottom of the image. Gee, yet again the head is tilted slightly—that looks so much more dynamic than a perfect vertical. Bill's glasses are askew, but this isn't a photograph he's going to use to apply for a job. Besides, that's Bill for you. Altogether, a pleasing, if simple image.

▲ **Figure 6.5**
Lighting, expression, eyes and energy – the ingredients of a successful portrait.

Rosco is a welder. Rosco is a character. I met Rosco during my many visits to Independent Machinery. He's normally a pretty rough and tough guy with a dubious history, but he's also the kind of person who, when I hadn't been to the shop for six weeks, was glad to see me and came forward to shake my hand. One afternoon, he was saying goodbye to his girlfriend (it was taking a while) so I changed lenses and lugged my tripod over to see if I couldn't capture a candid portrait (figure 6.5).

I was using my 70-200 f2.8 IS at f8, 1/10 second and 130 mm. I didn't even have time to rotate the camera to vertical so this is a significant crop of a horizontal image. 1/10 second is really pushing it even with IS but I had the camera on the tripod, the ball head slightly loose, and the camera in hand—a combination that works quite well for following action (a monopod would be handier but not as steady). The lighting for the image came from the large machine shop door facing north. Rosco was clearly aware I was there but was concentrating on his girl friend and the result is a very natural looking portrait.

In hindsight, I probably should have used a wider aperture and faster shutter speed, but it worked and that's all that matters.

> *Take advantage of the subject interacting with someone else, even if it is you standing away from the camera with cable release.*

Sam is another welder at Independent Machinery. He lives onsite with his two dogs in his RV, to which he's added an extra room, complete with wood burning stove. Sam seems a bit more shy than Rosco and I think this portrait of Sam (figure 6.6) shows a fair bit about him—rough clothes, grease smudged nose, glancing off to the side with a look of slight suspicion. I wouldn't normally choose a striped background for a portrait but you work with what you can find and this was the plainest background around, and being out of focus, the background works quite well. Both Rosco

▲ Figure 6.6

True to his nature, Sam looks warily off to the side.

and Sam were pleased with their images (and of course received a print soon after the shoot).

I did, by the way, remember to get releases from them both for unlimited use of the image. I suggested that if they made it to the cover of Kellogg's Corn Flakes, I'd share in the money but otherwise could use the images as I pleased. You can't predict now what you are going to do with an image later, and people move on and can be hard to track down, so get the release quickly. Most people are willing to sign when you hand them a print. You can find model release forms online.

Get a model release when you return with a gift print for your model.

▲ Figure 6.7

Position against the background is critical.

Turns out Greg is not only a welder and a machinist, he's a graduate of Alberta College of Art and a darn good watercolor painter. Greg too works at Independent Machinery. Here he is (figure 6.7), leaning on his lathe, cutting a damaged wheel rim back to size. The background was a bit distracting, though at least it was blurred with a 1/15 second exposure at f4 and 153 mm focal length. It is

remarkable that the picture turned out at all. I did add a bit more blurring to the background via Filter/Blur/Gaussian Blur applied to a duplicate image layer. I then black masked it in Photoshop and then brought back the blurring to the image through painting white into the mask. The overhead lighting really did a number on Greg's eyes and he looked quite evil, but some carefully masked curves applied to the eyes lightened them and now he just looks serious. I like his position against the background, his face against the dark plain part of the background—a matter of careful camera positioning. The glasses on his head are a nice touch—not planned but gratefully accepted.

Be ready to take advantage of Lady Luck when she presents opportunities.

When photographing the grads, at one point they tried draping thin shawls over their heads. I didn't get a really good exposure, managing to white out the highlights on the skin from an umbrella flash to the right, and I thought it a pretty hopeless situation. Oh, I adjusted the exposure for the rest of the series, but of course the pose for this first shot was not repeated. In color the image was harsh, the scarf too strong a color, and I was just not happy with the image. Figure 6.8 shows the best I could do in Camera Raw with normal settings.

When I was fooling around with Silver Effex Pro from Nik Software, I noticed a number of preset conversions including soft sepia and thought I'd try some of these on the MacKenzie image. Much to my surprise, it immediately looked dramatically better—the scarf blended, the lighting was softer. I decided to start over with the RAW file, doing everything to save the highlights, this time not caring if they resulted in odd color (when one or two channels of red green blue go to pure white but the third retains some brightness information). Later in the processed image I did some further work to lighten the shadows, and lightened the shadowed eye even more. I softened the light with some selective Gaussian blur (3 pixels worth) applied at 20% strength via the opacity setting for the paint brush. I removed an errant hair from in front of the right eye and cropped the image (Figure 6.9). While not exactly a recipe for a fine art image, it is handy, nonetheless, to know that there are ways to bail yourself out when an image is less than perfect.

Another option that Silver Effex offered was the antique vignette look (figure 6.10). Perhaps the look is a bit hokey yet I think it works well for this image, and often in shooting portraits it is critical to please the sitter. After all, you can always use a different style or even a different image for your own purposes.

▼ *Figure 6.8*
This was the horrible original image—overexposed, harsh lighting, too much color in the scarf.

So, here are my suggestions for photographing people:

1. When photographing people, it's all too easy to concentrate on the face, but you have to consider the light and the background just as much as the expression.

2. The subject has to look normal. Talk to them, interest them, amuse them, and relax them.

3. Few faces are charismatic enough to fill the frame by themselves. The environmental portrait is both kinder and more interesting.

4. Guide your subject as to where their hands are to go. While getting them to pose in a particular position often looks quite artificial, people really don't know what to do with their hands, so some guidance will help.

5. Consider having your subject move about or talk with someone else. You can use a tripod and long cable release and be chatting with the subject while they converse with and look at you. As you move, you direct their eyes. It can work well to have them look one way, and then you move and take the picture just after they focus on your new position.

6. Consider the environmental portrait in which there is sufficient space around the face to show something of what they do. Have a look at the work of Paul Strand, Arnold Newman, and Joel Myerowitz.

7. Local contrast enhancement might just make someone look more rugged, but most certainly won't flatter your female subjects. If you were to use this, consider masking so the effects don't apply to the facial skin.

8. If you do want someone to look more rugged in a black and white image, rather than enhancing local contrast, consider using the red slider in the black and white adjustment layer to darken reds (red is more or less anti–green so it has the same effect as using a green filter with a film camera). Expect to remove a few blemishes that now stand out. By the same token, sometimes women's skin benefits from lightening red in a black and white conversion to look more smooth and translucent.

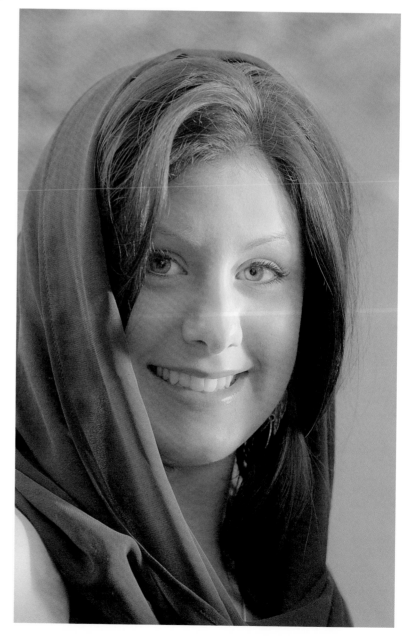

▼ *Figure 6.9*
An unexpectedly successful portrait of MacKenzie after having to deal with a horrible original image.

9. It is often better to fade permanent lines in a face rather than remove them. The Healing Brush tool applied at much less than 100% opacity will fade them nicely without changing the person into someone else.

10. Very occasionally it can pay to actually move the Clarity slider in Camera Raw to the left of neutral, resulting in an especially smooth, almost ethereal image, though a small amount left of neutral goes a long way.

11. Even if you are not normally a people or portrait photographer, there's nothing wrong with changing tracks now and again. How about shooting Aunt Angela the cook in her kitchen, or Cousin Bill working on his antique car? Keep in mind though that he'll probably look better leaning on the hood of a car, chatting about his hobby rather than "posed" with wrench in hand ready to attack.

Thoughts On the Images

I didn't think of myself as a people photographer before the last year or so when through a variety of circumstances the need and opportunity arose. This suggests that perhaps there are entire genres of photography that we do not currently include in our repertoire, or enthusiasms that, with a bit of effort, could turn into a real passion.

The challenge is to say something about the subject in your images while using the standard tools of good composition and tonalities and lighting to make the best possible image.

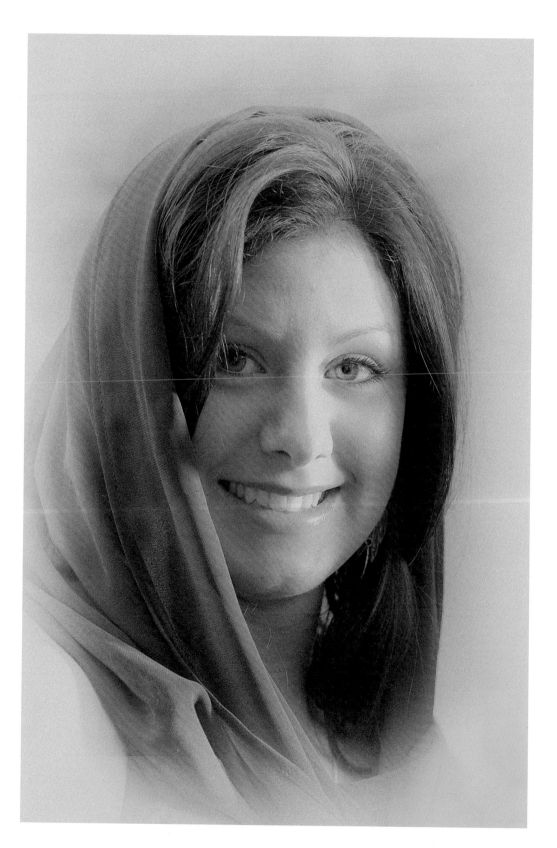

The vignette effect takes you back to the first half of the 20th century which seems to particularly suit this image, and most importantly, pleased MacKenzie.

7 Racks

- *Coping with distracting backgrounds*
- *Using Helicon Focus or Photoshop CS4 to focus blend for increased depth of field*
- *Issues in cropping*
- *Composition vs. substance*
- *Repetitive patterns*
- *Strong design*
- *Center of interest*

was wandering around the industrial part of Calgary and came across a field of machines. There were no fences or warning signs to stop me from going in. On closer inspection there were boilers and pipes, drums and racks, presses and stamping mills, and a variety of equipment I couldn't even identify. Over a period of few weeks I returned several times to photograph the equipment, each time finding new things to work with. On my last visit, there were poles around the field—obviously ready for fencing, and now it is enclosed by chain link and barbed wire. I am glad I went when I did.

◀ *Figure 7.1*
Digital "contact sheet" showing various images from the shoot.

Take the photographs now because you have no idea whether they'll be there tomorrow.

▼ **Figure 7.2**
High-key interpretation of a fan.

You can see from the "proof sheet" (figure 7.1) that I tried out a number of subjects and compositions. Most didn't work out very well, a few are pretty good, and one or two please me greatly.

There were a series of large fans standing near each other. Problem was, I couldn't figure out how best to make an image of the corrosion-speckled blades, given that they were covered in mesh, and everywhere I looked, the background was messy. I tried on three occasions to make an image, but I didn't feel good about any of them.

One afternoon I decided to try making a strong high-key image of a single fan, since that would wash out the distracting background and emphasize the lovely curves and lines. Likewise, black and white would further simplify the view. Figure 7.2 shows the end result. It is light, but with quite a bit of information remaining. I have lightened the image even further but at the moment, prefer the version you see here. In some ways, the image looks more like some sort of graphic art project, which suits me fine. I like the curves on curves on curves with the front grill, the blades, the back grill, and other similar shapes in the background.

Strong repetition is a powerful compositional tool.

Figure 7.3 also features a fan, this time on a much larger scale, taller than me. There is no grill and just the dust-encrusted blades forming very interesting patterns and textures. Notice again the absolute reduction of the image to its simplest form, this time accomplished in the cropping rather than the printing. The context is completely gone, and you wouldn't have known about its size if I hadn't told you. There

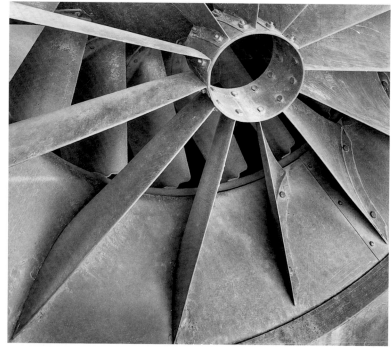

▲ **Figure 7.4**

The contrast between the sweeping curves and the radiating straight lines, and the way the light reflects off the metal makes for an interesting image.

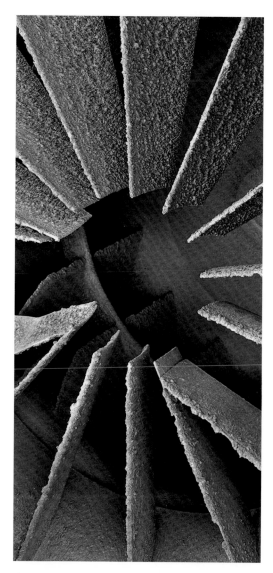

▲ **Figure 7.3**

Concentrating on the fan blades to the exclusion of all else.

are no distracting elements in the background, just a different pattern to reinforce the one in front. I don't think it's a brilliant picture, though were I organizing a show of images from this site, I would consider including this image.

Figure 7.4 features another and even larger fan. The graphic pattern isn't as strong as in the previous very "clean" image (clean in design, that is), but this one makes up for it with some lovely tones in the central support and the texture of the surrounding area. It is sufficiently different from figure 7.3 that I could easily include this image in the same show or submission. This is the third fan image. I wouldn't have thought they could be that different from each other, but these three certainly suggest that it might be possible to make a portfolio of only industrial fans.

Projects sometimes are born from the coincidence of a few similar images and the recognition that there is fodder for even more.

Some portfolios consist of a series of images from a single location or project, completed within a span of months. There's nothing wrong, however, with gradually acquiring suitable images from a variety of locations over many years until you have enough images for a show, submission, or portfolio.

A number of objects had bright blue tarps covering them. The color was a bit much, but the reflections on a soft-sun day seemed photogenic and I suspected this would work well as a black and white image (figure 7.5). I liked the fringes here, along with the series of lines, both straight and curving. The image makes good use of the corners. The tonalities did work out wonderfully, but overall I'm not convinced the composition is all that strong, especially given the line down the center and, somehow, the left

half not complementing or contrasting with the right. They are "sort of" different, and therefore not as strong.

> *"Almost" is the antithesis of good photographs. "Almost the same" means not the same; "almost opposite" means they aren't. Strong compositions are made of elements that are the same or are very much opposite of each other*

Lying on the ground were some sheets of clear polythene. Moisture had been trapped underneath and where metal was touching, rust had attached itself to the sheeting. The colors were wonderful, though I struggled with finding the right composition. There was a lot of good stuff but it was hard to relate it all together.

▼ *Figure 7.5*
A bit like kids who play with the box and ignore the toy.

▼ *Figure 7.6*
Full-frame image from which we have to select a strong composition.)

Several attempts ended in failures. I even tried rotating the images (after all, I had been shooting straight down), but that was worse than the way I had seen it in the viewfinder.

Figure 7.6 shows one full frame image. How would you consider cropping this image? For fun, you can access this full frame image in the book section of my website, so you can play with it in your editing software.

I played with the image using Akvis Enhancer. I tried a variety of crops. Some were very tight, others almost full frame, though none really satisfied me. Figure 7.7 shows the best I could make.

On a whim, I decided to see what the image would look like in black and white. Given that it's the colors that make the image, I can only say that somehow I had a feeling that the tones might work. Figure 7.8 shows the result.

Hardly any of this image uses Enhancer (except a little at bit bottom right). I did add a lot of contrast via Curves to the circle in the top left and toned down the "spikes" of bubbled wrap in the bottom half of the image. Now, this version I really like. Perhaps there were more good images from this shoot than I first realized. I photographed the plastic sheeting August 2008. It is now May 2009 and I only went back to the folder of images to help illustrate this chapter, certainly not expecting to find any ignored keepers.

▼ **Figure 7.7**
The best crop I could come up with yet still not entirely satisfactory – can you suggest a better crop of the original image?

▼ **Figure 7.8**
Surprisingly, given the dramatic colors, converting to black and white has worked remarkably well.

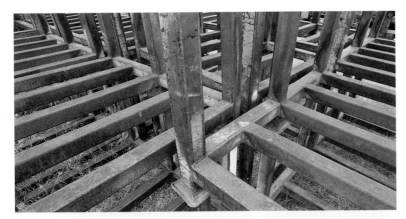

◀ *Figure 7.9*
The first attempt at forming an interesting composition out of these stacked steel racks.

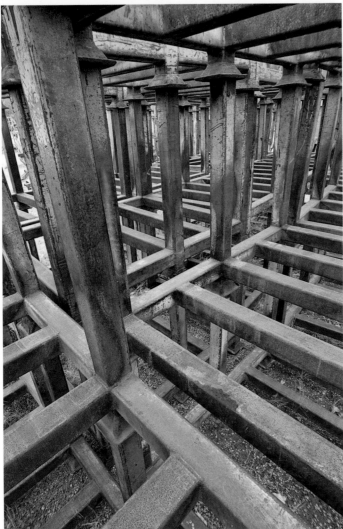

◀ *Figure 7.10*
Perhaps the vertical composition has a bit more energy.

Check old folders of images for hidden gems. After all, you had a reason to take the image. Perhaps the strengths and beauty of the image are hidden because it didn't look good as a thumbnail, without much editing, rotation, dramatic lightening or darkening, or stitching or blending.

There were a series of industrial sized racks, stacked together but not holding anything. The whole stack was difficult to photograph from outside, but I found I could place my head inside the racks and make compositions that weren't cluttered. The horizontal image of figure 7.9 was one of the earlier successes. Later (figure 7.10) I came up with the vertical image of the racks. In the latter shot there was more blue, and despite overly light background issues on the left, I don't feel they are problematic enough to discount this second version.

I thought that a black and white version of the vertical image would be nice, eliminating the color and focusing on the pattern (figure 7.11).

All three images of the steel racks (figures 7.9, 7.10, and 7.11) were made with my 17-40 mm lens at the wide end, on my full frame 1Ds2 for a true 17 mm. Despite such a wide angle of view, there wasn't sufficient depth of field, as some of the near parts were only a few inches away from the lens, and the furthest elements at 15 feet away were, for all intents and purposes, at infinity.

I did my usual focus blending with Helicon Focus, which, in fact, didn't do a perfect job on the gravel.

Working the scene is a little bit like a child with a new toy who puts the toy aside and spends several hours playing with the box. You don't know where your best images are going to come from.

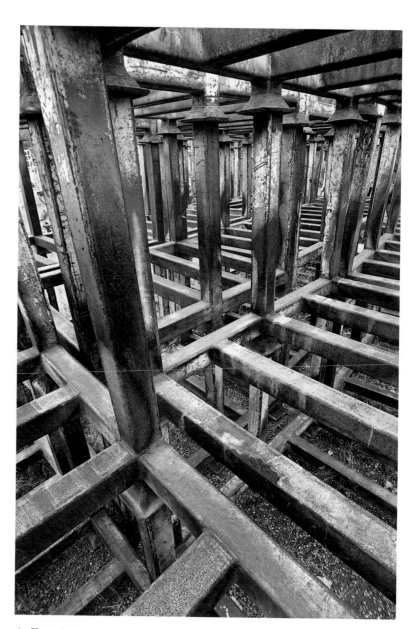

▲ *Figure 7.11*

Eliminating color to concentrate on form – the strength of black and white.

▲ *Figure 7.12*
Focus blending errors
in Helicon Focus – sig-
nificantly better than
the Photoshop blend.
(Closeup crop of figure
7.10.)

▶ *Figure 7.13*
Focus blending errors in Photoshop.
(Closeup crop of figure 7.10.)

For the first time, I decided to try the new focus blending options in Photoshop CS4. Regretfully, while Helicon Focus didn't quite render the background gravel perfectly, Photoshop made a real hash of lining up the near parts of the image close to the edges. You can see closeup crops of the two attempts in figure 7.12 (Helicon Focus) and figure 7.13 (Photoshop).

I have comfortably gone back to using Helicon for all my focus blends. Here's the whole sequence of steps, both in shooting the sequence of images and then processing with Helicon.

Focus Blending

The basic idea is to shoot a series of images of the subject, each focused at a different distance, starting with what's nearest and working to what's furthest. I strongly suggest you do it this way because if you aren't consistent, you are more likely to forget which way you are rotating the lens and screw up the sequence. More importantly, you can take all the care needed to focus on the nearest part before starting the sequence, and at absolute worst, you will have to quit at infinity as the lens runs out of room to turn.

There are two basic options in taking the photographs. To achieve maximum depth of field from the nearest point to furthest, I set my lens at f/11—just a bit sharper than f/16 but with good depth of field—so I don't have to take too many pictures for blending. I carefully focus on the closest part of the subject. (The new live view and magnified view of the latest cameras make this a snap compared to peering through the viewfinder as I had to do, trying to focus in a corner which is hard to see

with my glasses on.) I then take a series of images, rotating the lens about 1/8 inch between exposures until I get to infinity or at least beyond the furthest point of focus. The camera is on a tripod, and the lens is on manual focus and manual exposure, just like when stitching.

The second option for shooting a focus blend is to use a much wider aperture so that the background is thrown far out of focus and therefore blurred. This time I need to shoot more images with half the focusing ring rotation (1/16 inch) between images until I have focused as far away as I want. I don't continue on to infinity since I don't want a sharp background. The net result is great depth of field within the subject, but with the background nicely blurred. This could be ideal for photographing a flower (assuming no wind), or other three dimensional objects with a cluttered background.

Image Processing for Helicon Focus Blending

The process for working the images in Helicon Focus is as follows. I select the images in Bridge—the companion cataloging software that comes with Photoshop (or you could use Lightroom). I type Command O to open the set of images in Adobe Camera Raw. On the left side of Camera Raw, above where the thumbnails are shown, are two buttons: Select All and Synchronize. I press them in that order. Up comes a dialog box asking what criteria you want to synchronize. I want everything and I hit the OK button. I now make any changes to the first of the series of images in the various Camera Raw settings and these will be copied to all the other images in the sequence. Just as with stitching, I move the white balance off auto a little or a lot as desired, and now all the images have the same white balance.

I select Save Images (bottom left) and the images are saved as TIFF files in a special folder for my stitches and blends, and it is those TIFF files that are brought into Helicon Focus. In previous versions of Helicon Focus, one could drag the set of images to the icon for Helicon in the dock (on a Mac) but with the current version, the software has to already be opened for this to work—not a big deal.

Once Helicon has loaded the images, it is a simple matter of pressing the Render button in the upper right to blend the images. There are a number of settings you can play with but I have not found changes that will fix the wide-angle issue, otherwise the defaults work very well for me. I do go to Helicon Focus/Preference in the menu bar to change the formula for blending to Lanczos3. While it is the second slowest blending formula, it does an excellent job almost all of the time. For more information on the various settings and fine-tuning your blending, consult *Photographic Multishot Techniques* by Juergen and Rainer Gulbins.

The fact that focus blending works at all is a miracle, and we can do things with this technique that were impossible previously— whether digitally or on film. Not even view cameras with all their tilts and swings can create infinite depth of field in three-dimensional objects. One of the reasons this is a miracle is that as you focus, the image changes size on sensor or film, but Helicon takes that into consideration. I suspect it is the large amount of magnification change between images with extreme wide-angle lenses that has thrown off the blending process at its default settings. I am not even sure that Photoshop can take the size change into consideration, perhaps explaining its difficulties near the edges of the image.

Image Processing for Photoshop Blending

Despite my concerns about the Photoshop blend, there will be some of you who would at least like to try focus blending in Photoshop before spending money on new software, so I will describe my method for blending using Photoshop.

I select the images in Bridge. I type Command O to open the set of images in Camera Raw. Press Select All and then Synchronize. Adjust the color temperature of the first image so all the rest will match. I now make any changes to the first of the series of images in the various Camera Raw settings and these changes will be copied to all the other images in the sequence.

Now, instead of opening the images or saving them, I hit the Done button (at bottom right in Camera Raw) to save the changes to the images. Next, in Bridge I choose Tools/Photoshop/ Load Files Into Photoshop Layers menu, and my images for blending are loaded into a single image file in Photoshop, with each image on its own layer within this one file.

In Photoshop I now select the Edit/Auto Blend Layers menu. Up comes a dialog box asking if I want Panorama or Stack Images. I want to stack the images. This sounds like such a little thing for Photoshop to do, but in fact, what now happens is that Photoshop finds the sharpest parts of each image, masks everything else, and then blends the sharp parts together for an image that is sharp near to far.

While Photoshop failed to properly blend my extreme wide angle images (17 mm), it might work for longer focal lengths, therefore it may still have a use for you. For me, I don't want the bother of finding out afterwards that I missed the flaws which are now hard to fix. I'll stick with Helicon Focus, thank you.

This tall skinny image (figure 7.14) is another polythene sheet and rust image. I liked the repetitive pattern of the folds. There is little manipulation in this image. Some people will tell

▲ *Figure 7.14*

Plastic sheeting can take on interesting forms, and sometimes colors.

you that every photograph has to have a center of interest, but it isn't true. If you flip through this book, I think you'll find lots of examples of images that work well despite having no single area that takes precedence over the others.

The stronger the design, the less need there is for a center of interest.

This furnace (figure 7.15) was marked by a series of what look like copper doors, each surrounded by pink corrosion. They begged to be photographed, although there's no way I could figure out how to compose them strongly. In the end I did a straight-on shot and am letting the image ride on its color. While it should be pretty obvious by now that I believe strongly in composition, like every rule in photography, there are times when you can throw the rules out the window.

Contrasting the handle image (figure 7.15), which was weak on composition, the yellow angled steel image (figure 7.16) is all composition; and while I think it's so-so, I am not sure that it doesn't need something more than clever lines and angles. The top half of the image is not as strong as the rest. (Perhaps what it needs is a cute kitten sitting on that top sheet.) Doesn't this rule contradict what I said earlier about strong design mitigating the need for a center of interest? Well, yes, if I'm honest with myself; so it's worth a moment's thought. In this image, there is a very strong design around the edges, but not so much in the middle, and I think that's why it needs something more here. It wouldn't necessarily have to be a center

▲ *Figure 7.15*
There really isn't any composition to this image so it relies on its color to make a statement

▲ *Figure 7.16*
Very strong shapes but not much happening in the upper middle.

▶ *Figure 7.17*
Less dramatic shapes in
this image but with some
very nice color – yet is it
enough?

of interest, just more compatible design—an either or situation.

> *You can't afford to have a significant area of an image devoid of both design and interest, unless it is simply acting as background.*

Figure 7.17 shows a closeup view of stacked pieces of steel in an image bordering on the abstract. Color is more important in this image. I am slightly bothered by the angle iron that is in the bottom right corner and visually touches the diagonal line behind it. Knowing whether something should touch, approach, or overlap another object in a composition isn't easy, and in hindsight I wish I had given it just a little breathing room. Of course it might have

messed up something else in the composition, but that's only making excuses.

In figure 7.18, I liked the matching of the pale mauve flowers, yellow flowers, and the yellow graffiti on a backdrop of blue/gray paint of the machinery. The delicacy of the flowers and their fern like leaves contrasts nicely with the solidity of the background. Compositionally, it is a little weak. In fact, I hesitated about placing the image in the book but it illustrates nicely the thinking process both in looking for things to photograph and in selecting your best images.

My favorite image of all my trips to this field of machines shown in figure 7.19 is the abstract rust image of figure 7.20. It shows the side of a vertically standing pipe, about four

▲ *Figure 7.18*

The matching color in graffiti and flowers and the furnace and other flowers, and the solidity of the furnace against the fern like weeds makes this a better image than it might be otherwise.

▲ *Figure 7.19*

Overall scene of the junkyard with the large pipe from which the next image was made, sitting in the middle.

feet in diameter and about my height. Most of it was covered fairly evenly in rust (read boring), but on one side I found this engaging pattern in the rust.

I think this is one of the strongest images I have done in a long time, though it's not one others seem to especially like. I just tell myself "I'm ahead of my time", and keep on enjoying it. I will be interested to see if you like it at first, and whether your opinion changes over time.

> *If you love it, keep it, frame it, show it, but don't be disappointed if others don't feel the same way about your image.*

Thoughts On the Images

It is wonderful when you discover a subject that can be truly explored. It is even better when you can look at your images and go back and do a better job than on the previous images and find new things to photograph. Independent Machinery was like this, resulting in a total of 16 visits. This field gave me a total of four chances before it was fenced off. Just about any scene can be visited productively two or three times. One might even go so far as to say that any scene visited only once hasn't really been covered. In fact, about the only time I don't revisit a scene is if I got nothing on the first visit and can't figure out how to make a second trip worthwhile. Now, that isn't to say a second visit wouldn't be worthwhile, only that I can't see it and so don't try. I think there is a lesson in that—Go back anyway!

◀ **_Figure 7.20_**
Looking more like an im-
pressionist painting of a
sunset than an industrial
image, this is one of my best
images in the last year.

8 Stoney Park

- Photographing with a friend
- Black and white conversion
- Fixing the less than perfect image
- Knowing when you have gone too far

was out photographing with Lawrence Christmas, who is known for his photographs of miners and other industrial workers and also for his knowledge of the coal industry in Alberta. I like photographing with someone else, especially if they work at about the same pace, so we don't feel we are holding up or hurrying each other.

When working with friends, you encourage each other; when one is ready to give up, the other insists on pushing on and you both get more work done. You might think that you'd inevitably trip over each other's feet and, while it's true that we occasionally wait for the other person to move on, I rarely see things the same way as the other photographer and so we quite happily coexist on the same scene, producing quite different images.

Lawrence had photographed Stoney Indian Reserve before, but each time the lighting was different. On this visit, we had the remains

of fall color, a decent if not dramatic sky, and lovely lighting on near hillsides if not on the mountains themselves.

The location of the view in figure 8.1 is on the Stoney Indian Reserve which is a public park, accessed from Highway 1A, west of Calgary. The spot has been immortalized in some movie scenes, most recently *Appaloosa* and *Passchendaele*.

The skill in a situation like this is not in the discovering—after all Lawrence had been there before, as well as the countless movie crews, and I dare say lots of other photographers. The skill lies in capturing the light and then transforming the recorded image into what the photographer felt about the scene.

Figure 8.1 shows the image straight from stitching and at this point you'd be forgiven for wondering why I bothered taking the image in the first place. For all the accuracy of digital cameras these days, this photograph

▼ *Figure 8.1*

The image right from the stitching program, minus space off the top which had been created to get the horizon centered properly for the stitch so perspective is correct and vertical trees remain vertical in the image.

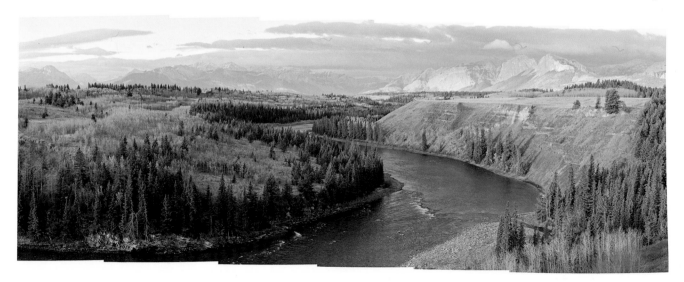

portrays absolutely nothing of the feeling I had that morning while standing on the cliff edge, the sun peeking under clouds in the east to light those yellow aspens. At least the sky looks interesting, but the mountains are quite unspectacular. This was real. The sunlight on the river valley and nearby hills didn't reach the mountain range, especially on the left. It would be understandable if someone walked away from the image at this point and simply planned to return on a better day, but there's enough about it that is right, that it is worth seeing what can be done to "fix" the parts that are wrong.

In figure 8.2, I have used Command A to select the entire image, and instead of cropping it, I used Edit/Free Transform (Command T) to adjust the edges of the image until the clouds are at the top of the canvas. I didn't want to lose any water at the bottom so I left small areas off the edge of the image and plain white, then I cloned in surrounding water. As these were tiny slivers at the edge of the image, it wasn't difficult to do and should not be noticeable, and it was all there anyway.

Had there been issues with perspective distortion, I could have fixed this at the same time. However, I had taken care of perspective during the stitching process in PTGui. I had placed the image horizon in PTGui's own horizon line, so that correction was already done. There was a fiber on my sensor, so of course it duplicated itself in each frame of the stitch. I removed it in each appearance with the Healing Brush tool. Things like fibers are most noticeable in a sky, but fortunately are also most amenable to editing out of a sky with a combination of the Healing Brush and Clone tools; using the former if not traversing any significant tonal changes and the latter if there are.

My next step was to work on the sky. I wanted a sky with some impact—after all, the landscape is fairly dramatic with the fall colors (at least it would be when I finished). On the other hand, I didn't want the sky to overpower the landscape. I definitely don't want the editing to look obvious. The sky isn't a huge part of the image area-wise, so I didn't need the drama of a thunderstorm.

The sky is quite good as is but needs balancing and a little bit of emphasis. I'd like to whiten up the lightest parts of the clouds, which are still a long way from being white. I start with a Curves adjustment. Since no part of the sky on the right is anywhere near white, I elect to move the white point to the left, turning gray into white. This can easily be overdone, driving whole

Figure 8.2

The image after being stretched to almost fill the canvas.

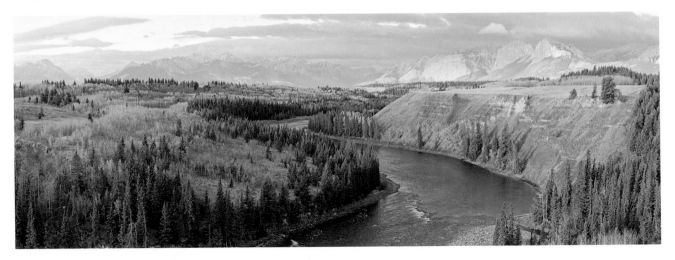

areas to pure white, but it is a curve and can be masked and faded, and then the mask painted darker again.

Just because you can make the sky black in Photoshop, doesn't mean that you should.

▼ **Figure 8.3**
Curve to improve the sky.

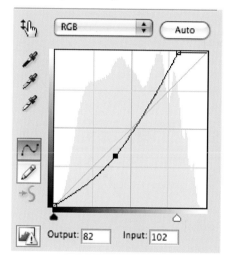

Moving the white point to the left steepens the slope of the line, and just like the middle part of an S-curve, this increases contrast in the image. At the same time it also increases color saturation. This might be acceptable, but often results in too much color and it needs either to be toned down by using a Hue/Saturation Adjustment Layer on top, by moving the saturation slider to the left, or by setting the blend mode for the Curve Adjustment Layer to Luminosity (the last choice in the blend list in the top left of the Layers palette).

Figure 8.4 shows the effect of the curve using Normal Blend mode, while figure 8.5 depicts the Luminosity Blend mode, which means the curve only affects brightness, not saturation. Sometimes using Luminosity mode results in an odd looking image in which the increase in contrast without increased saturation looks just as bad as overdoing the colors. Generally, I prefer to use Normal mode and then desaturate the color where needed with a Saturation/Hue Adjustment Layer. Here though, there isn't much color in the sky to start with and I know I'm going to be converting to black and white, so it doesn't really matter which method I use.

▼ **Figure 8.4**
"Normal" blending mode – note the increase in color saturation when contrast is increased.

▼ **Figure 8.5**
The effect of using "Luminosity" blending mode to eliminate the increase in color saturation side effect of increasing contrast in the image.

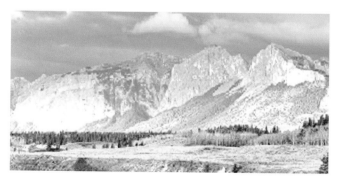

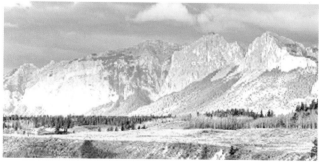

In the crops (figures 8.4 and 8.5), you can see that despite being fine for the sky, Luminosity mode has not done the field any favors. However, I'm also covered because I intend to mask everything but the sky, so no, this isn't a problem.

If the final image is only going be shown in black and white, do the black and white conversion fairly early in the editing process.

To continue my work with the sky I masked the effect to black (select the mask and Command I to invert the mask). Were there no white mask, I'd have to add a mask and Option click on the mask icon in the layers palette to produce a black mask in one step. Next I started painting in the effect where I want it within the sky. I used a 40% opacity round soft edge brush and adjusted the opacity as needed.

The one curve is not enough. I then used a curve to increase contrast (figure 8.6) and another curve to darken (figure 8.7) to better balance the left and right areas of the sky with the result in figure 8.8.

I still wasn't totally happy with the sky. I wanted to further darken the left side and lighten the right. I decided to leave the sky for the time being and get on with adjusting the mountains because that might have an effect on how the sky appears.

If making large changes to various parts of an image, it can pay to get several areas "in the ball park" before going back to the areas to get things exactly right. What would have looked right before the rest of the image was changed may no longer be correct.

The trick to working on the mountains was to massively increase contrast (as if the sun were shining) without messing up the sky or the trees on the hills in front of the mountains.

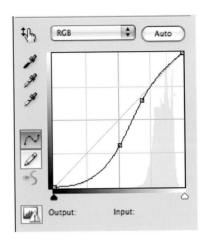

▲ **Figure 8.6**
Typical S-curve graph indicating increased separation of tones (increased contrast) in the tones represented by the steepest part of the graph

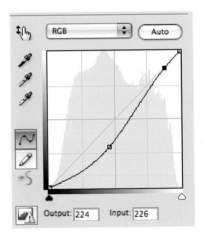

▲ **Figure 8.7**
Curve to darken image, without changing the blacks or whites (i.e., the ends of the curve).

Here more accurate masking was called for. I could reduce the softness of the brush but feared leaving brush marks behind so I simply relied on a smaller brush that would diffuse its effect over a smaller area.

After a total of six Curves Adjustment Layers, all with masks, I produced figure 8.9. This is a dramatic change from the rather flat

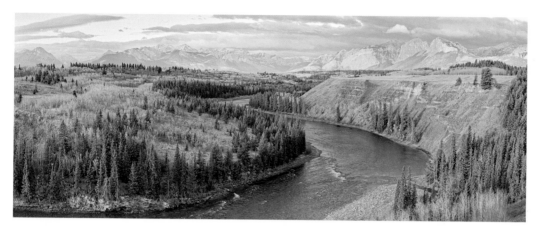

The effect of working on the sky with the combination of darken and increase contrast curves.

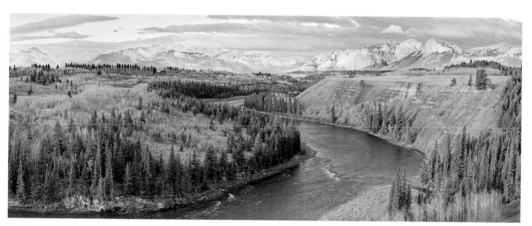

◀ *Figure 8.9*
The biggest flaw with the original image was the flat, dull lighting on most of the mountains. Work with several Curves Adjustment Layers has improved things dramatically.

inconspicuous mountains of the previous stage. Some of the adjustment layers were S-curves, a few were darken curves, and in one I moved the white point to the left. I didn't move the white point to most of the curves because I was afraid of damaging the sky (i.e., driving it to pure white). I was moderately careful not to apply the curves to the trees and I'm happy with the results.

Now it was time to work on the hillsides. Those yellow leaves needed to pop out more and the bluffs on the right leading down to the river could use some sun on them.

A 27% increase in saturation with a Hue/Saturation Adjustment Layer set to yellows nicely brings out the fall colors. It did

seem to have a significant effect on the greens, so I was careful to keep the effect only where appropriate. I took advantage of my previous experience playing with the Hue slider in the Hue/Saturation Adjustment Layer. Although it can turn the colors completely bizarre, I know that if I shift it a hair to the left, the yellows will warm up a little closer to orange, while in the other direction they will go to yellow/

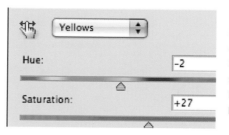

◀ *Figure 8.10*
Setting the Hue/Saturation Adjustment Layer to Yellows, and increasing saturation while ever so slightly moving the hue slider to the left, results in warm bright yellows like I remember.

green. Figure 8.10 shows the settings I used in the Hue/Saturation controls.

A subtle S-shaped curve added some sunlight to those riverside cliffs on the right side of the image by increasing contrast while at the same time lightening the lighter tones. The accumulated effect of all these changes is seen in figure 8.11.

At this stage, I was getting close to where I wanted to go. The mountains and even the clouds are a bit too blue. The cliffs on the right could use more sun. Were I most interested in the color version of the image, I would probably use the Dodge Highlights tool (Dodge with the control set to highlights), however, because I'm going to convert to black and white, I decided I would leave well enough alone for now.

I applied the Black & White Adjustment Layer then moved the yellow slider to the right to lighten the aspens and moved the blue slider to the left to darken the sky and bring the distant mountains into more relief. Since moving the yellow slider to the right could completely wash out the yellow aspens, I used the Highlight Threshold action to check on their progress as I moved the slider. I discovered that I was right—I went too far and so eased up on the yellow slider, saving the aspens from going blank white. As I suspected might happen, lightening

yellows has helped the riverside cliffs on the right and they now look downright sunny.

As you gain experience editing, you will be able to anticipate the effects of future steps, rather like improving at chess.

At this point, further adjustments were going to be made in smaller steps. It doesn't mean they aren't important, but it's quite possible that if I showed the steps one at a time, you wouldn't even be able to see the subtle differences on screen, never mind in print. You will find all these images on my website so that you can download them, bring them into Photoshop as a series of layers and then you can turn layers on and off to see the effects clearly. Anyway, it was time to even out the sky, strengthen the edges of the image, fix a couple of white spots in the sky on the right, and a dozen other "little" things that will result in a better image.

I used a combination of various Curves Adjustment Layers and Dodge Highlights to balance the sky, darken corners, bring out reflections in the water, darken the base of the cliff relative to the top, and darken the trees next to the river at the far left bottom (they seemed a bit anemic). I also added some darkening to the hillside on the left between the

▶ Figure 8.11
Increasing contrast and lightening the cliffs to the right of the river is like adding sunlight.

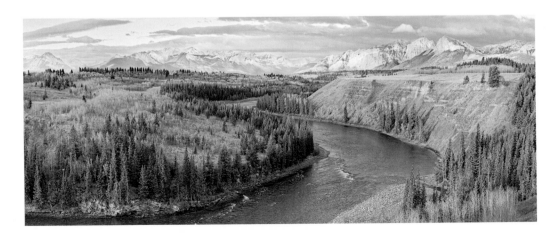

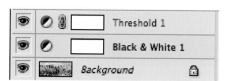

▲ *Figure 8.12*
The Highlight Threshold Adjustment creates a
threshold layer above the image layers to show
when highlights are getting clipped.

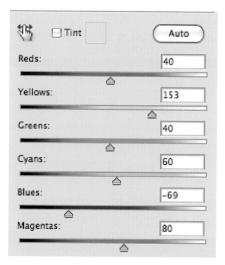

◀ *Figure 8.13*
I have lightened the yellows
and darkened the blues.

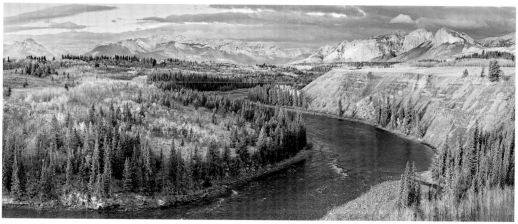

◀ *Figure 8.14*
The image in black and
white.

aspens. All in all, I probably changed a good
two-dozen areas, using perhaps a hundred
strokes of the mouse.

*Sometimes it is better to darken the surrounding
area than lighten the area of concern.*

It might not be obvious to you why I did all
of these minor adjustments. I balanced the sky
because the viewer doesn't care that the sun is
to the left and the sky is naturally paler. It just
doesn't look right in print so has to be fixed.
There were interesting tones in the water but
they were so dark it was unlikely they would
be appreciated in print so it seemed natural

to bring them out by lightening the water. I
wanted the top of the cliff to feel really sunny
and one way was to darken the areas around it.
The trees on the left were anemic because of the
yellow that is contained in most natural world
greens and in moving the yellow slider when
converting to black and white, I created "issues"
with the trees. It was an easy fix, so no big deal.
I wanted to further emphasize the clumps of
aspens on the left and since I didn't want to
lighten them further, I darkened the areas
between. Simple really.

Some time ago I purchased a graphics tablet
with which to do my editing, but have gradually
gone back to using the mouse almost exclusively. I

can't remember the last time I used the pen and tablet. I dare say I am missing out on some aspects of control, but the mouse works well for me and even with practice, the tablet was only okay. Your experience might be quite different, but other fine art photographers have confirmed my observations. I wouldn't rush out to purchase a tablet just because you think the experts use one.

By now, I was ready to take a break from editing the image. Making a print and pinning it to the wall might be a worthwhile step at this point because there's a risk that further changes will actually make things worse rather than better. The most important thing to do is save the image file to disk, and then if I do make further changes, I don't want to save them over this version. A Save As follows the Save and I'll call it "...V2" just in case I need to go back.

For the most part, well, almost always, I don't save images in huge numbers of layers. By now I have added something like thirty Adjustment Layers, but have already also flattened the image several times in order to save various versions to use in this book. Sometimes you need to flatten just to get to the next step. Besides, by this point I had made so many changes that going back 17 layers to fix something would get pretty silly. It is far better to add more layers to the flattened image than try to go back to previous adjustments. Saving a file with 30-plus layers means a huge file that is slow to save, slow to load, and takes up a lot of storage space. Do I sometimes regret flattening the image because then I can't go back? Sure, but I'd be more frustrated dealing with huge files if I tried to save everything from the start.

Save only as many steps as you can reasonably remember what they were for. Anything more is likely to be a waste.

You can label the adjustment layers for clarification, but I never bother, feeling it is faster to add another layer than to go back.

Do save a few versions of your image. If you have done a lot of work on it, it's time to save—just in case. Saving just before a major step in the editing pathway that may not easily be undone is just common sense. Already in editing this image, Photoshop crashed once when I tried to use Akvis Enhancer on it while having too many applications running on my Mac. Fortunately, I'd saved everything just before launching Enhancer so I lost absolutely nothing.

Akvis Enhancer sometimes chokes on large files, especially if you have several images open in Photoshop, or if there are several other applications running. Stitched images are usually very large and are most at risk. When I am stitching and want to use Enhancer, I will make a point of restarting Photoshop. I will make sure I have as few applications running as possible and, if I can avoid it, I will not duplicate the image layer and use the History Brush tool to backtrack as needed.

"Figure 8.16 shows the final image. Perhaps I did take it too far—there are times I certainly think so—but in fact this final image is a lot closer to how I felt about the scene than any of the preceding versions. The scene was dramatic and all the others failed to show that." I wrote that statement some time ago. I later decided that I needed to illustrate more steps, therefore I started the whole edit anew and the new final result is figure 8.17.

I now have fewer reservations about the image being over the top, even though in many ways I have taken it further than I did months ago. Compare the two images. Decide not just whether you prefer one or the other, but think about which parts of each image are better and how would you have handled it. You can

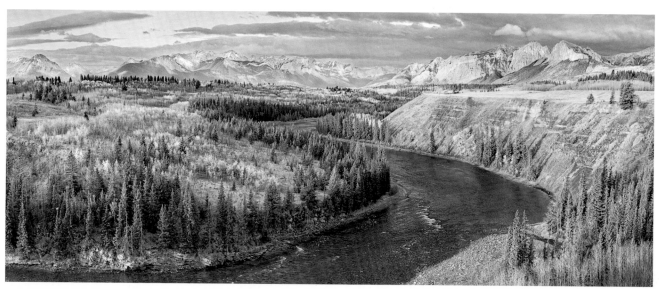

▲ *Figure 8.15*
Dozens of small changes later… mostly with masked Curves.

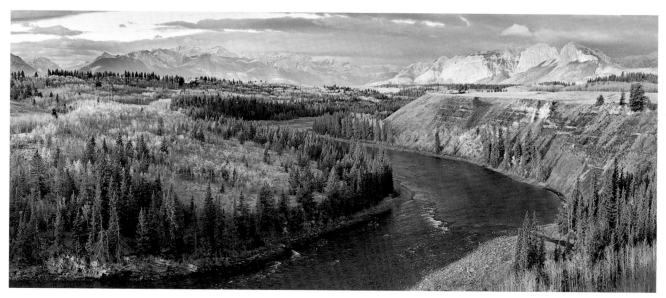

▲ *Figure 8.16*
An earlier "final" edit to the image.

download the original stitched image from my website and do your own editing to see what kind of result you think works best.

The final image includes electrical poles fairly prominently on the left. It wouldn't have been difficult to remove them in Photoshop, but while I am happy to remove skid marks and other "temporary" features, in this case, I felt it was part of the scene, like it or not, and it did feel like I'd be cheating if I removed them.

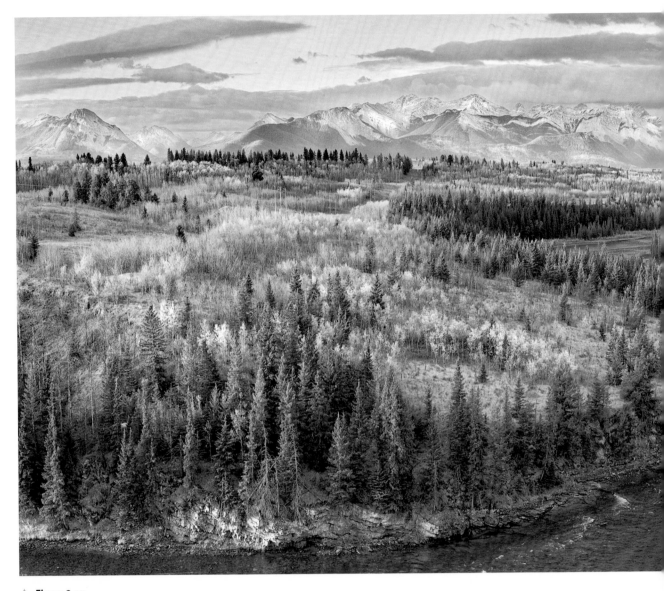

▲ *Figure 8.17*
The end result, being comfortable with taking the image further than previously while still looking real.

Thoughts On the Image

An image like this makes you realize that great photography can be mostly about finding the image or largely about making the image. Here, the finding was provided, the making was a solo effort, which produced a result quite far removed from what was initially recorded.

Perhaps you think that in manipulating an image as much as I did here I am cheating, just like extensive use of the cloning tool. Perhaps you are right. But consider this: traditional large format black and white photographers have been doing almost the same thing. Only, instead of software skills, they mastered the N++ development and water baths, and they masked negatives while dodging and burning

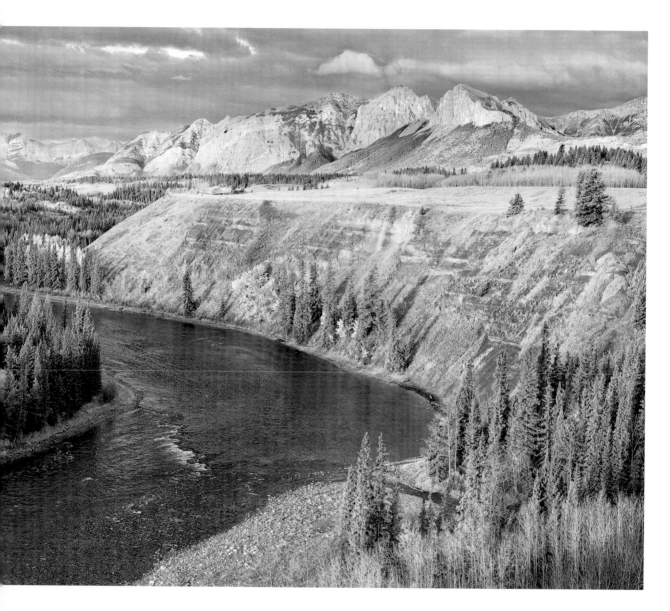

and using various contrast filters under the enlarger. And they bleached their images to make those highlights sparkle, just like when I use the Dodge Highlights tool. They even stretched images by tilting the view camera back and otherwise manipulated images beyond real.

The final image of this series gives me the feeling I had when standing there. I could see that the light wasn't on the far mountains and that they'd not photograph well, but I could see the details just fine. It was only the image that muddied those details to the point of blah, requiring so much work to fix. For me the yellow aspens jumped right out at me, not at all like the image before the work of editing the image.

Photographic images often need help in compensating for the accommodations the human eye makes and in trying to create the feeling you had from the full experience in a two dimensional medium of limited brightness range on a small piece of paper.

9 Logs

- Long panoramas
- More on black and white
- Working the scene
- Walking away
- Returning to the scene a second time

Robin was driving. We were simply cruising for snaps, looking for anything that might catch our eye, with the vague plan of visiting some small towns southeast of Calgary and not really knowing what to expect. We'd already been at a fertilizer plant but as we drove past this facility making utility poles, I noticed strong patterns in the stacked logs, aided by a snowfall a few days previous that lined some, but not all, of the logs. We did a quickie U-turn and headed into the plant. We could have photographed from the side of the road—there was no chain link fence blocking our view, but it did look more interesting if we could get closer to the piles of logs. So we stopped by the office to ask permission.

You miss a lot when you are the driver, so take turns being the observer, a good reason to travel with a friend.

We had to wait a while for the boss to come in and, with safety notices all over and us not in safety boots, we fully expected to get tossed out on our collective ear. In fact, that didn't bother the fellow at all but he was concerned that we could do a log inventory for his competition by photographing within the plant itself. He happily agreed he would be fine with us photographing from the edge of the road (not like he could stop us) but then went on to generously offer to have us photograph from their entrance driveway that put us right next to the piles that had so caught my eye in the first place. Sweet!

We suspected there was a great image here, but finding and seeing it proved a lot more challenging. Both of us walked up and down that road, sometimes setting up, then disappointed by what we saw in the viewfinder, moving on again. I shot 182 images. To be fair, some were focus blends, others stitches for panoramic images, but still, we were trying very hard.

Wonderful material does not automatically translate into wonderful images. It takes organization of the scene into a meaningful whole within a rectangular frame. It doesn't always happen, but it is your goal.

How do you reconcile photographing dozens of setups with how hard it was to find a possible image? Well, some setups were of sufficient interest through the viewfinder to be worth shooting because it might work. Early in your career, "might work" usually means, "probably won't". But the good news is that with experience it turns into "sometimes does", often enough anyway to have me record anything that looks even vaguely possible. After all, the hunting takes far more time than the shooting, even with stitching and focus blending. I do, however, walk away from fatal flaws, no matter how nice the rest of the subject is.

A fatal flaw would be something that interrupts a series of repetitions, no matter how you maneuver. It might be a harsh shadow that spoils the shapes, perhaps nothing more than that; or no matter how wonderful the center of the image might be, the edges trail off and completely spoil the image.

When I do find something I like, I work twice as hard to make sure that I caught it at the best possible angle—a little higher, perhaps six inches to the left, what if I did this, or that—so 182 images isn't difficult at all.

Most days, shoots last a few hours of actual photographing. Any more time and I tend to get a bit stale. This may include a few different scenes. For example, this chapter's scene was captured the same day that produced the Grain Elevator images in chapter 3, so on that day we were able to spend well over three hours photographing productively.

On returning home and loading the images into the computer, it didn't take long to find a single image among the logs scene that particularly appealed to me (figure 9.1). Later I put together the focus blended images and the stitches and though some I like (e.g., figure 9.6), none I feel are as strong as figure 9.1.

If you take the trouble to shoot a focus blend or especially a panorama of several images for future stitching, then stitch it when you get home. You can't tell the strength of the image until you put it back together again.

One early attempt is figure 9.2, an image blend for depth of field. Note that these logs are rather dull brown unlike the bright orange logs at the end of chapter. Since the image had very strong patterns, conversion to black and white seemed like an obvious solution (figure 9.3).

Many photographers claim to "see" only in black and white when photographing, arguing that over the years they have learned to ignore color entirely in visualizing images. Others can only see in color and don't "get" black and white photography. I prefer to remain open about what works best. The risk is that I will weaken my ability to "see" as a photographer

▼ **Figure 9.1**
Logs coming in from the left, logs from the right, and across the bottom a fanning of logs all pointing into the middle of the image.

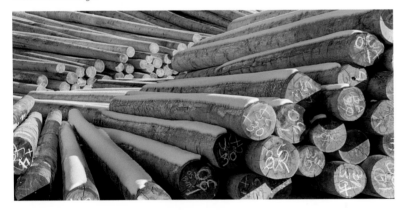

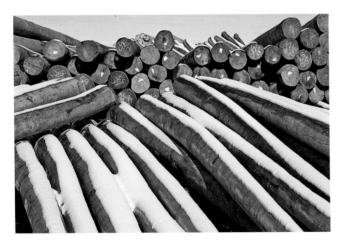
▲ **Figure 9.2**
The snow makes a bold pattern but the logs do not have enough color to justify a color image.

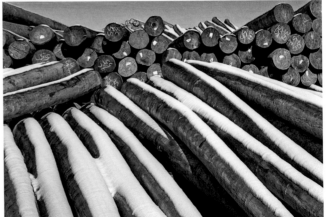
▲ **Figure 9.3**
In black and white we can concentrate on the lines of the snow, and the blue sky is darkened – better but not wonderful.

by working in both black and white and color, which is a bit like playing both piano and violin. However, despite being a black and white man most of my 40+ years in photography, since going digital with its perpetual option of color, I'd have lost out on a lot of wonderful photographs if I refused to work with color.

Whether I keep an image in color or convert it to black and white depends on a number of factors. Not all those factors have anything to do with the particular image or even project I'm working on. If I have seen some strong images in black and white in, say, *Lenswork* magazine, I am probably predisposed to work in black and white for a while afterwards. Sometimes I happen to be in a black and white mood for inexplicable reasons. Other times I'm on a roll in one or the other medium and want to continue in that bent. Occasionally I have displayed, sold, and published the same image in both black and white and color. In the end,

most images are best in one medium or the other, seldom both.

Obvious clues that an image will do better in black and white is when color interferes with the design of the image, when color is too strong or too weak, when there are too many colors, or when there are not enough colors. These are all reasons not to keep the image in color. Reasons you would want a black and white image is when there are sensational tones, patterns, and shapes that simply don't need the addition of color to be powerful.

Figure 9.4 shows a scene I was especially attracted to and I spent some time trying for the strongest framing and position. I moved in close and used a wide-angle lens. I backed off and used a long lens. I moved about left and right to get the strongest arrangement of the vertical posts. In the end it's okay and I'm not even sure what it is that doesn't work quite right, but sometimes logic doesn't enter

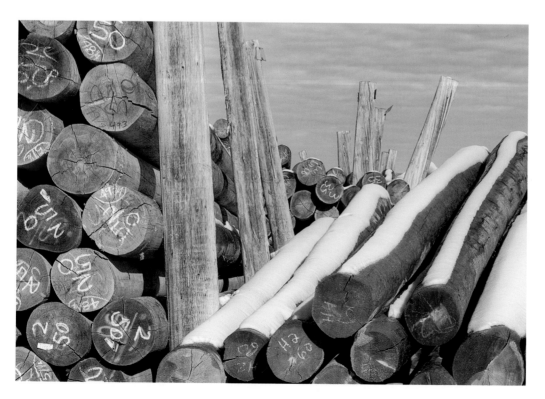

◄ *Figure 9.4*
I had high hopes for this image, but even at the time I knew it wasn't working well.

into the equation—you like it or you don't. It can be hard to know why you are attracted to another person from the moment you meet them, yet that is often the case and it defies logic. Perhaps we shouldn't be surprised when the same thing happens to images we make.

> *Images that should work but don't are all too common. That's why it's so important for you to give yourself choices.*

Gradually I finished all the focus blends and the stitching and came up with several panoramic images. Unfortunately, the poles aren't stacked all that high, but they stretch out for hundreds of feet, so the panoramic images end up being extremely long and narrow.

Figure 9.5 is one of the earlier stitches of the day and is, quite frankly, a disaster. Not only does the image fall off on the left hand side by being too high in camera position, the more distant pile of logs has a lot of boring ground in front of it. I should have seen this at the time, but when stitching, since you can't see the image in the viewfinder, it is all too easy to zoom in your mind as you scan left and right for the image and ignore the parts that don't work. Although I carry a viewing frame with me, it doesn't adjust beyond the standard ratio of 2:3. Perhaps if I had used a piece of cardboard to "crop" the viewing frame I would have recognized my error.

Figure 9.6 is an image I like a lot, but at a 6:1 image ratio (width to height), it's really pushing the envelope and many might well consider it so long and narrow that it is hard to see as a single image. Perhaps it won't matter in a large print. This image makes 52 x 9 inches at 300

▼ *Figure 9.5*
My eye followed the stacks of logs, ignoring the obvious flaw in the exposed ground on the left.

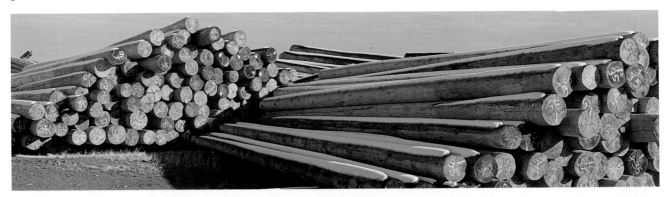

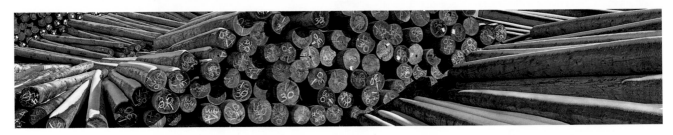

▲ *Figure 9.6*
The patterns are terrific, it works in black and white, but the middle section of logs is too big and unrelieved without something more interesting. Also, the image seems top heavy, and we haven't even discussed the shape yet.

dpi. I'm a lot more comfortable with image ratios of 3:1 or less. What I'd really like is for that middle section of logs to be half the width it is. (Wonder if I could get them to move the logs over a bit, all 500 of them?)

Not uncommonly you make an image that is really nice, except for one flaw. You try to justify it, you argue with yourself that it isn't that bad, that this time you got away with it, but really, it continues to nag you and even if you can overlook the flaw for a while, it will haunt you again and again.

If you can't fix a fatal flaw, then don't pretend you can ignore it. Abandon the image and move on.

Figure 9.7 is the closest I came that day to an image I like as much as figure 9.1. Figure 9.8 shows the uncropped original. While I don't like cropping on all sides (you can't make such big prints), sometimes the resultant composition is noticeably better. So why not go for the chop?

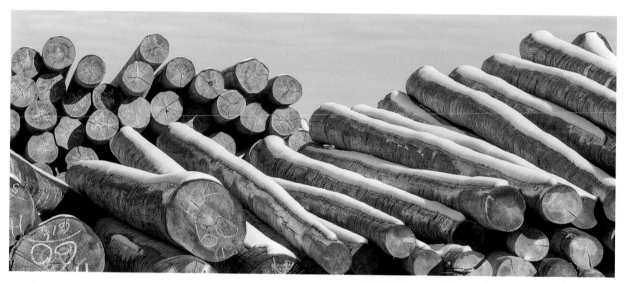

▲ *Figure. 9.7*
I really like those silver and blue logs on top, but the surrounding brown ones are unexciting.

▶ *Figure 9.8*
The original uncropped image shows too much sky and even more of those boring brown logs.

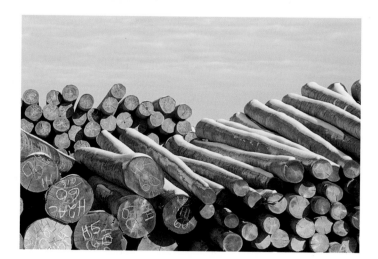

In this case I didn't want as much sky so off went the top. I really didn't like that dark hole in the stacked logs on the left so out goes the left side. On the right, there is one small section of log at the top of the pile which bothered me so a trim here too. That only left the bottom and I didn't think that more logs was better—the strongest part of the image is the blue, snow covered logs on top; therefore, trimming some off the bottom would clean things up, simplify things, and emphasize the blue logs more.

Cropping is not illegal or immoral, if you're sure it will result in a strong image. You may not be able to make big prints, but a great 8.5 x 11 beats a mediocre 17 x 22 every time.

All of us have gone the route of struggling to find something worth while within an image, cropping further and further until even if we did find something good, it wouldn't be of much use for anything but a postage stamp– and don't count on even that.

Crap tends to stay crap when you crop. Good stuff tends to get better when you trim.

I thought that figure 9.1 was a really good shot, but two weeks afterwards, I returned to drop off some prints and of course took advantage to see if I might find any more decent images. The second trip was well worth the effort.

Figure 9.9 is quite different, showing nothing but gray and blue diagonal stripes, except for that one log end in the corner. I had every intention of cropping it out by going above it, but in the end, after playing in Photoshop with the cropping tool, undoing and redoing a few times, darned if I didn't like the one log in the corner and I elected to keep it. What do you think?

Just before cropping is a good time to save your image. That way, you can always go back.

The last image, figure 9.10, is my new favorite from the two days of shooting, bumping figure 9.1 down to second or third place. There's nothing wrong with including two or more images of the same subject in any portfolio or submission for publication, although too much similarity does weaken the presentation. This is a flaw I quite commonly see in portfolios. You have to ask yourself whether the presentation gains from that second (and sometimes third and fourth) image or in fact is weakened by it. In this case, several images are fairly similar—in shape, viewing position, content, and character, so I only would include more than one of them in a portfolio if the patterns photographed were fundamentally different. If I were selling images, I might choose to include a few different images in my baskets of prints, letting the customer decide which they prefer, but for a portfolio I would only include images that are quite different.

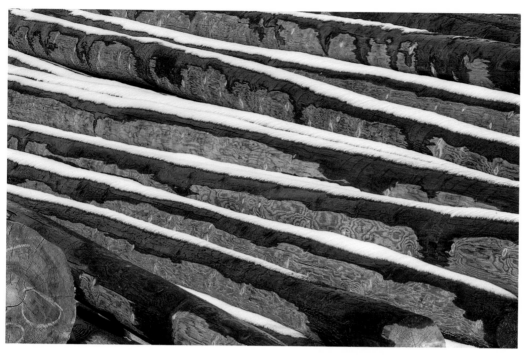

▲ *Figure 9.9*

I quite like the single fairly bright orange log in the bottom contrasting with the diagonal stripes in the rest of the image.

I think that figures 9.1, 9.9, and 9.10 are sufficiently different to be comfortably placed together in a portfolio, or even next to each other on the wall.

You can include two images of the same rock, but one better show you something more than just a close-up of the other for it to fly.

We need to be really tough minded. Does the extra image add anything to the portfolio? Even if it is a lovely picture, we might have to say no. Mind you, if an editor were to see a portfolio that included figure 9.10, and then ask to see everything else that is similar, I'd have no hesitation sending any of the others, and wouldn't be surprised to find that the editor actually preferred one I didn't first send. (Note that I speak from experience here.)

Never assume to understand the mind of the editor. Submit your best work, send more if asked, and if the images published don't match your idea of the best then perhaps you are missing something about the selected images. Keep in mind that, if you absolutely hate an image, you can bet it will be chosen for the cover picture.

Thoughts On the Images

The log plant was totally unexpected. The driver didn't even notice the logs, but as passenger, I was able to see them, register a possibility, look around and confirm the possibility, and then ask the driver to do a U-turn. You can see things when driving, but you might be well-advised to go a bit slower than usual, let other drivers pass, and possibly not do your scene searching on the freeway. I often pull over to let a car pass rather than be distracted by the other vehicle.

You can make assumptions about the kind of reception you will be met with when you ask permission to photograph on private property, but you could be missing some great opportunities if you assume a negative answer to your request. Be brave. Ask! In chapter 18 on pairs of images there are two shots of the Graymont Limestone Plant. When I phoned there, they didn't sound terribly enthusiastic, but when I arrived, they not only welcomed me, they went out of their way to be helpful. The plant manager had me listen to a short safety talk about risks in the plant like lime burns and to watch for the huge front-end loaders whizzing round the plant. So I darn well listened. The manager himself spent over an hour taking me around the plant and then left me to my own devices and I had a great time.

On the other hand, sometimes you are refused access, for whatever reason. I still haven't made it inside the ADM Flour Mill, and I ask everyone I know with even the most tenuous connection for an introduction. All you can do is smile, say thanks anyway, and work on the next possible location, whether it's a farm, a private stretch of river edge, an industrial plant, or some other site. Enough people and places will say yes to keep you busy for a lifetime.

If, like me, you have a penchant for industrial scenes, do invest in a pair of safety boots. Hard hats are easy to come by on site, but boots are trickier and often mandatory. You may also need safety glasses.

How about photographing in an art studio, a sculptors workplace, a welder's shop? Ever consider a project on quirky stores and their owners—the store that sells tanks (yes, the army type), the voodoo shop, the store that sells clothes for poodles, and, of course, the store owners. There are countless post offices and city halls.

Lots of people have one or two pictures of dramatic freeways, but what about doing an entire essay on the roads of your home town, from stop signs to traffic lights, bridges, lighting, overpasses, roads in the rain, roads at night, roads in the snow. This would be a fabulous project and if you get your work into *Lenswork* before I get mine, well done.

What about teaming up with a writer to interview and photograph a group of people with a common theme. It could be people working after age 65, or women doing traditional men's work (okay, maybe, that idea is old hat), or people doing really odd jobs or dirty jobs or even a project on all the people who serve you from the gas pump jockey to the lady at the deli who slices your pastrami for you. Hmm, this last one might be really good—I could include my barber and my pharmacist, maybe my optometrist or family doctor if they'd be willing—just the idea of all these people who consider me their client/customer/patient and whatnot as a collection could be well worthwhile.

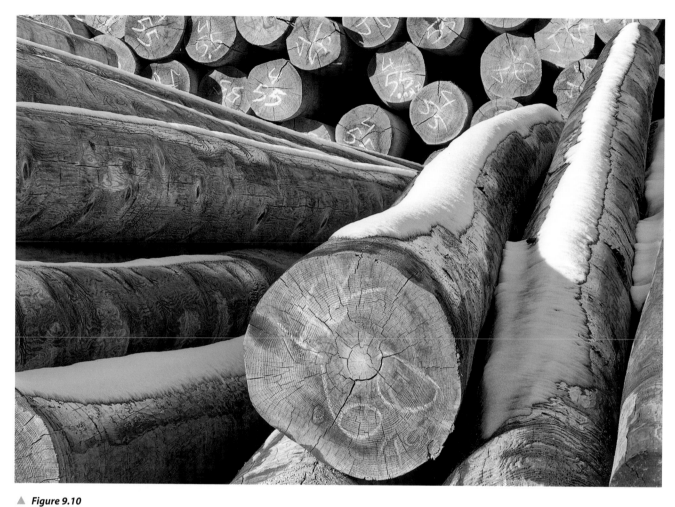

▲ *Figure 9.10*

By moving in, the detail in the log-end is seen and the other orange logs simply act as background; a successful composition is achieved.

One of the problems with coming up with ideas is that we want each and every image to look incredible, dramatic, a Grand Canyon of photographs (or a photograph of the Grand Canyon). Some of the best photographs in history are of very ordinary subjects—a room, a view from a balcony, people working, vegetables, scrap, rust, puddles, and other everyday things.

10 Abstract Images

- How to find and make abstract images
- Just how obscure does an abstract need to be?
- Clues as to material, scale, subject, and location

define abstract images as photographs in which the subject is not recognizable and thus the image is simply a series of un-identified shapes. Like so many things in life, abstraction can be a matter of degree. What if only 50% of people recognize what the subject is? How about if the material is identifiable, even if it's location and use are not clear? In this chapter I present a series of images for your consideration that vary from mildly to completely abstract. At the end of the chapter, you'll find a description of each of the images for those who must know what the subjects are.

Just like abstract paintings, abstract photographs are an acquired taste. Even if you are not ready to embrace the genre yet, you might want to try one day. Try starting around your own home and property, just to see if you can find them. All the same rules of composition apply. Just because the shapes aren't identifiable as a tree or rock doesn't mean you can place them just anywhere in the frame. There still needs to be a pattern or organization to the shapes so that they make a pleasing whole.

Years ago in a newsletter, Fred Picker told the story of a young man who could not afford the equipment or the time away from his family to do "serious" photography. Instead he took virgin newsprint and laid it on the couple's bed in loops and folds and proceeded to photograph it, lit by a single bare bulb, producing a wonderful portfolio of abstract images. Andy Ilachinski recently had a portfolio of images published in *Lenswork*. They were macro photographs of plastic candleholders, or to be more accurate, of the bubbles and flaws cast in the plastic. They looked celestial. Quite amazing.

Suggestions For Making Abstract Images

1. You don't need to travel far. Your own home, property, and surrounding neighborhood can supply plenty of opportunities for the observant photographer. It could be anything from garden tools to sewing accessories.

2. Close up or macro images can result in very good material since at magnification objects often look abstract.

3. Shallow depth of field isolates the subject and blurs the aspects that would identify the image.

4. Subject motion or camera movement can certainly abstract an image, although most images including movement seem to be better when there are some clues as to the subject photographed.

5. Think about how you can turn an ordinary object into an abstract. Forks have been done to death but there are a million other household items that can be used.

6. Don't forget that shadows, which in themselves, are more or less abstract and can be a very important part of an abstract image. Thus, seek out lighting that produces interesting shadows. A low light source with long shadows is an obvious place to start and brings out texture in the surfaces it glances.

7. Lighting coming from an unusual angle can abstract an object.

8. Photographing a part of something can abstract it.

9. Approaching the subject from anywhere BUT the normal viewpoint helps abstract.

10. Consider making a small, affordable Blurb book of abstract images. Blurb is a web-based "print on demand" book publisher, making reasonably priced books for very small markets. They will happily print a single book for you at a reasonable price. In general, a collection of abstract images doesn't need to be large to work, which would keep the cost of this kind of project very affordable.

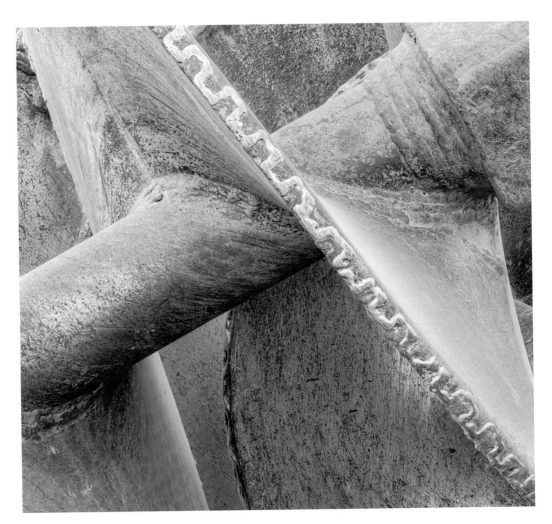

▲ *Figure 10.1*
It is hard to tell the scale of this image, though it isn't difficult to guess its general description and purpose. I find industrial subjects very suitable to this sort of close work, but even the human form can produce interesting and abstract close ups that are hard to identify (e.g., what you thought was a breast is in fact an elbow, etc.).

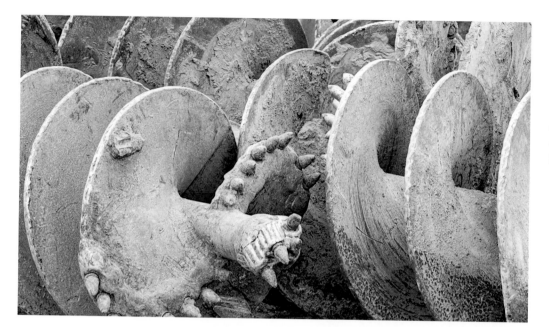

◀ *Figure 10.2*

Notice the strong repetitive shapes. I'm not wild about the tight crop across the bottom but as so often happens, you have to crop some good stuff (the teeth of the drill) to eliminate the bad (foreground gravel).

◀ *Figure 10.3*

Cropping the image even tighter would add to the abstractness of the image but frankly, I like this as is.

▲ *Figure 10.4*
Scale is the only thing a bit hard to identify here. Although the material is easy to identify, in many ways the image looks like an abstract. I have several similar "abstracts" in my previous book.

▲ *Figure 10.5*
No mystery here, the subject is easily identifiable but the image is all about the sweeping curves and overlapping shapes, and the actual material doesn't really matter. We can even see that they belong to Greg.

▶ *Figure 10.6*
Scale, function, and object identification are all difficult here. The corrosion forms the abstractness of the image while lack of edges helps hide the identification.

◀ *Figure 10.7*
This is a common hom-
eowners tool that becomes
a completely abstract image
when only the flat surface of
the item is captured.

▶ *Figure 10.8*
Looking a bit like Aladdin's lamp, the source of the image is
pretty much immaterial.

▶ *Figure 10.9*
This image very much looks like a watercolor—and perhaps in a way it is.

▶ *Figure 10.10*
Who knew there could be beauty in such a utilitarian object?

◀ *Figure 10.11*
This image comes complete with a builder's plate. Yet, it is
still an abstract work.

▼ *Figure 10.12*
There are clues to scale and possibly subject. Does that spoil
the image?

▲ *Figure 10.13*

This looks more like something you'd find on a Greek vase than what it really is.

Thoughts On the Images

Abstracts are a category of photography unto themselves, just as much as nudes or landscapes. They are every bit as rich. Whether you find your fodder in a junkyard or backyard doesn't matter. There's challenge and reward, beauty and surprise for those who follow this path.

Certainly, none of the subjects here was anything exotic, hard to find, far away, or tricky to photograph. All it took was an observant eye, one that would stop from moving loads of compost onto the flower beds long enough to appreciate the paint fading to rust on the sides of a wheelbarrow.

There are lots of exercises you can do to help develop your eye. There are workshops that train you to be observant like those by Freeman Patterson and Craig Tanner. The books by Freeman Patterson are an excellent start toward being more observant. Sure Freeman has traveled to Namibia, but his reputation was made on images taken within 100 miles of his home. Harold Mante is a retired professor of photography and while I find his writing a bit dense, his images are wonderful and for anyone who likes color, his books are well worth obtaining and are available in English.

Most of all, seeing is about making the effort to look beyond the labels, and when you do that, even the ordinary and the familiar can become interesting. After all, it was my wheelbarrow—not an antique, not some exotic import—just a working tool that caught my eye.

Image Descriptions

1. Augur for drilling holes big enough to sink a telephone pole.

2. More giant drill bits.

3. Bollard on a dock, for tying up cruise ships et al.

4. Rock face at a limestone quarry.

5. Tires.

6. Side of an old combine harvester at Pioneer Acres.

7. My wheelbarrow.

8. Deck of a tour boat—the no-slip surface.

9. Concrete surface.

10. Garbage can.

11. Industrial hydraulic cylinder.

12. Abandoned gas station siding, well worn.

13. Rust and paint on faded tarp.

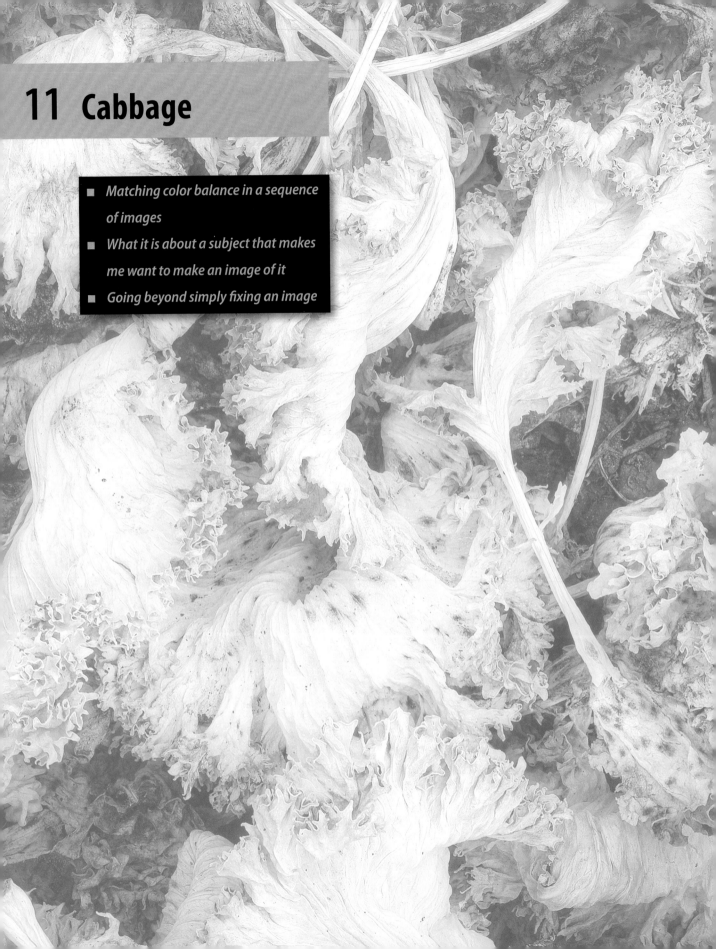

11 Cabbage

- *Matching color balance in a sequence of images*
- *What it is about a subject that makes me want to make an image of it*
- *Going beyond simply fixing an image*

A completely arranged still life in which every object is chosen, placed in the composition, and then lighted can be very difficult. It's far easier is to take found objects and photograph them in place, with a bit of tweaking to get things arranged just nicely.

This image of ornamental kale (cabbage) is pleasant (figure 11.1), but hardly spectacular or original. Still, the plants intrigued me and I have continued to photograph them since spring. I tried doing a Photoshop manipulation of one of the images and you see the result in figure 11.2. It is fun to do but I don't suppose it's high art.

Not long ago these vegetables started flowering and then proceeded to wither horribly

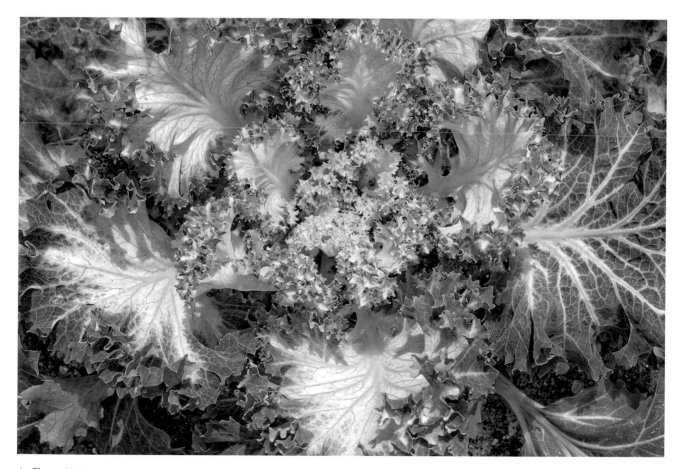

▲ *Figure 11.1*
The plants have interesting local patterns but there is no overall organization to the image.

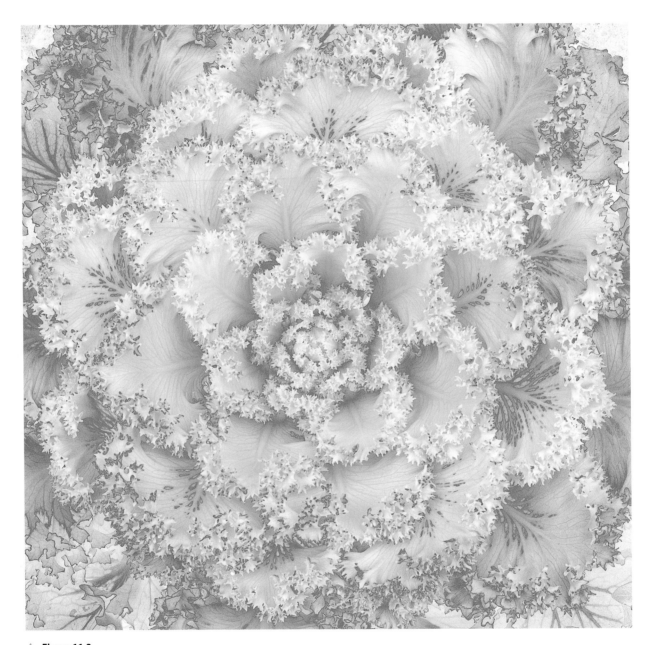

▲ *Figure 11.2*
I really like this manipulation but I have no idea what I should do with it.

(something about long roots and short containers). By the time I pulled away all the dead leaves at the base, the plant was a shadow of its former glory. The next day, though, I noticed that there were interesting patterns in the pile of dead leaves I'd removed but so very typically had not cleared away. Ah hah, a possible photograph! Figure 11.3 shows the results of simply composing as best I could what I found piled there. I was pleased with the result, yet not entirely satisfied. It could be better.

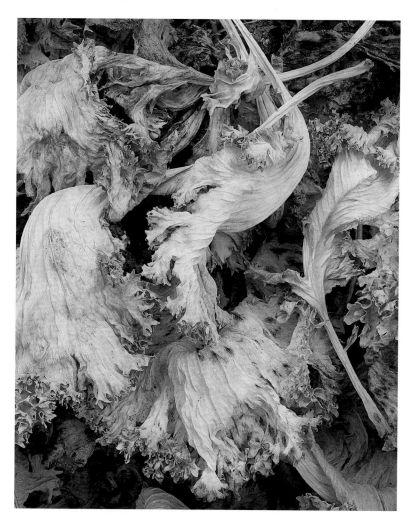

▶ *Figure 11.3*
Hints of something worthwhile but not organized enough. This is the beauty of a still life – we can now rearrange things.

On Finding Photographs

This is a good opportunity to discuss what it is that I see that makes me think there is a possible image. As often as not, it is not the subject itself but rather a combination of the shapes, the way the subject interacts with the lighting, and how various parts of a subject relate to each other.

For example, had the sun been strong and overhead and harsh, I don't think I would have even noticed the withered leaves that form the basis of this series. What I did notice was that in the soft light, the withered leaves made a series of interlocking curves, fine sweeping textures and a light colored surface that I could readily see would make for glowing highlights in a black and white print. Throughout this book, a similar pattern of recognition exists. It wasn't the telephone poles in chapter 9 that intrigued me, it was the patterns they made when stacked, along with the striping caused by the half melted snow. In the Badlands (chapter 2), it wasn't a single especially photogenic bluff that caught my eye, first it was the cave; and then it was the relationship of the foreground rocks, the bush, and the bluffs in the background that seemed to frame the bush, which itself was quite ordinary.

Okay, the Stoney Park image (chapter 8) is about a spectacular view, so, clearly, not all images are found via the shapes, textures, and relationships path. But here's the thing. The spectacular views are easy to recognize, and even non-photographers can see something worth capturing. Developing a strategy for seeing the less obvious compositions is much

harder. It takes more experience, and requires that while looking around, you consider what you are seeing in terms of shadows, reflections, spaces, and lines.

Meanwhile, kale awaited me. I went back out and started moving things around—we're talking dead plant leaves here—fragile, frilly, easily snagged or torn, so I was limited in what I could do. I did find a particularly nicely curved leaf for the bottom of the image. Depth of field didn't bother me because I would be using Helicon Focus to blend a series of images for essentially infinite depth of field.

The image was made with my Canon 1Ds2, using my 90 TS-E lens, in this case more for its sharpness and ability to focus closely, rather than for its tilt function, since I was blending anyway. A zoom would have been handier for correct framing, but by adjusting the center column of my tripod, I could adjust the image margins, if not quite as conveniently. Some photographers recommend having a tripod without a center column, but I find too many situations like this one where small up and down movements are helpful, and there are occasions when the full column height is essential to an image. When shooting to blend for depth of field, I generally use the smallest f-stop that maintains full sharpness. Usually this is f/11, though with macro shots, depth of field is so limited, I do sometimes use f/16 as I did here.

Previous experimentation has shown me that while images shot at f/16 are slightly lower in contrast (because of diffraction), they are just as sharp and a modest increase in sharpening can compensate for the effect of diffraction. Going beyond f/16 however, the image starts going downhill fast and you lose more than you gain. There are no circumstances in which I would shoot at anything smaller than f/16 on a full frame camera. On a reduced sensor size camera like the APS-C-sized sensors that are popular in many DSLRs, even f/16 is pushing it, and in consumer digitals with their tiny sensors, f/8 is about as small as you should go.

Find the smallest useful f-stop you can use to compensate for diffraction and never go beyond that stop—ever.

The wind was blowing briskly for the kale image, the lighting nice for the most part. The sun was soon going to come round a tree and spoil it though, so I was able to block both sun and wind with a saddle blanket (long story) and found this did not spoil the lighting. You use what you have on hand.

As usual, I exposed to the right; that is, using the maximum length of exposure consistent with not blowing out the highlights. The lightest parts of the plants were almost white with little detail in them. I could simply darken everything, but I have found that even though the highlights were not blown, by using the Recovery slider in Photoshop I could add the detail and reduce the glare on the highlights, while not spoiling the rest of the image. Mind you, this lowers contrast. In this case it made for nice tones. In other situations you don't want the reduced contrast caused by too much application of the Recovery slider.

One trick to remember when trying to match a series of images for stitching is that if you have your camera on auto white balance, as you swing your camera, color balance will vary from image to image. To avoid this, when all the images for the stitch are loaded into Adobe Camera Raw, and you have selected all and synchronized the images, go to the color temperature slider (top slider on the right) and move it. Even if you like the current setting, move it just a little bit. This will set color temperature to "custom" instead of "as shot" and since the images are synchronized, it will set the same color balance for every image of the sequence. The images are saved into a special folder as TIFF files, a format compatible with both Helicon Focus and PTGui. I could put the camera on manual white balance, but why bother? This way I get images in the thumbnails that are easy to look at and matching color balance is painless in Camera Raw.

Figure 11.4 is the output of the RAW file, without using the recovery slider and also showing how I subsequently cropped the image.

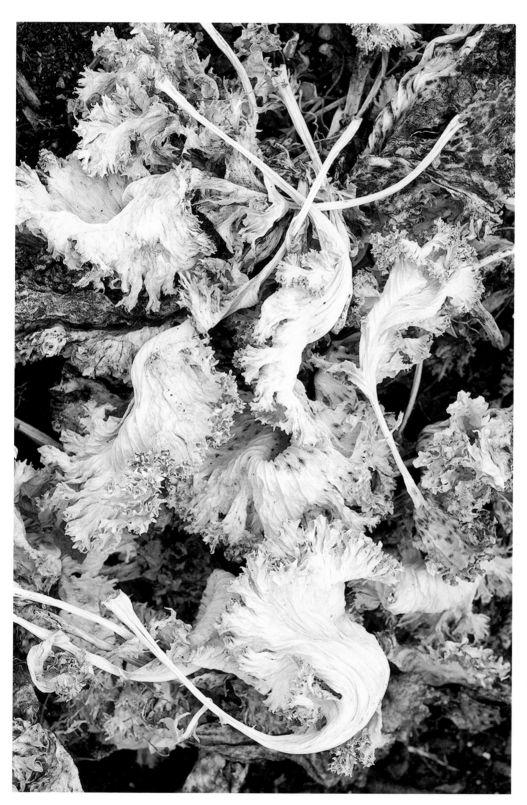

◄ *Figure 11.4*
A most inauspicious beginning though you can see the organization of the image is better.

The editing of the image is largely a matter of de-emphasizing those parts of the image that don't add to the patterns, while bringing forth those that do.

Differences between images are pretty subtle so I haven't tried to illustrate the entire sequence. I think you might agree that the rather harsh ordinary looking image right from Camera Raw doesn't look like it would turn into an attractive black and white image with pleasing tonalities

Sometimes cameras record scenes as dull and flat compared to what you see; other times the recorded image is harsher. As long as you captured the entire range of tones, it should be possible to adjust the image until the tones are where you want them.

◀ *Figure 11.5*
It is hard to believe that the subtle tones here came from the harsh original of the previous image.

◀ *Figure 11.6*
The image cropped a little tighter.

Thoughts On the Image

What a mundane subject: the dead leaves pulled from a plant found eight feet from my back door. No Yosemite here, yet all of the same issues come into play, such as composition, tonality, the edges of the frame, and more. How do you emphasize the good and make the bad (or at least the ordinary) recede? Do you have a good idea of which surfaces, tones, and reflections photograph well? Have you studied 10,000 good photographs so you don't have to think about what might be good? You just know.

The other night on the radio, they reported on some tests done on how fast people can recognize faces. It turns out that recognition takes something on the order of a few milliseconds, which is barely enough time for a nerve to conduct a signal once across the brain, never mind do a careful analysis of what is seen. Apparently we have small clusters of cells whose only function is to recognize Abraham Lincoln, and other clusters that recognize a million other familiar objects and people. These cells get the information directly from the retina and bypass all of the thinking, analyzing, assessing, and weighing that you might think would happen ("Let's see, stove pipe hat, tall lanky build, beard, serious outlook, old fashioned clothes, yep, that's Lincoln all right"). No, the light goes in, the cells recognize a pattern and the bell goes off, all in one step. What you want to do is recognize photographic subject potential the same way, not by analyzing the material, thinking that well, it's metal and metal shines and it will probably reflect light nicely, and gee, it's an interesting shape, and wow, that's a good clean background. No, that is not it at all. It is a lot faster and smoother than that. You see, you recognize potential—all in one step— but only after studying the 10,000 images.

Before this automatic response develops you start by labeling every object, and instead of seeing interesting angles and shadows, you see a chair. Next you learn to look at the chair and recognize its potential because of shapes, lines, angles, and shadows. Eventually you graduate to "shapes, angles, shadows—that's a picture" without having to inventory the possibilities.

Great images can come from very modest subjects given the right lighting, juxtapositions, background, repetition, harmony, or dissonance. They can come from a visual pun or an image that tells a classic or interesting story. Images can be great because they inform or make you think or challenge what you think you know. It all starts with recognizing the possibilities of the subject rather than the achievements.

Figure 11.7
Considerable work has been done to bring forth the important and help the mundane recede into the background through the use of brightness and contrast. The image feels better balanced.

12 Europe

- *What to take*
- *How to carry it*
- *What to shoot while traveling*

First, let me make it plain that I am not a travel photographer by inclination, experience, or skill. I don't want you to think that I can teach you how to be a good travel photographer. However, sometimes photographers do get to travel and it only seems sensible to bring along a camera and make the most of the opportunity.

Often, between limited time and family commitments, there are not nearly as many opportunities to photograph while you are on the road as one might hope. So make the most of the time you do have. It would be reasonable to assume that the kind of photography we do while traveling may be substantially different from the work we do at home, which in many ways is the point of a holiday.

Equipment

As a serious photographer who may find a really nice image while traveling, you want equipment that is capable of making the size prints you might need. You don't know ahead of time what you will be photographing—people, things, landscape, in good or bad light—so a camera with a decent-sized sensor and high ISO capability is ideal. At this point, however, full frame sensor cameras are very expensive and there is the risk of cameras being stolen or dropped while traveling, so a smaller DSLR makes sense. Their ability to capture a decent image at ISO 1600 makes for considerable flexibility and their fast focusing more than compensates for the larger size of camera you need to carry.

There is nothing more frustrating than publishing an image on your website and having a customer lined up, only to have to tell them that the image they want above all others can't make a print bigger than 5 x 7.

Thus it was that on a recent trip to Germany and Prague, I used a Canon 40D. For lenses I picked the very compact 18-55 IS lens, which for the price is remarkably good. As a second lens I purchased the 55-250 IS lens with coverage from 18-250 mm on an APS-C camera (equivalent 35mm focal length would be 28-400 mm). Combined, these items fit in a relatively small package. You might wonder why I didn't use a single zoom lens covering the same range, but the reading I did suggested

▼ **Figure 12.1**
Cologne train station, view of the tracks leading into the station, and the complex overhead wiring.

▲ *Figure. 12.2*
Cologne Station – view from Cathedral.

I wouldn't be happy with the quality. I think that 28-300 mm lenses are for people who are happy with 4 x 6 drug-store-size prints. It isn't that they can't sometimes produce a great 13 x 19 print, but you can't count on it. To be fair, they are a lot better than they were even a few years ago and perhaps I will be eating my words within a year or so.

I debated about whether to take a tripod. On the one hand, I felt silly carrying one along, but I was afraid I would miss out on some opportunities without it, so I decided to bring the lightweight and relatively compact, metal, Manfrotto 725B tripod that I'd purchased some time ago. It could reach eye level with only a modest use of the center column. I

seriously considered the carbon fiber tripods costing several times as much, but in the end felt they didn't offer much advantage on a trip. Sure, legs that splay at multiple angles are handy in some situations, but not when you are on a trip and in a hurry. Five section legs are compact but slow to set up. I found I could put one leg of my tripod inside my belt and carry it very easily there. Also, it fit inside the larger of two suitcases we were bringing. I wasn't wild about flopping the camera over on its side for vertical images, but as it happened, it worked just fine. Yes, an L-bracket and better ball head would have been nice, but also heavier and bulkier. So, in the end, I had no regrets. Did I use the tripod? Darn right I did.

▶ *Figure 12.3*
Photographer Captured – next to Cologne Cathedral.

One afternoon my wife and I took a walking tour of Prague (sans tripod) and on the excursion I found a number of things to photograph, all of which would have been better if I had the tripod with me. On my own the next day, I recaptured those images and a bunch more, and was mightily glad that I brought the tripod.

Mind you, it seems that cathedrals and tripods don't mix during tourist season. All my inside work was done handheld and, boy, was I happy the 40D can make a decent image at EI 1600.

The new Panasonic G1 would be a tempting camera to travel with, but the larger size of my 40D and two lenses did not create any problems. I carried everything, including one spare battery, an international charger, and an adapter, in a Tamrac Velocity 7 case. I backed up to my laptop since I needed it for Photokina anyway (I was giving a workshop for Rocky Nook). Something small like the Canon G10 is okay, but really only does well in low contrast good lighting. A camera that is more versatile, albeit much bulkier, is worth the effort in my mind.

I own a Panasonic FZ50 and took it on a cruise last year. It was decent for stationary subjects, but was hopeless for whales. I think that small-sensor cameras are for when you don't anticipate photographing and want something just in case. The FZ50 could just about make an 11 x 14 print; my wife's Panasonic TZ5, while ideal for her, could make a fairly good 8 x 10.

Figure 12.4
Aachen Dom –
Charlemagne's Cathedral,
Aachen, Germany.

Frank Gehry Building –
Dusseldorf, Germany.

◀ **Figure 12.6**
Curtains, U Suteru Hotel – Prague.

On that cruise, I also had my 1Ds2 and a rented 100-400mm lens. After two experiences renting lenses, I would say that rental lenses are the worst examples available—the lenses seem to be the ones that shops couldn't sell or were returns. If you can cope with the worst example of a particular lens that is available (and with every manufacturer some lenses are known to be better than others), then fine. I found this particular 100-400 mm downright horrible at 400 mm. Since then, of course, I have the 40D and a 55-250 mm lens, which is equivalent to 400 mm at the long end and is quite sharp—odd considering it's one-forth the size and price of the 100-400 mm lens, but is a much better lens for travel.

Try to limit yourself to two lenses when traveling with others. Your companions won't want to wait while you cycle through three or more lenses. The 18-55 mm IS is quite small and makes a good walk-around lens if you don't want to carry your case.

I traveled with lens hoods on both lenses and didn't bother with lens caps. That way, the camera was ready for action as soon as it was out of the case. I never once used the flash. Some people want to keep the camera case small and will reverse lens hoods on the lens for storage but the slowness of getting the camera ready and the need for a lens cap make this unattractive in the extreme. I strongly

recommend lens hoods—much harder to lose than a lens cap, and not only does it keep the sun out of your lens, it's handy in the rain too.

I did a Rocket German course before leaving, and though I couldn't follow conversations, I could and did ask for help in German and darn handy it was.

The final image in this chapter (figure 12.14) is of the Dom in Aachen, home of Charlemagne, and though the building is not as large as other cathedrals we visited, this one was absolutely beautiful. The image of the walls in gold and the window is handheld at half a second, using image stabilization (IS) of course, and with me leaning against a pillar to steady the camera. Not every image was sharp. In fact, it would be more accurate to say that most were not. However, I liked this image enough in the viewfinder to shoot a series of six and one was sharp.

My handheld ISO 1600 images revealed far more of the detail of the cathedral than could be seen by eye. Actually, a beanbag camera support might not be a bad idea for inside buildings that don't allow tripods. You could use it on the floor, a chair, pew, table, or even to brace your camera against a wall or pillar. One of my images was photographed with the camera vertical, balanced on the arm of a chair and held in position by a paperback book. Of course, self-timers save the day in situations like this. Yes, I think a beanbag would have been a really good idea, perhaps even stuffing it with socks, local rice, or emergency candy.

If photographing at borderline shutter speeds, assume that some images are going to be much sharper than others, so take at least half a dozen images of each composition. You will dramatically improve the odds of getting one sharp image.

▲ **Figure 12.7**
View from Charles Bridge – Prague.

Too bad I hadn't thought of taking multiple images earlier, but with the cost of shooting in digital being close to zero, it makes sense to take multiple images when hand-holding at questionable shutter speeds. The old 1/focal length for slowest hand-holding shutter speed

▲ Figure 12.8
Window and Reflection –
Prague.

should still apply with image stabilization (IS) lenses, knowing that IS may allow you to capture images quite a bit slower than that. If you want to guarantee capturing a sharp image at lower shutter speeds, then take a lot more than one shot.

If I use a 50 mm lens on an APS-C sized sensor camera, then the equivalent focal length in full sensor or film terms would be 50 x 1.6 = 80 mm. I would use 1/50 as the lowest reliable shutter speed for an IS lens, but I'd be willing to go with a much slower shutter speed if I had the option to shoot a series of images.

What people forget when they think they won't need a tripod is that tripods allow increased depth of field. People make the image with the lens almost wide open and are then frustrated because little of what they wanted is sharp. Smaller f-stops also mean that sharpness can reach the corners of most lenses.

During my travels, I found it practical to get up well before sunrise to head out shooting, finishing by 8:00 a.m., and then being ready to join my wife for breakfast. We'd spend the

▶ *Figure 12.10*
Window– Prague Cathedral.

▲ *Figure 12.11*
Steps, Charles Bridge –
Prague.

day together and then around sunset I'd disappear again. My wife had my attention throughout most of the day, so she didn't feel neglected, and I was free to photograph during the best light.

I had worried about camera theft on the trip, but in fact, had no difficulties at all. Just as well. I checked with my homeowner's insurance company with whom I have extra coverage for my camera gear and learned some important things. First, I learned they don't cover out-of-country travel, which was a bit of a shock. Second, if you sell any of your work, even once, you are considered a professional and your homeowner's insurance rider won't cover anything photographic. Even worse, if a customer were

to come to your house and trip on your front step and claim damages, the insurance company could refuse the claim. If your house burns down and it can be suggested that the fire might have started in your homemade darkroom wiring or in your studio, that one sold print makes you a professional so no luck there either.

Just to add icing to the cake, my insurance representative said that if you have insurance for the house and insurance for your photographic business (sensible), and if something happens at home that could be related to your photography, the two insurance companies could each claim that the other is responsible, leaving you with having to fight them both. He suggested that the only way around this little

▶ *Figure 12.12*
Globe– Prague.

gem is to have the same company insure both your home and your photographic business, so they have to take responsibility, and finding fault or cause wouldn't come into play (at least for you).

Now, this advice was given to me in Canada, and it might be different where you live, but I think you would do well to ask some pointed questions of your insurance agent and to read some fine print before glibly thinking you are covered. What did I do? I decided that $2,000 for professional insurance that would cover overseas travel wasn't practical, that the risk

of the house burning down because of my photography was absolutely minimal, and that few customers ever come to my house. So, I have no extra insurance and accept that should I lose or destroy my equipment, I'm out of luck.

As to what to photograph on my trip: I quickly realized that with limited time I was not likely to be in the right position and with the perfect light for the grand landscape or dramatic sky over city scene. That meant I would be better off concentrating on details for my images. This worked for me. It was after capturing the fellow photographing the

sculpture next to the Dom in Cologne (figure
12.3) that I realized most of the people you
see when traveling are fellow tourists (and
even more specifically, fellow photographers),
so they might make good subjects for travel
photography. I'm definitely going to explore
this the next time I'm in areas with tourists,
whether downtown in my own city of Calgary,
at famous viewpoints, or in other cities.

Thoughts On the Images

It is probably more accurate to describe the im-
ages in this chapter as impressions of the places
I visited rather than illustrations. I'm guessing
that some travelers who have visited these
cities didn't even notice the details that I pho-
tographed; although, people who have looked
at the images seem to enjoy them. I think that
if you can come back from a place with images
that record your impressions, this will serve you
well, even if it doesn't garner you any fame.

◀ **Figure 12.14**
Window and Walls – Aachen
Cathedral.

13 Steps

- *High dynamic range (HDR) vs. manual blending of exposures*
- *Focus blending and exposure blending at the same time*
- *Revisiting a scene to fix problems*
- *Cropping and framing*

I was on a walkabout in downtown Calgary and came across this stairway that was in deep shade on the south side of the street. The building's north facing windows were reflecting the bright sky very effectively. The lines and angles of the stairwell combined nicely with the windows in the background, and the red/brown bricks contrasted with the pale blue of the sky reflected in the windows. I was very happy with this image but on close inspection I note that there is a three-way corner that is hidden by the brick wall and railing in the foreground.

It might have been better to move over half an inch to have aligned the stairway, pillar, and horizontal rail. These kinds of subtle positionings are hard to see in a small viewfinder or even on a 3-inch LCD screen. At least you can use Magnify View to double check the position, and with Live View you can even adjust position of the camera on tripod while still in magnified view for perfect alignment. Still, figure 13.1 is a nice image for all that.

I didn't have my tripod with me. I was aware of the huge range of tones (large dynamic range); therefore I attempted to do a handheld,

▼ **Figure 13.1**

There's little wrong with this image but it is interesting nonetheless to illustrate how one image can lead to another.

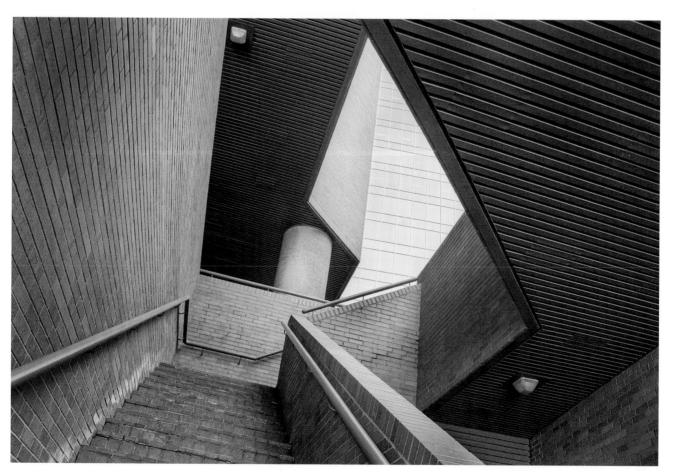

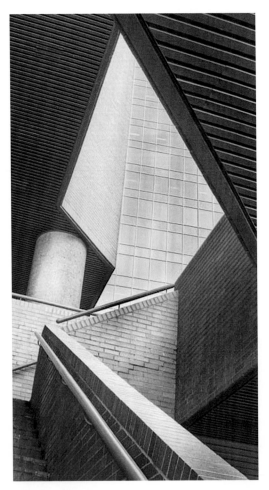

▲ *Figure 13.2*
Just a low res crop of the original image I posted on my blog but raising some interesting ideas.

bracketed exposure. Unfortunately, the camera shifted substantially enough that even though Photomatix Pro has the ability to compensate for some movement, it couldn't overcome my shaky hands. Figure 13.1 is from a single image file. The 40D did a remarkable job capturing the range of tones. Mind you, it just barely hung on to the sky and the shadows are a bit noisy.

I posted the image on the Internet and Chuck Kimmerle, a friend and seriously good photographer, sent me back the cropped image in figure 13.2, showing a fairly radical crop into a vertical image combined with conversion to black and white (his specialty). I was impressed with this effort and it got me thinking.

I liked the idea of a vertical image. Chuck had managed to crop out one of the lights which I had found distracting, but had also had trimmed the corner off of the ceiling on the right side. I decided to see if I could get the best of both worlds. I played with the file for a while and definitely felt this idea was worth taking further, but soon decided I needed to reshoot the image with exposure blending, my best camera, and a tripod.

At first I couldn't find the stairs again— they'd moved them a block north since the first visit. Well, maybe I got lost. Anyway, three days later I was able to reshoot the image. To my surprise, the best focal length was 45 mm. You would think that with all those dramatic angles it would be an extreme wide-angle shot.

This created some problems. The near bricks behind the handrail were only a few feet away and at 45 mm focal length you can't get sharp details from three feet to infinity. I decided I'd have to do two series of focus blends—one for the highlights and another for the shadows—and hope that I could then blend them together.

Do you know roughly how close you can keep an image sharp while maintaining infinity too? For all your usual focal lengths? You should!

I had no difficulty shooting the series, other than some odd looks by passers by. Getting the images back together was a whole other matter.

The obvious place to start would be to focus blend the two sets of images. This was easy. I now had two images that would need to be combined. Problem was, they were different sizes. It wasn't enough to shift one over, or even rotate. No, they needed resizing. I decided to place one blend over the other, switched blending mode to Difference so the misalignment would be easy to see. I then used Free Transform to stretch the one image to make it align. Free Transform works on a specific layer, not the entire image, so you need to select the layer you want to stretch. I managed to get the corners aligned perfectly, but when I did, the center of the image was out by about 10 pixels.

What had happened is that each focus blend used slightly different focal points for the start image and each subsequent image in the series, enough so that when they were combined, the image sizes varied between the two blended sets. Further complicating this problem is the fact that with internal focusing, the image distorts slightly as you focus, and so, not only are the two sets of images different sizes, the size difference is not applied equally across the image. Were I do to it again, I'd shoot pairs of images, one for the shadows, another for highlights, then move on to the next focus position, create another pair, and so on. Whether all this gripping of

the camera to change settings would keep the image alignment perfect is another matter. Perhaps auto-bracketing of three images with the widest possible exposure range across the three would be the way to go since that would not require touching the camera between every shot. One of the nicest features of Live View is you no longer need mirror lock-up and even better, the start of the exposure is electronic and entirely vibration free. Combining bracketing with Live View could be a very powerful tool.

Try to avoid doing both exposure blending and focus blending in the same image. Of course, if you really want to go over the top, do both of them in a stitched image. It can be done, just not most of the time. The odds of something going wrong are significant and the huge number of images generated would be a major pain. You could be looking at a six-image stitch, 12-image focus blend, three-image exposure bracket for 6x12x3=216 images to make one picture!

▲ *Figure 13.3*
The amplification required to open up shadows in the short exposure image results in a large amount of signal noise.

▲ *Figure 13.4*
With a longer exposure, the shadows are much smoother.

By the way, if you doubt that you need a better exposure for the shadows, figures 13.3 and 13.4 show the images cropped and magnified and somewhat lightened to make the noise easier to see.

This is a significant difference in noise between the exposure for the shadows and the other for highlights. One image is useable (the shadow exposure), the other not. Now, I wouldn't have opened (lightened) the darkest corners of the building that much, but it doesn't really matter how much you open them, the noise is there. It just gets more obvious the lighter you make the corner.

Opening shadows, via the Camera Raw Exposure or Fill sliders or in Photoshop, by a variety of methods all result in increasing noise in the shadows. The further you lighten the shadows, the more obvious the noise. Go far enough and you will see banding in the image—striping of the noise due to inherent flaws in the sensor and its electronics.

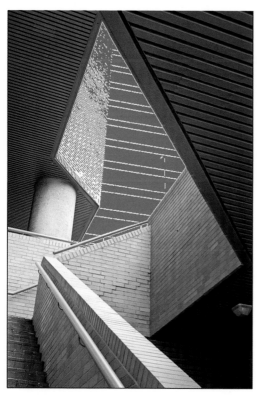

▲ *Figure 13.5*

The long exposure image in Camera Raw – red indicating blocked highlights, blue lost shadows.

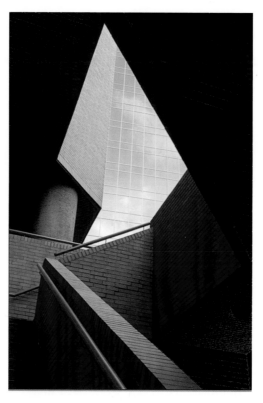

▲ *Figure 13.6*

The short exposure image in Camera Raw.

I decided I could accept the nearest part of the bricks being out of focus, if the rest of the image was sharp, so I took the furthest focus of each set of images and blended those two images. I chose to do this manually by laying one over the other rather than use exposure blending and high dynamic range (HDR) techniques.

Note that you can see out of focus areas at 100% magnification on screen, which in normal print sizes looks just fine. This is especially so with high megapixel count cameras.

In figures 13.5 and 13.6 you can see the screen captures for the long and short exposures, showing both under (blue) and over (red) exposure warnings in Camera Raw. I still needed the Fill Adjustment slider to open shadows a little in the long exposure image to open up the bottom right part of the image and the Recovery slider in the short exposure image to keep the full details of both blue sky and white clouds reflected in the glass. I then blended the images by copying one and laying it over the other (as another layer). The good news was that they lined up perfectly. So when do you use HDR techniques and why didn't I use them in this image?

If you are not sure whether two images lie exactly one on top of the other, try setting the blending mode to Difference and any mismatch tends to stick out.

HDR is a technique for blending two or more images taken at different exposures of exactly the same subject. Instead of placing the full range of tones in the normal 16 bits of data for each color, tones from several exposures are combined in an extended range of tones in 32 bits of information. Now your monitor can't display the full range and your printer most certainly can't print it, but the point is that the full range of tones in all their detail are recorded in this one HDR file.

So far that doesn't do you a bit of good, but fortunately there are ways to compress that huge range of tones back into 16 bits worth of information that can be displayed and printed. The result is often very dull looking. After all, if you had two objects in the scene that are two stops apart in brightness to start with, after compressing the image, they could end up as only one stop apart. Here comes the trick. If you now apply local contrast enhancement, you can differentiate the two items nicely, restoring textures and adding contrast, all without losing the really bright or really dark tones.

Of course the more brightness range there is in the original scene, the more it will have to be compressed to fit into a regular 16-bit file, and compressed even more for print. Therefore, you have to apply greater local contrast enhancement until you end up with very odd-looking images. That doesn't mean they don't look nice to some people, some of the time. But look normal? Not a chance.

HDR is best for handling images that are only a little bit outside of the dynamic range of the camera in a single exposure. The minor compression won't look bad and is easily corrected with small amounts of local contrast enhancement. This can be done by Photomatix, Akvis Enhancer, or even within Photoshop. Personally, I don't often shoot in that kind of harsh light so HDR is of limited use to me. Other people have taken great advantage of HDR, both in natural looking images from slightly higher dynamic range scenes and way over the top blends from extreme range scenes. Check out the work of Uwe Steinmueller of OutbackPhoto.com. He recently posted some lovely work from Fort Point using HDR and tone mapping (local contrast enhancement).

There are two situations that don't work with HDR—very large ranges of brightness as noted above, and images in which there is a relatively short range of tones over most of the image (i.e., low contrast, low dynamic range) except for one or two areas that are dramatically lighter or darker than the rest of the image. To contain them you have to flatten the already low contrast parts of the image when what you'd probably like to do is increase their contrast.

In the case of a huge dynamic range, there is simply no way to get a natural looking result. Either go for the arty look or forget it. In the case of the one bright area, as we have in this image with the windows of the building, then manual blending works better. You don't compress anything. Of course, masking to do the blend can be challenging.

I placed the shadows image on top (the light image in which you can see into the corners). I then black masked it and painted into the

▲ *Figure 13.7*
The mask used to blend the two exposures, long on top of short.

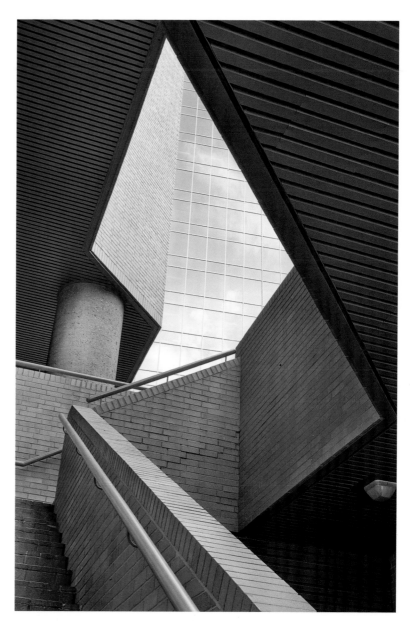

mask (figure 13.7) as needed to open up the dark areas to taste. I did try it the other way round but found this way easier because I didn't need to be as precise with my brush.

Figure 13.8 shows the result of the combination using the mask in figure 13.7 for the shadows image layer. I next used Enhancer although the result was too much in several areas, so I masked the layer back and only used Enhancer on some parts of the image.

▲ *Figure 13.8*
The combined image after manually blending the two exposures (masking).

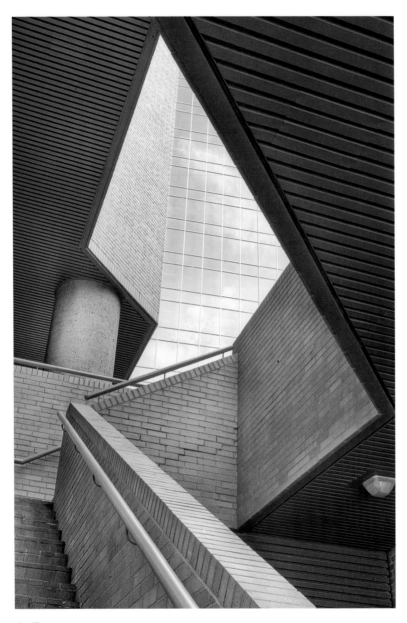

▲ *Figure 13.9*
Image after application of Enhancer.

I had deliberately left myself some breathing room in respect to the two lines coming together at the top middle of the image, and also the corner of the ceiling in the middle right. A tiny piece of another wall was showing in the bottom right and all these needed fixing with a crop. Some contrast increase was applied to the bricks in the middle of the image via an S-shaped curve, and you see the final color image in figure 13.10. It isn't perfect and were it my goal to stay in color, I'd do some further work, but since I'm going for black and white, it will be easier to visualize the result if we convert now to black and white.

Cropping early in image processing can be a headache if you later realize you needed just a bit more image. While Photoshop will let you hide rather than crop the trimmed areas, it only works once and with some editing steps it will show a line when you restore the larger image. Better to crop a bit later and save just before the crop.

I played with the yellow and red sliders in the Black & White Adjustment Layer until I liked the bricks, and then worked with the blue slider to darken the sky and make the clouds more prominent in the reflection. You see the results in figure 13.11.

I did some additional work on the black and white image, evening out the brightness of the ceiling via curves, and then brought out some highlights with the Dodge Highlights tool, especially in the brick above the railing on the stairs.

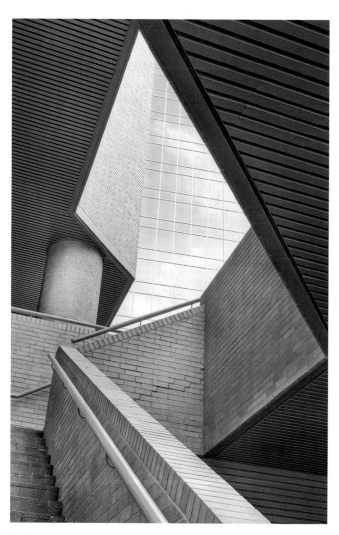

▲ *Figure 13.10 brick*
The last color image, with some contrast added to the bricks in the middle.

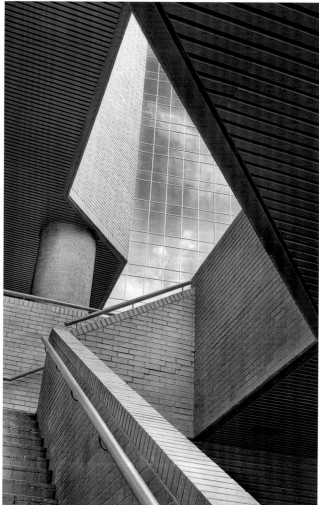

▲ *Figure 13.11*
The black and white image right out of the conversion via Black & White Adjustment Layer.

Thoughts On the Image

It pleases me that I was able to take a very ordinary looking stairwell, probably avoided by most people, and turn it into a strong image (figure 13.12). This must be what it's like to search a beach with a metal detector and find a Rolex still ticking.

The "thrill of the chase" and the satisfaction I get from taking the images and making a lovely print does a lot for me and I'd never give it up. Successes like this happen more often when you are better prepared, more skilled at seeing, and not too desperate to find a great image.

That it wasn't my idea to go vertical or black and white doesn't matter. I'll take advice, suggestions, and help from wherever I can get it—whatever makes the image stronger.

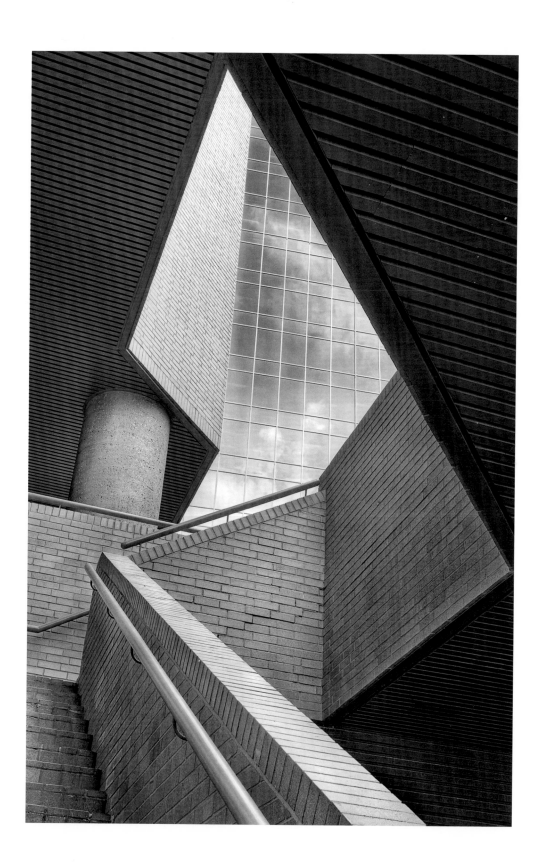

◀ *Figure 13.12*
The end result of a horizontal shot, followed by a suggestion from a friend, then modified by me, and finally reshot as a two exposure manual blend for optimum quality.

14 Waterfall

There is a problem with photographing famous and beautiful locations. How the heck do you do justice to the scene? Think of it this way: if the image represents the scene and if it is pretty clear that you'd rather have the scene (i.e., be there) than the image, then what purpose has the image served? Other than as a reminder of places visited, people met, or simply a "wish you were here" message, there probably isn't a point to the image.

This problem of image vs. being there is especially true in landscape photography. Would you rather have the spectacular sunset that surrounds you as you stand on the mountain peak, or would you prefer the photograph of it? This can apply to other kinds of photographs too. Would a grandparent prefer to see their grandchild doing something cute, or choose the photograph of him or her? Would you rather attend the football game or look at the pictures of it?

Ask yourself what your images show that being there does not.

Broadcasters have learned that TV needs to offer something to sports shows that being at the game doesn't. What can it offer? Well, TV offers replays, sometimes from multiple angles. It moves in close, far closer than you would ever be at a game, and follows the action with professional skill that you probably wouldn't have as you attempt to follow the action with binoculars. Parabolic microphones bring the crunch of the tackle, and with closeup shots you can see the fingers of the quarterback grip the ball.

Study the best photographs. You are likely to find that there are elements of the image that offers something being there doesn't.

As you look through *Sports Illustrated*, you will note that the vast majority of photographs show the athletes in closeup detail you'd never get when attending the game, or from angles you couldn't get to. A children's photographer catches the moment that is classic and represents all children who get caught doing something they shouldn't. Because it is so representative of anyone's child, we all go "Aaaah!" when we see the image.

Figure 14.1 is Takakkaw Falls in Yoho National Park, a nice but extremely steep drive from the Trans Canada Highway. It is famous, at least among tourists, judging by the buses I saw heading up there. The falls are 825 feet high and there's a goodly amount of water coming over the falls even in the summer, being glacier fed.

My mission, if I choose to accept it, is to take 825 feet of waterfall and place it on a piece of paper that is 19 inches high (but don't forget the border). Pardon the pun, but that's a tall order.

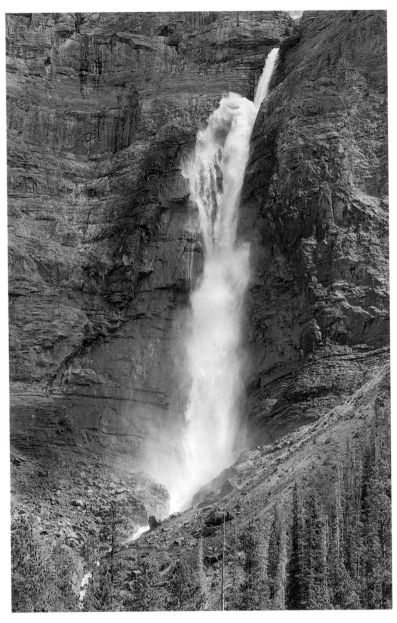

▲ *Figure 14.1*
Record picture of the scene.

In the case of a waterfall, when you are there you can see and appreciate the whole thing, in three dimensions with its sound and majesty, as well as the feel of spray on your face. Figure 14.1 illustrates the falls, which would be fine for a book on geology or perhaps an encyclopedia entry, but it shows nothing you wouldn't see when there and is missing so much that you *would* experience standing there.

So the question is, how can you make an image of something like this waterfall stand on its own merits? Perhaps the easiest solution is to not even attempt to capture the whole thing and to concentrate on details instead, especially details that would be hard for the tourist to see or notice. We can use the ability of the shutter to capture a moment in time to bring out details not seen by those present. We can eliminate color so as to concentrate on form, shape, and line.

Figure 14.2 certainly captures the falling water patterns in a way that standing there cannot. On the other hand, it's missing the mood, the atmosphere, and the movement implicit in a waterfall, so it is still more illustrative than artistic. However, it beats the heck out of the first image.

I would like to capture the feeling of being at the falls, and while recording detail in the water, show movement too. In this case, I don't want the unreal effect of very slow shutter speeds on flowing water.

One option when photographing the grand landscape is to capture it in exceptional circumstances. Thus photographers choose to get up before dawn, make the hike, and be there for those exceptional circumstances—the first light, the sun bursting between clouds to shine just on the falls, or the huge storm clouds above, or perhaps lit by an incredible sunset.

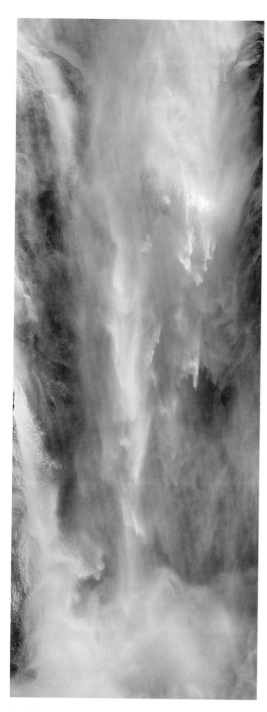

▲ *Figure 14.2*

Concentrating on the spray—at least it's better than the previous record shot.

It may be entirely laziness on my part, but I can't help feel that what the photographer brings to the scene in these exceptional circumstances has more to do with perseverance and determination than artistic skill. Anyone could capture the scene provided those miraculous circumstances. That said, we can certainly admire the wonderful circumstances *we* haven't seen because *we* didn't put the effort in and they did. It's not much different from a war photographer who risks his life to get the image, or the sports photographer who photographs hundreds of games, tens of thousands of images, to get that one perfect image.

But I still think I'd rather be sitting on the edge of the Grand Canyon admiring the view than looking at an image, no matter how perfect the image was.

This is reflected in my own photography—often capturing the ordinary, the small, the overlooked—so that I don't have that problem of comparing my image to the original, and inevitably choosing the real thing.

Instead of trying to capture the whole of the grand landscape experience in your little camera, consider the landscape as simply material with which you will forge your masterpiece.

Perhaps you have not given a lot of thought as to why you photograph particular subjects. If that is the case, then it might explain some frustrations when you do photograph because you don't really know where you are going with your images. If it is your goal to capture the grand landscape in spectacular circumstances, then anticipate a lot of early mornings and repeat visits, and enjoy the outdoor experience since most often you won't get the spectacular

circumstances for your particular kind of image.

If you are simply using the landscape to compose interesting patterns of boulders and trees, water and wind, then the images don't have to even be recognizable for their source. You can use only the parts of the landscape you want, and everything is about that piece of photographic paper and the beauty you can create on it.

The next time you are photographing, ask yourself the following questions:

1. What could a photograph of this subject do that being here couldn't? A photograph can:

 b. Move in close.
 c. Show the passage of time with a long exposure.
 d. Put the viewer in a place they wouldn't normally go, which probably explains why wet and cold are intimately familiar to many photographers. (See chapter 1 on how I photographed Athabasca Falls.)
 e. Relate the various parts of the scene through positioning and framing.

2. Is there a way to capture the feeling that this situation brings to me?

3. How can I replace the third dimension, sound and touch, with the visual?

4. Can I tell a story with my image?

5. What can I see/look for, that others untrained might not find?

6. Is there a way beyond straight translation from scene to image that would enhance the above points? For example, just because a scene is bright doesn't mean we can't print dark, or the reverse. Should I pan the camera with the falling water? How about using very shallow depth of field to isolate interesting details?

Thoughts On the Image

When I look at figure 14.3, I can almost hear the thunder of the falls and feel the spray. Composition-wise it isn't all that exciting—the water straight down the middle as it is—but there are a series of repeated diagonal lines in both directions which are nice. It is quite unlike the experience of being at the falls, which certainly looked more like the first image, albeit wetter and noisier. By concentrating on just the base of the falls and not including any foreground, I was able to emphasize atmosphere.

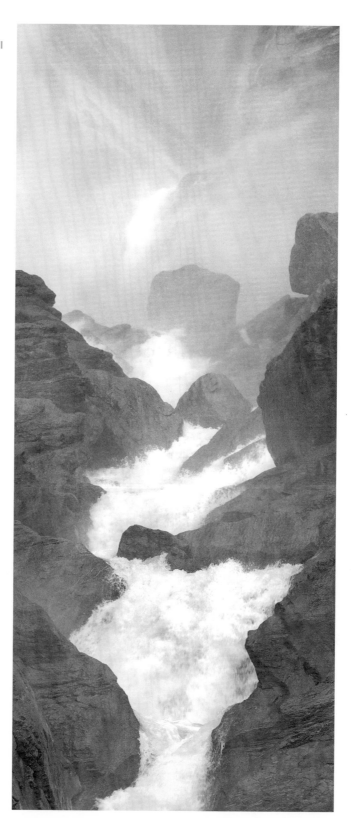

▶ *Figure 14.3*
Showing only a small part of the falls, it still manages to get across a lot more of the feeling of being at the falls.

15 Lensbaby

- *Lensbaby as a tool for abstract images*
- *Contemplating the characteristics of a lens to use it to maximum advantage*

Some very nice work has been done with the cheap 120 roll film Holga camera. Its crude lens and plastic body with only a couple of possible settings has been used to make some lovely images of nudes, gardens, and all manner of subjects. People have tried to adapt the lens to digital cameras but even medium format camera digital backs don't include the soft flared edges and uneven borders which are the hallmark of this camera, and so only those who continue to use film (and medium format film at that) can partake.

Along came Lensbaby—a simple lens perched on a corrugated plastic tube that could be extended and bent. Unfortunately, the images looked nothing like Holga photographs and, for the most part, I have been unimpressed with the work this lens has produced. Still, the idea was intriguing. Eventually, a second and then third generation lens came along. The latest lens, the Lensbaby Composer, did seem to have potential even if it hadn't yet produced outstanding results. I broke down and purchased one. The lens is two elements, now coated, and can be swapped out for a pinhole, zone plate, single element lens, and even a plastic lens. Still the images look nothing like those produced by the Holga.

Lensbaby Composer may not be a Holga, but perhaps its unique properties can be exploited. Image sharpness in the center is excellent, even wide open, but the sharpness falls off fast and far. In addition, there is a lot of flare around the edges and the image seems to stretch away from the center. What it doesn't do is darken toward the edges like the Holga.

At this point, I'm very much in the learning curve and remain undecided on whether it's a serious tool for me. I suggest you do your own searches on the Internet for images. Here I include a few of my own early efforts.

The image of the Adirondack lawn chair (figure 15.1) covered in snow at least takes advantage of the characteristics of the Lensbaby, the flare and blur and distortion giving a sense of unreality, and clean borders while the center remains quite sharp. The melting snow looks vaguely like someone slumping down

▲ *Figure 15.1*

The blurring of everything but the center of the image places attention on the snow.

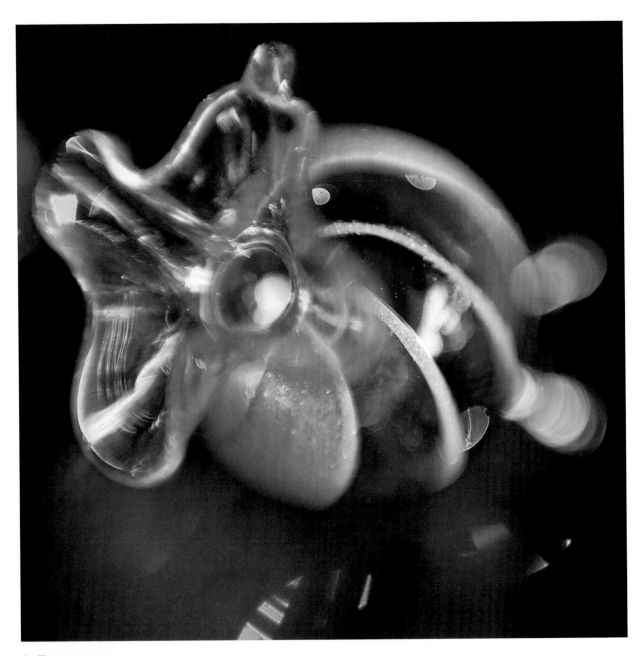

▲ *Figure 15.2*
A simple tree ornament becomes a collection of interesting shapes and tones when photographed with a Lensbaby Composer and closeup lens.

▲ *Figure 15.3*
Beads of water on a glass block bath enclosure.

in the chair, and the blurring gives a sense of movement.

Figure 15.2 is a glass bon bon Christmas tree ornament. I was able to use the tilting feature of the Lensbaby (plus a closeup lens) to put the sharpest area well to left of center and increasing the blur, flare, and distortion in the rest of the image. The light in the background adds nicely to the image.

I have been photographing the glass block wall in our bathroom for some time (figure 15.3). The patterns and colors coming through the glass from our backyard garden can be quite varied with changes in season and lighting.

I photographed this glass vase next to a mirror (figure 15.4), but a normal photograph might have shown too much detail even with a wide lens. When stopped down, the Lensbaby had the right combination of detail along the edge of the vase while throwing the borders of the image into a suitable blur.

Thoughts On the Images

I don't think any of these images would or should persuade you to rush out and purchase a Lensbaby. However, they do illustrate the nature of the lens and give you some idea of what the lens can do.

My thoughts are:

1. Taking a crappy composition and shooting it with a Lensbaby will just result in a crappy blurred image.

2. Taking a good image with a Lensbaby might just make it better if the subject and circumstances are suitable.

3. To make most effective use of a Lensbaby, we need to use the characteristics of the lens to its advantage. Is this an image that would be helped by blurred edges and a very small sweet spot? Can I make use of the tilt facility to help the image by throwing the sweet spot off center and further blurring the rest of the image?

So far, I would say that the Lensbaby is good at:

1. Uncluttering edges

2. Softening contrast

3. Isolating the important element

4. Turning images into abstracts

5. Simplifying images

6. Adding atmosphere

7. Distancing from reality

8. Creating a dream-like view

So, if you think you could take advantage of a lens that does all this, then have at it with a Lensbaby or even something cobbled up from a magnifying glass, a cardboard tube, and electrician's tape.

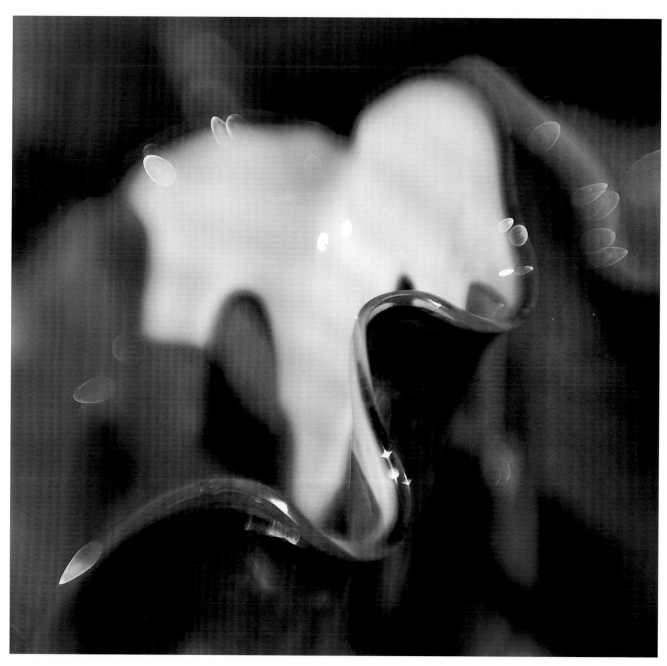

▲ *Figure15.4*
A vase reflected in a mirror with interesting out of focus highlights.

16 Knuckle

- *Working the scene*
- *Exposure blending with Photomatix Pro*
- *Finding the unexpected*
- *Returning to old images to make successful prints*

Recently, I had an opportunity to photograph #2816, the preserved 1930's steam locomotive owned by Canadian Pacific. This lovely locomotive continues to work, pulling passenger cars on special trips, for promotion and for rent. For example, a group of railroad fans rented the train for several days so that instead of riding it, they would chase it by car, racing ahead to be at the next photogenic spot, ready to capture the train as it steamed by. My friend Jim Scott, who is heavily involved with both preservation and running of this locomotive, had even promised to let me climb inside the smokebox, if I didn't mind dirt and didn't suffer from claustrophobia. Actually, he also offered the firebox but one look at my waistline and another at the firebox opening and I had visions of Winnie the Pooh staying stuck until he lost enough weight to free himself from Eeyore's house. Getting wedged notwithstanding, I approached the shoot enthusiastically.

This first image is of the inside of the smokebox (figure 16.1), the space under the locomotive's funnel where the steam and smoke both arrive before exiting upward. I certainly found it interesting, but you have to be interested in locomotives because the image itself isn't especially good in photographic terms—it's more illustrative than artistic. Nothing wrong with that, so long as you recognize what you have achieved, and perhaps more importantly, what you haven't. I didn't see that I'd get anything better by climbing inside so I declined Jim's offer.

◀ *Figure 16.1*
Smokebox interior – not your typical locomotive shot, but is it any good?

I tried shooting the smokebox from further back, including the opening and some of the rest of the front of the locomotive, but didn't find anything all that appealing.

As I have said in earlier chapters, I usually do photograph things that might work, even if I know that they probably won't. This may seem odd to you. How could I think that an image I already have doubts about will somehow magically be good enough later on? Some things are fixed, like the basic design, but what if the doubts focus on issues like how much does the center of interest stand out? That is something that can be changed in the editing, whether through changes in brightness or in the process of converting to black and white. Something that doesn't quite work on the LCD or looks even worse in the viewfinder, could possibly work in a much larger print. Something that glares in the viewfinder as being all wrong, might be reduced in effect through careful adjustments. I might not see how I can crop this image but I'm hoping it can be worked out—so I shoot anyway, leaving the decisions for later.

I have read about photographers who like the slowness of 4 x 5, who are happy to spend an hour or more lining up the camera and recording the single best composition. Perhaps I'm just not as good as them, but I struggle to compare compositions. In the field, I remain uncertain which of several possible compositions is going to be best. But I have to tell you, returning with one that works beats returning with images that are not quite right every single time. I have gone from most shoots not producing one good image to most doing so with my strategy of giving myself options to take home.

It is not uncommon for me to work my way round the scene so enthusiastically that I don't realize I'm back where I started, even reshooting the earliest compositions. Sometimes a second attempt at exactly the same composition turns out to be significantly better in some small but critical way. I don't see this "duplication" as a problem.

> Before you leave the scene, be absolutely sure that you have checked every possible composition. If you don't know whether it might have been better with the camera three inches lower, then give yourself a break and take the trouble to shoot that new position, and then decide which is best when you get home and all the possibilities are already in the bag.

Working the Scene

In a typical shoot, I have some preconceived ideas of what I might be able to photograph. In this case it was to shoot from inside the smokebox and firebox. I'd already "done" the outside of the locomotive on a previous visit. When I arrive on scene, circumstances may change. The lighting is different or rain has washed out the roots of a tree that now lies across the scene I wanted to capture. I have learned from experience, that more often than not, it isn't the planned images that turn out to be the best from a shoot and to keep my eyes out for other possibilities. I think it is this one strategy that accounts for a considerable part of my success.

I start looking for possible images while I'm on the way to the shoot and am still looking on the return trip. Some of my best-ever images have been found on the way home from a shoot, tired and hungry and not really thinking photography, yet my "photographic" eye keeps working and when the alarm bell goes off in my head, the brakes go on and I'm out after another image.

First search for scenes and only then start looking for possible images.

Remember that I am looking for suitable material, not suitable images. After more than 40 years, I have a pretty good idea of what will photograph well. I check for repeating patterns, for light and shadow, interesting reflections, and surfaces that photograph well. At the engine shed, as I was walking toward the locomotive I had to step round a pile of

cut steel, which I noted to shoot later and it is included in chapter 22.

Perhaps a bit more than a record shot, figure 16.4 has had a lot of work done with the Dodge Highlights tool, as usual using the Highlights Threshold action to prevent taking the highlights over the top. Figure 16.2 shows the start of the image. I had to convert to black and white, moving the yellow and red sliders to the left to darken the orange background without significantly affecting the locomotive. I needed to rotate the locomotive one-half degree clockwise. I don't normally use a bubble level on my camera and, frankly, if I can get my

▼ **Figure 16.2**

Locomotive front, straight from Adobe Camera Raw

▼ **Figure 16.3**

Photograph of me sitting on the loco, taken by Hans Berkhout.

camera to within half a degree of level, it probably wouldn't help much, but it is remarkable how easy it is to see such a small degree of tilt in a print. At the same time I used a vertical perspective correction since the camera height is only at about one third of the way up the locomotive and thus the locomotive appeared to tilt backwards because of aiming the camera upwards. Along on this shoot was fellow physician and photographer Hans Berkhout, who was working on a project to photograph doctors and their passions. You can see the height of the locomotive from the picture Hans took of me sitting on the locomotive (figure 16.3). The flat area I'm sitting on is at camera height.

I photographed the front of the locomotive but was concerned about the cluttered background. I cloned out a couple of bright objects, removed a couple of highlights from the floor

▲ *Figure 16.4*
Locomotive front cropped, cleaned up, converted to black and white, and adjusted further to make a "clean" image.

▲ *Figure 16.5*
Interesting lines but way too cluttered; no overall design.

▲ *Figure 16.6*

The same coupler as seen in figure 16.5, but shot from the other side and then cropped into this horizontal shape so we can concentrate on the form rather than the function.

that were distracting, and of course cropped in tightly to eliminate as much of the background as possible. It would be an impressive studio that could fit, light, and pose the locomotive.

I knew that eventually I'd try working with the sides of the locomotive, taking advantage of the lovely sheen on the bright metal parts, the connecting rods, and so on. In the meantime, I was intrigued by the locomotive's front coupler. Now, I had no particular interest in couplers and hadn't thought of it as a possible subject. It was only when I studied the shape that I recognized the possibilities.

I took a number of images of the coupler from several angles. Some were complete disasters—totally boring or compromised by flaws not initially seen or appreciated. Others were so-so, and a few were quite nice.

Fatal flaws can be anything from a bright light in the picture causing flare, hoses in the way, repeated patterns that are broken up by something else, elements that cannot be cropped out yet don't fit the rest of the composition, or simply a part of the image that

just doesn't go with the other part, neither part strong enough to make an image on their own yet not working together.

In figure 16.5 you see the knuckle coupler of the steam locomotive. The orange color comes from the sodium vapor lights, but it is balanced by white reflections from the garage's large doorway admitting cool north light so the highlights are all white instead of orange. My first impression looking at the image is

▲ *Figure 16.7*

There doesn't appear to be any way to redeem this image.

why didn't I include the bottom of the coupler? And, second, is why didn't I squat down lower?

For the purposes of illustrating this chapter, I decided to go ahead with the focus blend of five images that ultimately made figure 16.7. Clearly it was going to need to be cropped. Off went the hoses on the left—a bit better. The right edge wasn't as bad, but remember the rule—if it doesn't add to the image it doesn't belong—so off went the right side. I couldn't seem to make the black top to the coupler work, and in several stages cropped tighter and tighter into the center of the coupler, eventually deciding to choose as the top of the image, the dark hook above and behind the knuckle. I was still not convinced it was right. I decided to crop off even more on the left and even some on the right so I wouldn't have to deal with the corners of the coupler showing.

Figure 16.8 is a decent image. I did use Akvis Enhancer and wondered later if I didn't take things too far, and perhaps I could reframe the shot with just a bit more breathing room. Back to the whole frame and I recropped it in a single step. I decided that I liked the image

Figure 16.8
Perhaps something can be done with the image after all.

enough that I wanted to improve it. I went right back to the blended file and started over.

This time when I cropped, I gave the right side a bit more breathing room. This means I included the edge of the coupler at the top and cloned out the edge. There is a tiny amount of space below the coupler in the bottom right corner and that was cloned out too.

Some of you will be horrified and feel that this fundamental change to the photograph in cloning the corner disqualifies it as a real image—that, put simply, I cheated. I sympathize with this view yet I have gone ahead anyway. My feeling, rightly or wrongly, is that if more than 98% of the original image works, and if the problems are only at the edges, it isn't that big a sin. If I were to show this print (figure 16.10) to someone intimately familiar with the locomotive (say, Jim, who has scraped, polished, and painted every inch of it), I suspect he would accept this as being real. Part of my logic in this is that I am far more concerned for the image as art than I am as it being a record of a locomotive coupler anyway. Figure 16.9 shows the crop for the final version, including where I went over the edges of the coupler and had to clone.

The problem with my logic is that it is a slippery slope. Knowing that I am willing to cheat just a little, how does one know that I didn't cheat a lot? In fact, it's possible that the left part of the coupler came from one locomotive, the right from another, and I imprinted a pattern of a third sheet of steel onto the coupler to "improve" it. I didn't, but you have no way of knowing that.

My response to this kind of thinking is that when photographers added an orange filter to darken the sky (and they did it routinely in film days), they too were cheating. Okay, it's one thing to change the brightness of part of

the image, and another to replace it wholesale. What about photographers who used their view camera's movements to straighten verticals (which isn't real after all) or tilted the back to stretch the entire image or change the plane of focus to something completely un-lifelike? How about the photographer who used to carry a saw with him to remove errant branches and even trees in order to get the perfect view?

Like it or not, there is a strong tradition of cheating in photography. It's just that we can take it further than our predecessors, and, frankly, many of them would have done just the same or more if they could.

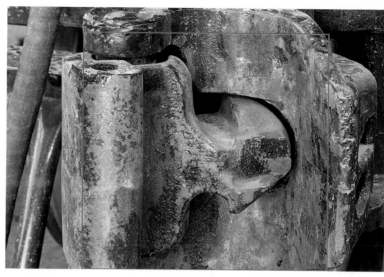

▲ *Figure 16.9*
Showing the cropping for the final version of this image.

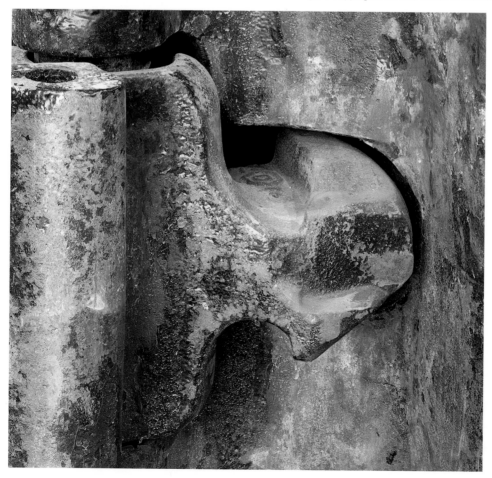

◄ *Figure 16.10*
Not a great image but a heck of a lot better than one would have expected, after some cropping and adjustments.

While Hans was setting up his 4 x 5 to photograph me, I started wandering around the workshop. Not far from the steam locomotive was a pair of vintage diesel locomotives used for more regular passenger outings by Canadian Pacific (if you have to ask the price, you can't afford the trip). The locomotives were handsome in their own right, but having been interested in the coupler of the steam locomotive, I decided to check out the one on the diesel. Turns out they don't paint these things so that cracks in the casting aren't hidden from inspection (someone got carried away on the steam locomotive and had painted it black). Anyway, the diesel's coupler was very interesting. The casting was quite crude and looked more like a handmade sculpture than a piece of machinery. I tried photographing the coupler from several distances. I'd already decided that the best angle was from a height

equal to it (so I was on my knees) and from straight ahead. All that remained to be decided was just how much to include. I mistakenly thought that f/16 would provide enough depth of field to cover the front to back of the coupler, forgetting that at this close range, depth of field practically doesn't exist. In the end some of the images were unusable, with the near part of the "hook" blurred to a degree that was not acceptable.

Do you know that you have enough depth of field to cover the subject? Don't guess. Either check with magnified Live View or review on the LCD after the fact.

Very fortunately, a couple of images were okay and subsequently with a bit of extra sharpening with Photokit Creative Sharpening, I was able to more or less fix my mistake

▶ *Figure 16.11*
Not what I expected from the shoot, yet one of my best images in some time.

◀ *Figure 16.12*
Three exposures used for
subsequent blending of
exposures in Photomatix
plug-in for Photoshop.

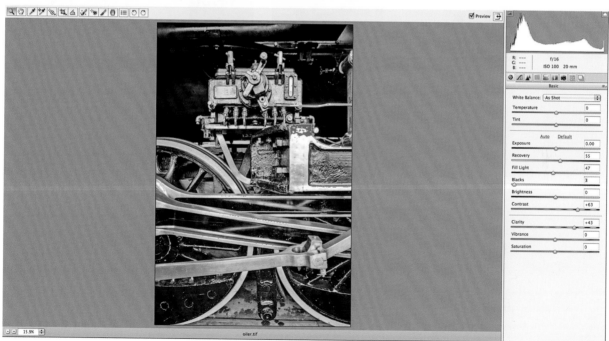

▲ *Figure 16.13*
Here you see the screen
when you bring the output
blended TIFF image into
Camera Raw.

(at least in reasonably-sized prints). What I
should have done was to use the multiple im-
age blend with Helicon Focus. Given that this
is an image that I particularly like, I'm hoping
I may be offered the chance to shoot it again,
next time with proper technique.

*Depth of field is never as good as you hoped. Lens
scales are only good enough for a 4 x 6 print. If
you are able to confirm depth of field through a
darkened viewfinder with a preview button, then
you have better eyes than I do.*

▲ *Figure 16.14*
Recovery Slider at default setting.

▲ *Figure 16.15*
Recovery Slider at maximum setting.

I had photographed the driving wheels and connecting rods on a previous occasion, and from multiple angles, so I didn't hold out much hope for anything new or better. As it happens, each time the steam locomotive is parked, the rods are in a different position, and on the side of the locomotive facing some large windows that provided indirect lighting the various lines formed an interesting composition. Sitting above all these lines of the locomotive mechanism was the oiling device, with its copper tubing running off to lubricate all these moving parts. I decided to include this in the composition, along with the slope of the boiler.

The brightness range was dramatic and continuous—from the highly reflective connecting rods bouncing back the light from the window, to the depths under the black

The subject may be the same, but with different days, circumstances, lighting, weather, and even time of day, the composition may look significantly different and could well make for a better picture. It is always worth the trouble of going back—even if the circumstances don't improve the original image, there's a good chance you will see something totally different that could be even better.

boiler. It was clearly a situation where multiple exposures were called for. In this case, since the brightness of tones spread over the entire range, I felt that manual blending with masked layers in Photoshop was not the best way to go. Therefore, I used exposure blending in Photomatix Pro. Figure 16.12 shows the three images that will be blended in Photomatix.

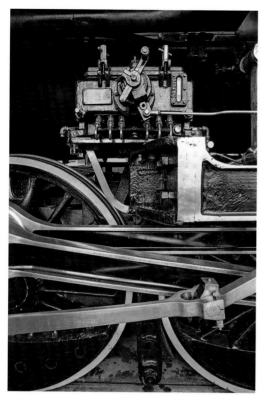

▲ Figure 16.16

The images as blended in Photomatix.

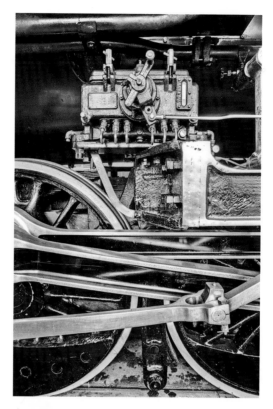

▲ Figure 16.17

Image after Akvis Enhancer.

The blended image is saved as a TIFF file and then brought into Camera Raw (figure 6.13). This illustrates a few points. First, a little bit of the brightest metal has gone "over the top" to pure white, which I could see by the red highlight blown indicators in the Camera Raw image window. Second, note how far over the fill light slider is (half way). Normally, this much lightening (opening up) of shadows would result in tremendous noise in the now easily seen shadows. Fortunately, in this case, the longest exposure did a great job on the shadows and they have no more noise than any other part of the image. Therefore, opening the shadows does not cause undue noise. It does look like I should have taken a fourth exposure to handle that brightest piece of metal. Oh, well, I'll find a way to deal with it.

You can bring a TIFF image into Camera Raw, but usually you can't rescue the blown highlights to the degree you can with a RAW file. That said, you can do some work on highlights as is illustrated by figures 16.14 and 16.15, which show default and maximum Recovery slider in Camera Raw and acting on the blended TIFF image.

Figure 16.14 shows the blended TIFF image with the default Camera Raw settings while Figure 16.15 shows the same crop with the Recovery slider set to maximum, illustrating nicely that you can recover a little bit of highlights even in a TIFF image brought into Camera Raw. Still, a fourth really short exposure added to the three image sequence would have prevented the need for this trickery.

Figure 16.18
Curve used to dull down distracting areas.

Should you want to bring a TIFF image into Camera Raw from Bridge, use Command R to do so (Command O would take you straight to Photoshop, bypassing Camera Raw). Issues other than highlight rescue can most certainly be helped with importing the TIFF image into Camera Raw—from color temperature to white balance, sharpening, vignetting, clarity, vibrance, and so on.

If you want to save highlights in a blended image, then correct the highlights in the original RAW files first, then blend the saved results rather than the RAW files directly.

Not uncommonly an exposure blend from a wide range of tone brightness results in a lot of compression of tones, with a loss of contrast, not to say downright muddiness. This time it wasn't too bad, but my first step in these cases is to increase local contrast. I could have done this to some degree within Photomatix but preferred to use Enhancer with the results seen in figure16.14.

There are problems with the enhanced image though. The floor looks like it has been floodlit and is way too distracting. The highlighted metal is even brighter. Suitable black masking of the Enhancement takes care of this so that the enhancement doesn't apply in some parts of the image (black in mask) and is only partial in other areas (gray in the mask).

Even with Enhancement removed, the concrete floor is distracting, so it was burned down using a curve in which the maximum white was dropped down on the right of the graph to record as middle gray. This had the effect of darkening and reducing contrast, and eliminating any overly bright areas from the floor that would stand out (figure 16.15).

I wanted to brighten the connecting rods without affecting overall tonality. The Dodge

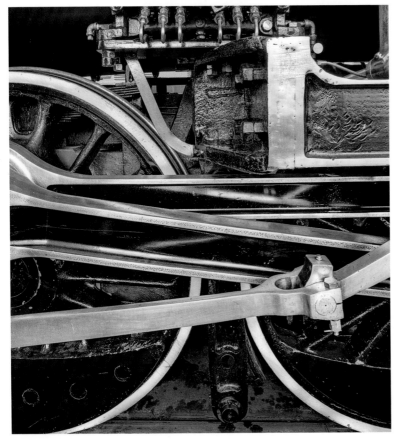

▲ *Figure 16.19*
The image has been cropped and the highlights dodged.

Highlights tool was ideal for this purpose, returning the wheel treads to almost white and bringing out the reflections in the connecting rods very nicely (figure 16.16).

A quick word about cropping the image: there was nothing wrong with the top part of it. There were some interesting shapes, no fundamental flaws, and overall a nice composition. *But* what makes this image is the driving and connecting rods against the backdrop of the wheels, and it seemed to me that by removing the top part of the image, I could emphasize the strongest part.

It can be extremely painful to throw away perfectly good parts of an image. Fortunately you can offer up a choice and live with the two options for a while before deciding which is best. I frequently have tough decisions to make and if it isn't clear which is better, I'll save the new variation on the image as a Version 2, so I can always go back if need be. In a few instances I have five "final" images, all versions of the same photograph. For the most part, I do end up with the last image as the keeper—but not always.

If you save what you have, then do a File/Save As (Command+Shift+S) , you can now make any further changes and save them without erasing the previous version.

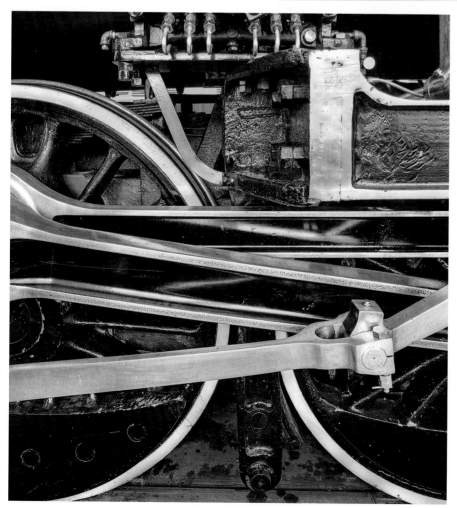

◀ *Figure 16.20*
Image converted to black and white—all but the distracting orange background that I want to save for a different black and white rendition in which it is darker.

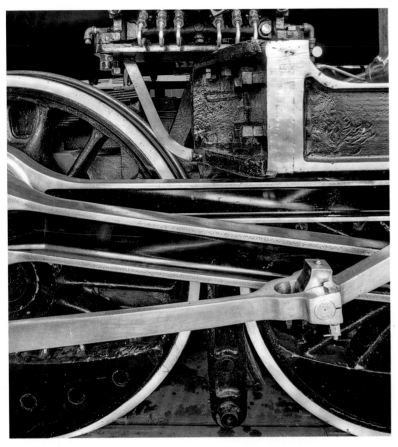

▲ *Figure 16.21*
Using a second Black &
White Adjustment Layer to
work on the orange back-
ground.

down a bit. Because we are converting to black
and white, I did a general conversion of the
image to black and white (figure 16.17), then
masked out the areas that needed toning down
so that the black and white conversion didn't
apply to these areas.

I then added a second Black & White Adjust-
ment Layer above the first, this time taking
the red slider to the dark side. As the only color
left was in the areas in which the first black
and white layer was masked black, the second
conversion layer only had an effect on the
remaining color, taking it darker just as desired
(figure16.18).

*Use two Black & White Adjustment Layers with
masking of the lower of the two layers so that you
can use one "filtering" set (slider adjustments) for
one part of the image and another (in the upper
layer) for the rest of the image.*

Thoughts On the Images

The only reason I went back to the steam
locomotive coupler was to find an overview
picture so I could show how I zeroed in on the
interesting parts. Now I have another coupler
image I like (figure 16.10), and it is sufficiently
different from figure 16.11 for both to be in-
cluded in a portfolio. I think that figure 16.11
is one of the best images I have done in a long
time. I don't know what I'll do with the images
at this point—I don't have enough coupler
images to make a portfolio. Perhaps I'll lump
them together with other closeup images of
steel castings of non-railroad origin. More
likely I'll simply sit on it for now and at some
point in the future, perhaps, I will have enough
images for a portfolio.

Figure 16.16 is close to what I had wanted
in the beginning. However, I have decided that
this image would be better in black and white,
without any distracting color at all. In many
images, the subtle color tones in what appears
to be monochrome parts of an image (e.g., ice)
turn out to be extremely important and the
black and white image looks nothing near as
good. In this case, though, we lost nothing
and gained a cleaner image that works for me,
thus this black and white version becomes my
portfolio image.

The background contained some very bright
orange-lit material that showed through the
spaces in the locomotive. Had I decided to
keep this in color, I would have toned this

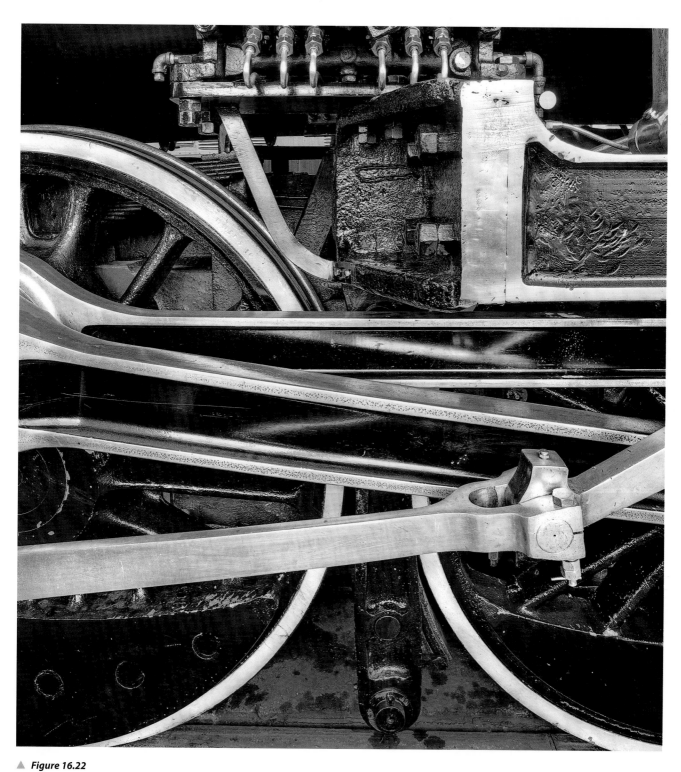

▲ *Figure 16.22*
The final black and white image that emphasizes the shapes and forms of the connecting rods and driving wheels.

17 Manipulations

- *Inversions, posterizations, tricky curves, and other manipulations*
- *Thoughts on the role of manipulated images and just having fun*
- *Diffused highlights techniques*
- *Is it "Art"*
- *Going well beyond real*
- *Are artists allowed to have fun and what do you do with the results if they do?*

I'm guessing that most of us have messed around with the settings in our favorite image editing software; inverting the image tones and colors, solarizing, or using any one of hundreds of Photoshop tools to make an image surreal. Most of the results are just fun and serve no purpose other than our own entertainment—nothing wrong with that.

Some manipulations can look very nice. Check out the recent color flower work of Huntington Witherill, himself a painter by background and a large format black and white landscape photographer by inclination. Some of his manipulations are wonderful.

At one point I decided to do a project on hands, more specifically, my hands. At 59 years old, they have character. I got to playing with my first efforts. Don't think others will give you any credit for doing this kind of work, but who cares? This is for yourself, and I'm simply showing you mine to illustrate.

I started by using a combination of image inversion, solarization, posterization, and wacky W- or M-shaped Curves Adjustment Layers. Figure 17.1 is the end of a long line of changes and I can't remember the steps, never mind the sequence, and could not possibly reproduce it if I wanted to. Inversion reverses tones—black becomes white and visa versa—creating, essentially, a negative. Solarization works on edges, much like sharpening taken to an absurd and very obvious high degree, producing rings around objects. Posterization reduces the tones in the image to a defined and limited number of shades. The M-shaped curve means black is black, white is black, light gray is white, dark gray is white, and medium gray is black (the middle stem of the "M").

If you like a result, does it really matter how you got there? Sure does if you are a journalist, but otherwise….

At one point in the process I copied the original full-toned image and blended it with the limited-tone image to bring back at least some of the detail of the original. You can do

▼ *Figure 17.1*
The result of playing with a failed project to photograph my hands.

this by flattening the current image, selecting all (Command A), and then copying it (Command C). Next, go to the history palette and scroll back to the top where you will find an icon of the original image you loaded. Click on that to revert to where you started. Now paste (Command V) the manipulation on top of the original. You can then use masks and layer opacity to bring through a little of the original image. If, for some reason, you need the original image on top of the manipulation, then double click on the bottom background layer (which Photoshop does not allow you to move). A dialog box will come up and you simply hit OK, thus saving the background layer as layer zero, which *can* be moved. All you do now is drag one of the two layers past the other to reverse their order.

▼ *Figure 17.2*
Going even further to manipulate the image, adding back some false color through playing with the individual color graphs in a Curves Adjustment Layer.

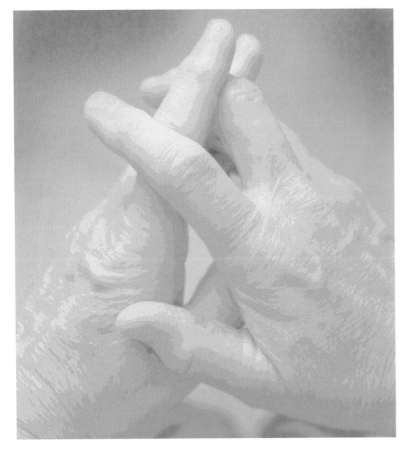

There is no limit to what you can do to an image. Whether it produces a worthwhile result is another issue. And do you even call the result photography? If you like the image it doesn't really matter.

Using the same techniques, though not in the same order, and adding some color back after the image had been converted to black and white, I ended up with the result in figure 17.2. I had a black and white image, so I added a Curves Adjustment Layer and instead of leaving the setting of the curve at RGB, I switched to one of the color curves and adjusted that curve, giving the image some color.

At about this point the whole idea for the "hands" project fell through. I felt that too many weird manipulations using similar techniques would be boring. Yet if I used too many varying techniques and the results looked radically different (as in these two images) then it would defeat any continuity in the project. There is always a fine balance in making any portfolio of images and with no easy answers. How similar is too similar? How different is too different? If considering the portfolio for publication, then I would strongly recommend getting second and third opinions on which images to include.

Sometimes we are too close to our own work to judge it objectively and we need outside opinions before getting too far along in a project. Remember, though, that whatever anyone else thinks of your work, if you are strongly attached to it, then, "To hell with everyone else!" But don't expect fame or fortune. Be satisfied, and even be a bit proud of your work.

Sometimes a subtle manipulation is called for. Now that digital makes it easy, a technique that is quite popular is to diffuse highlights in an image, giving it a bit of a glow. Entire portfolios using this technique have been printed in *Lenswork*, giving it a sort of "seal

of approval", but it can be easily overdone, it doesn't improve poor photographs, and it's probably used too often. When some images in a presentation are diffused and the rest not, it looks very disturbing—this is probably an all or nothing issue.

Figure 17.3 is one I showed some time ago. I made a print, put it up in my office, and lived with it for a few days. But I wasn't happy. Oh, it's nice enough, but what I had imagined is not what the print shows. There was too much clutter and distraction. I see the image as being about the three light-colored bumpers, looking a bit like the reverse of some Japanese character painted on paper. I tried darkening the rest of the print, but didn't like it. I wondered whether there was some kind of curve that would keep the darkest parts of the print showing some detail, while the mid-tones were pushed way, way down, and while still leaving the highlights where they were. I tried doing this and, though I didn't record the curve, trust me, it's a bizarre looking one and figure 17.4 is a reproduction of roughly how the curve looked. Normally this would produce a very unnatural looking result with incredibly muddy tones, but guess what, it did exactly what I wanted!

The image of the bumpers seemed like it might be a good candidate for the "glow" effect. I duplicated the image in another layer by dragging the layer to the second from right icon across the bottom of the layers palette (figure 17.6). I then used Filter/Blur/Gaussian Blur at around 20 pixels (on the copy layer) and changed the blending mode to lighten (figure 17.7) so we get the flare, not the

▲ *Figure 17.3.*
Straight photograph—which didn't emphasize the light bumpers as I remembered.

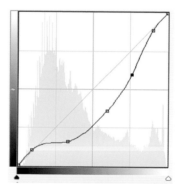

◀ *Figure 17.4*
This bizarre curve actually did a great job of darkening the midtones while not sacrificing the shadows.

▼ *Figure 17.5*
Darkening the rest of the image helps to some degree.

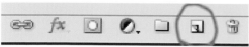

▲ *Figure 17.6*
Duplicate layer icon.

spread of dark pixels. I then used the Adjustment Layer Opacity slider to tone down the effect until I thought it reasonable. Oh, and there were several dozen other minor changes made. For example, I cloned out the numbers pasted on a bumper in the bottom of the image, removed a collection of scratches and spots that looked more like print defects than like part of the image, and lightened the third light bumper on the right to make it stand out equally to the vertical one in the center and the one on the left.

I'm quite pleased with the print (figure 17.8); certainly a lot more than with the original. The glow is subtle—You can't actually see it in the details, it just exists. Exactly what I wanted! You might have to check this book's section on my website to see the full effect.

▶ **Figure 17.7**
Changing the blend mode to Lighten so that only pixels that are lightened by this layer show through. Note the Opacity slider adjusted to tone back the effect of the layer.

▲ **Figure 17.8**
Now there is a subtle glow to the light colored bumpers against the darkened and muted background.

▲ *Figure 17.9*

A casually made image of me. With minor clean up of the background, I used this image for the inside flap of my first book. Photographing me was Lawrence Christmas.

▲ *Figure 17.10*

I certainly had fun playing with this image of me.

I was having tea with Lawrence Christmas (he of the coal miner photography) and I had my brand new Canon 1Ds2 with me. At that point, Lawrence was still lugging around his 8x10 camera, though he had started scanning negatives for inkjet printing. This is a first step on the path to digital for many of us old timers and in fact, Lawrence has since succumbed and purchased a DSLR to use for at least some of his work. Anyway, Lawrence fired of a few images with my new camera and figure 17.9 was one of them.

I checked with Lawrence before using the image as my back flap picture for my first book. I had to simplify the background for use in publication, but one afternoon I took things a bit further and really started playing with Lawrence's image. I used inversion, posterization, solarization, funny curves, and whatnot.

I was simply playing with the image, backing up where I made it worse, pushing on if I thought I was heading in the right direction. There is not a hope of me duplicating the editing sequence but that hardly matters and is in fact part of the fun of manipulations. Figure 17.10 really is a one-off. My wife doesn't like the image, but that's hardly surprising. Even though she's normally a very insightful critic and I often follow her assessments (like nice try, great paper, try it upside down, and so on),

I didn't expect her to approve of this over the original color version. But I happen to like it!

There are times when going "over the top" is exactly the right thing to do; other times, subtlety is the order of the day. Which is right may depend on what you propose to do with the image and why you were making the changes.

Figure 17.12 isn't so much of a manipulation as simply taking what's there and running with it. One of my more popular images, it's pretty obvious that the color is over the top, yet the result is very attractive. Figure 17.11 shows one of the original images pretty much as recorded—pale, soft, and lacking detail, drama, and, frankly, interest. Editing was done entirely with a series of increasing contrast, S-shaped Curves Adjustment Layers, working on parts of the image, sometimes several times. As this

drove the color to become way too saturated, it was necessary every few steps to reduce saturation to bring it back from "comic" to "dramatic".

The final result in figure 17.12 shows depth of color, contrast and detail that were missing from the original recording. This kind of radical departure is relatively common in black and white yet very unusual in color, but makes a very nice semi-abstract, painterly image.

▶ **Figure 17.11**

The humble beginnings to one of my most popular images.

▲ *Figure 17.12*

Despite taking contrast and saturation to an extreme and unnatural degree, the resultant image is a long time favorite and has sold well.

The final image is a manipulation of the locomotive image found in chapter 16. The simplicity of the four-color posterization on top of some other manipulations produced an interesting effect. I noted that the locomotive numbers were not readable and so I added back the original image, manipulated it in a way that the numbers were readable, and then used a black mask to hide the effect. I painted white into the mask to show the number boards in the "improved" manipulation, and I had a result I am willing to share with you.

Thoughts On the Images

Manipulating images like this is simply fun. Perhaps you feel that as a fine art photographer, you aren't meant to have fun. Well, it didn't take me long to find out that Picasso had fun—for example, his modernistic copy of a Manet painting (Luncheon On the Grass). Given how many lovers and wives he had, I dare say he had fun at other times too. Surely if it was all right for someone as radical, as serious, as famous as Picasso to have fun, then I don't think we have to feel guilty for enjoying ourselves now and again.

If the manipulated images we produce remain interesting to us over a period of months, it is quite reasonable to assume they may be of interest to others. I don't think it does our reputations any harm to be seen in public with our fun images. They are so obviously different from our normal work that they do not dilute any credibility we have earned with our serious images.

◀ ***Figure 17.13***
Manipulations like these really don't serve any useful purpose, yet, like a classical pianist "just fooling around", the result can be entertaining.

18 Pairs

- *What makes one image better than another*
- *Understanding the difference between zooming and moving*
- *Refining compositions*
- *Lightness and darkness of prints*
- *Lenswork Special Edition Folios*
- *Telling a story with an image*
- *Finding, recognizing, and making high quality prints*

In other chapters I have shown you some digital "contact sheets" so you could get an idea of how I get to the final image—working the scene until I have the optimal position, lens, and framing. In this chapter I present you with a series of image pairs—both without technical problems, both of the same subject, and photographed not too far apart from each other—definitely part of the same scene. You will be able to compare the images side-by-side and see the differences.

I will explain both what I did to get what I think is the better of the two images. The better image is always the "b" image of the pair. For example, 18.2a goes with 18.2b and 2b is the ostensibly better image. It's even possible that you may disagree with me and prefer the "a" image. That's fine. After all, the framing, compositional tools, tonality, reflections, and shadows that I like are almost certainly not the exact same set of tools/features that you would use or select. Still, I think it will be useful for you to see why I prefer the "b" image in most cases, so that you may find some new ideas to embrace. At the very least, it will reinforce your own ideas about working the scene and composition and presentation.

In some cases the pairs of images are only subtly different and you may even need to read the accompanying text to figure out what the difference is, though you should be able to see it after it's pointed out—rather like one of those kids' newspaper puzzles in which two cartoons are next to each other and you are asked to spot the differences.

In other cases, the images are dramatically different because I approach the subject from a different angle or move forward or back substantially, or simply use my zoom to include/exclude subject matter.

I suggest that before reading the text describing the relative strengths of the images, that you first spend some time with each pair, deciding which of each pair you prefer and more importantly why. Then read the text that follows each pair of images and see how your assessment stacks up against mine. You will certainly see different things, so it isn't a matter of getting a "perfect score", rather that you decide what features you like, so that when in the field, you can recognize similar features in the scenes you work with. Don't assume that because you don't do landscapes, that you won't find similar features. They exist in all types of subjects from football games to nudes. Have fun!

▶ ***Figure 18.1a***

Photographed the morning after the companion image, shortly after sunrise.

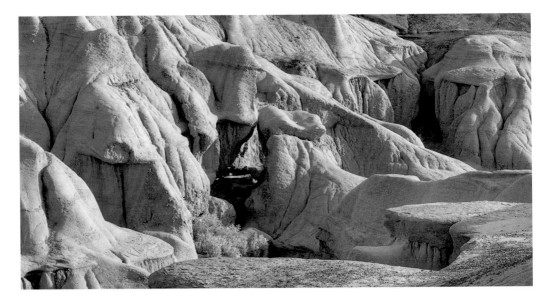

Pair 1 – Bluff Bushes

Shot in 2004, figure 18.1b is a long standing favorite of mine. Figure 18.1a was photographed early in the morning, just after the

▲ ***Figure 18.1c***

Outlining the main lines and edges in the image.

sun came up. The sun was on the right and low in the sky, and my theory was that this light would graze the shapes and give them dimension, which the flat light had not done when I shot figure 18.1b the evening before. Remember, that at this point, I hadn't had the opportunity to even see the evening image given that it was a series of images waiting to be stitched. It had been made after sundown, the sky to the left lighter than the rest of the sky. It made sense to try some light that was a bit more stimulating, thus I returned the following morning for another attempt.

Not surprisingly, the images are not identical in framing. In my opinion, figure 18.1b is more strongly composed and the subjects are well balanced. The sunlit background in 18.1a is more distracting, and the shapes are not as large or simple or as well balanced. I tried cropping the left-hand side of the image (the original shows more on the right) but the elements became even more unbalanced.

The way I see figure 18.1b is that on the left side we have a large, triangular shaped bluff extending from the edge and pointing toward the right, into the middle of the image. The triangle seems to be pointing toward the bush. On the right we have three main dark areas; the crevice at top right, the cave, and the shadow of the overhanging rock at bottom right. The bottom of the image is nicely contained by the large dark rock. There is a diagonal slope angling down and right from the top edge to the right edge, and which meets at the edge with the horizontal line across and leading toward the cave.

I quite like the tonalities in figure 18.1a. The sunlight did exactly what I predicted, but now the problem is that the image is too cluttered, with too many competing features and not in any particular pattern. I quite like the silvery bush above that foreground rock in the bottom middle of the composition (I was lower down), but elsewhere the image is too uneven. The

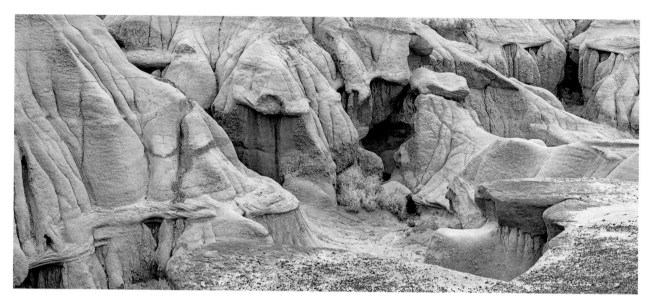

▲ *Figure 18.1b*
Bluffs and Bushes, 2004, from Dinosaur Provincial Park, Alberta.

upper right corner is rather dull. In figure 18.1b the "icing" of the bluff tops forms a line that starts almost in the upper right corner and extends down and left, going above the cave and forming another triangle with the upper edge of that original left side triangle.

Some might find 18.1b (the right hand image) a busy composition, especially on the right hand side. I don't have that problem and, more importantly, many viewers seem to agree with me, it being one of my best sellers.

In figures 18.1c and 18.1d you see the same two images with red lines outlining the main compositional features. (In my first book, Take Your Photography To The Next Level, see my suggestion for using this technique in the field to help with composition.)

I think the outlines in the second image work much better. In figure 18.1c, the lines underscore the image's complexity. The upper right corner shows a dark, rather boring cliff-side that doesn't work. I have tried lightening that area, but then it fails to frame the bluff below.

Apart from the arrangement of the shapes in the two images, I think the shapes themselves are more attractive in figure 18.1b, which is

interesting, since they are the same landscape features, just in different light and with minor variations in camera position.

Mind you, the only reason figure 18.1b image looks nice is because considerable work has been done on it to improve local contrast, balance the tones, bring out highlights, and separate colors. But it is the end

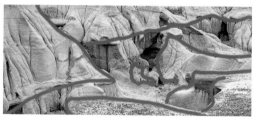

result that matters and I know I couldn't ever get figure 18.1a to be as good as 18.1b.

Apart from the arrangement of the shapes in the two images, I think the shapes themselves are more attractive in figure 18.1b, which is interesting since they are the same landscape features, just in different light and with minor variations in camera position.

Mind you, the only reason figure 18.1b image looks nice is because considerable work has been done on it to improve local contrast, balance the tones, bring out highlights, and separate colors. But it is the end result that matters and I know I could not get figure 18.1a to ever be as good as 18.1b.

▲ *Figure 18.1d*
Using lines either on an image or by making a very simple sketch of the composition can be a useful composition tool.

▶ **Figure 18.2a**
Shot a few minutes after the companion image, this is part of working the scene, but not all subsequent efforts are necessarily an improvement.

Pair 2 – Rugged Rapids Provincial Park

It is unusual to find that moving in produces the lesser image, but, in this case, including more did really pay off. There's a lot of stuff going on in figure 18.2b, but it is laid out in an orderly fashion—as can be seen in the overlaid lines of figure 18.2c.

Figure 18.2b takes better advantage of corners. The separation of the central tree from the birches is better. The bottom right corner is more interesting than figure 18.2a; especially how in the top left the overhanging darker branches nicely frames the image.

From further away we see more of the path. It is not as wide in the image and its bend looks nicer, and the gloom of the forest seems to me to better represent the atmosphere of the location. The inclusion of the base of the middle tree is an obvious plus for the right-hand image. I have successfully composed

images with only the trunk of a tree in the middle of a composition, but the roots nicely parallel the path on the left, and on the right the root starts the diagonal line into the right bottom corner. The inclusion of more water on the left side isn't compositionally important but it does identify this as a path along a stream, part of the storytelling that happens in some images. There are a number of other things that figure 18.2b has going for it. See how many more you can identify.

Oddly, figure 18.2a was shot at 20 mm, while figure 18.2b was at 23 mm, on my 17-40 on a Canon 10D (APS-C size sensor so 1.6 X mag. Compared to 35mm film). This tells us that the difference in the images was due to change in camera position rather than simply standing in place and zooming in. This is a fundamental part of working the scene.

Just a quick aside on print size. Although figure 18.2b makes a lovely 13 x 19 print (image size 10 x 15), the image falls apart

◀ *Figure 18.2b*
Rugged Rapids Provincial
Park, Ontario, 2004

when I try to make a 17 x 22, tricks of upsizing and sharpening notwithstanding. This was the consequence of using a 6-megapixel Canon 10D camera. A 10-megapixel camera should be capable of producing prints approximately 1.3X larger (square root of 10÷6) in each dimension. Other images might be printed larger with success, but the fine detail in this image does not upsize successfully.

Zooming in is not the same as moving in. Zooming in is basically cropping, while moving in causes close objects to loom larger since they are many times closer than distant objects. Think of it this way: Objects that are 4 feet and 20 feet from the camera with a wide-angle lens might become 12 feet and 28 feet with a longer lens because I moved back to cover the same subject matter. In the former, the near object is 5X larger than an equivalent sized object at the further distance while in the second situation with the longer lens, the difference is more like just over twice as large

(28/12). Moving in changes relative positions as well as sizes anywhere in the image except dead center, and this also changes composition as well as framing. For example, two trees that were in line, one in front of the other in one position, are now separated as you move forward and can peer around the closer tree.

Zooming is not an alternative to moving in.

I tried using Akvis Enhancer on figure 18.2b but it took away the mood and made it look more like a post card—not the effect I wanted. However, I lightened the fallen leaves and also bits of the path that enhance

the image considerably. Note how much the moss on the rock in the bottom right corner

▲ *Figure 18.2c*
The lines show a strong composition.

stands out from the rock itself—almost like dappled light coming through the trees—yet that isn't true in the unedited image (figure 18.2d).

Notice that in left side of figure 18.2a the leaves in the upper left are rather homogeneous—or to be more graphic—a blob, while those in figure 18.2b show both variation and depth to the leaves, all due to a change in position.

I find it very difficult looking through a small viewfinder to make judgments about the strengths and weaknesses of a composition. I tend to find the best position I can, make an image, then start looking to improve it, often in a series of multiple steps, multiple images. Yes, it takes time, but it is worth it. As LCD screens get bigger, our task becomes easier.

You may have positioned your eye to exactly the right spot for the image, but did you then place the camera lens so it is in the same position? Tripods that don't go high enough, the tendency to lean forward to look through the viewfinder, and even the short distance in front of your eye that you place the camera can all affect the relative positions of the subject. It is very frustrating to get home and realize that you cut off the last 3% of an object at the edge of the image; or that the two objects which were to just kiss, now cross; or that something you thought hidden (for a good reason) is now glaringly obvious because the lens was one inch off from your intended position.

In this pair of images (figures 18.2a and 18.2b), the "a" image was actually taken after the "b" image; three minutes after to be precise. I can only conclude that I didn't know just how good the earlier image was and in an attempt to make a strong image, actually made it worse. Welcome to the real world.

There's nothing wrong with going downhill after a certain point. After all, if you got everything right, then you *should* be starting to slide, and when you realize that you are, you move on.

Sometimes you come on a scene and immediately see an image, complete with framing. Everything you try afterwards is downhill quality-wise. It isn't too surprising since on seeing it first an alarm bell went off in your head telling you that this is an image worth having. Of course, more often further inspection reveals a number of flaws to the image not first appreciated. So you turn off the alarm and start moving around. Working the scene is about finding the best position and framing. Sometimes it's the first image that is the keeper, other times the 57th and last, and yet other times, somewhere in-between.

Pair 3 – Old Truck

The problem with figure 18.3a is that it is both cluttered on the right half while not giving enough clues as to the orientation and subject matter. Figure 18.3b has several things going for it, for example, the repetitive circular shapes of the headlight, mirror, and logo. It is simpler yet more explanatory. The windshield adds a lot to the image. The slats in the hood are good, but don't justify being the entire left hand side of the image as in figure 18.3a.

There's quite a lot to take in with the figure18.3b despite the cleaner "design". You can see a tire, the radiator cap, and, even faintly, the steering wheel. You can see the seat and the two latches to open the hood. You can even see the chain drive on the far left. Does that lift the dumper? Images like these two are far from being abstracts, which means that they should tell a story, and the bottom line is figure 18.3b does a better job of telling it. Now, I didn't think in those terms when shooting or selecting the image to be one to pin to the office wall, but I knew enough to offer myself choices and to recognize that in the other image I wasn't finished getting the best out of the scene.

▲ *Figure 18.3a*

Pioneer Acres, truck awaiting restoration—image needs work.

▲ *Figure 18.3b*

Sometimes it is more important to illustrate or tell a story than to make a really strong composition.

▲ *Figure 18.4a*
Cave And Basin, Banff, Alberta.

Pair 4 – Cave and Basin Hot Springs

There are times when it can be tough to de-
cide which is the better image. In the case of
this pair of images (figures 18.4a and 18.4b) I
like both, just not equally or in the same way.
I don't think either has the perfect shape of
yellow plant material. The patch of yellow on
the bottom of figure 18.3b isn't an especially

attractive shape and I like the cloud reflec-
tions in the center of figure 18.4a. However, I
find the reflected reeds "make" figure 18.4b,
and the top of the other image doesn't have
much to offer. Deciding which is best while in
the field is well nigh impossible.

I'm comfortable showing both images,
though the image on the right has been the
more popular seller. Remember that it isn't

▲ *Figure 18.4b*

Another image from almost the same spot at Cave and Basin.

necessary to decide. You could quite easily hang these two images next to each other on the wall—they are sufficiently different to work well together. On the other hand, I wouldn't submit both to a contest or for publication.

Images like these work well in large prints, even if you go beyond the normal resolution limits of your recording medium. 24 x 23 inch prints on the wall look quite abstract. Note the complementary colors and the limited color palette—basically yellow, green, and blue.

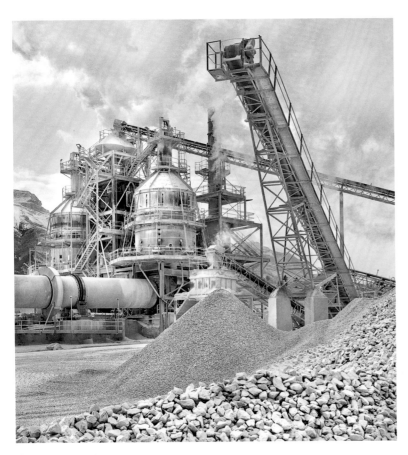

▲ *Figure 18.5a*
Getting so low I had to dig a hole for the center post of the tripod.

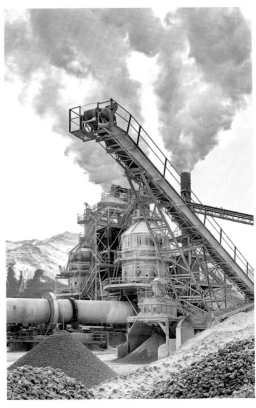

▲ *Figure 18.5b*
I thought I was being clever having the three objects meet like this—but was I right?

Pair 5 – Graymont Limestone Plant

I have no strong preference for one of these images (figures 18.5a and 18.5b). I like them both and presented both to the manager of the plant, who then drove me around for more than an hour to visit the quarry site several miles away.

One issue I have with figure 18.6b is that everything seems to come together in the middle of the image in a mishmash. It's one thing to have things come together, but this is a bit much. In figure 18.5a, there is separation in the main features; the conveyer doesn't cross the stack or hide either of the towers. While we don't have that lovely billowing steam to quite the same degree, we do have a gray background instead of white, as happens with the bright sky behind the steam in figure 18.6b. The white

of the limestone-coated machinery shows up better against the gray backdrop.

Keep in mind that I'm being pretty picky here, as I do like both images. What would have happened if I had got down on my stomach for figure 18.6b? The conveyer would have been over the towers instead of in front of them and the composition might have been cleaner. We'll never know if it would have worked because I didn't try it. Why didn't I try it? Because I didn't see the problem at the time. In fact, on the small LCD the confluence of the towers, stack, and conveyer might have looked like a good thing—and in some ways it is. I was there though, I could have seen with my eyes on the scene that this convergence would possibly be a

bit much. The solution is to try it both ways and decide later. Sigh....

Well, I remind myself that having two decent images isn't bad, even if I would like to have seen that third one. Elsewhere in the book I referred to playing chess and looking ahead. Here we have an example of whether you can look ahead two or three moves. The better the chess player, the further you can see into the future of the game, and that is just what's happening here, except instead of future moves, we are seeing future consequences. If I stand here, then I'm going to have to live with that and deal with the other, and so on.

Crushed limestone is white. The plant is covered in white dust. I like the lightness of figure 18.5a, but the steam really helps the other image. I could probably edit figure 18.5b to lighten it, though the billowing steam wouldn't be as effective. Figure 18.6a seems to have some weak sun making it look a bit nicer overall.

Figure 18.5c shows what I could do to figure 18.5b in less than five minutes of pretty casual and careless Highlight Dodging. With more effort I could do a better job, but I wanted to make the point that it isn't that difficult to add a little sun to an image (lighter on the side the sun is supposed to be coming from). Notice that the pile on the bottom left has actually had its direction of light reversed from right to left, all with just a few minutes editing.

How light or dark to make an image is often about the mood you want to create.

I thought I'd done a decent job on figure 18.5b, but just in the effort to write this, I realize that I could have gone further to bring the light. Do I now prefer figure 18.5c? No, I've just made the decision even harder. Mind you, there's nothing wrong with having two decent images.

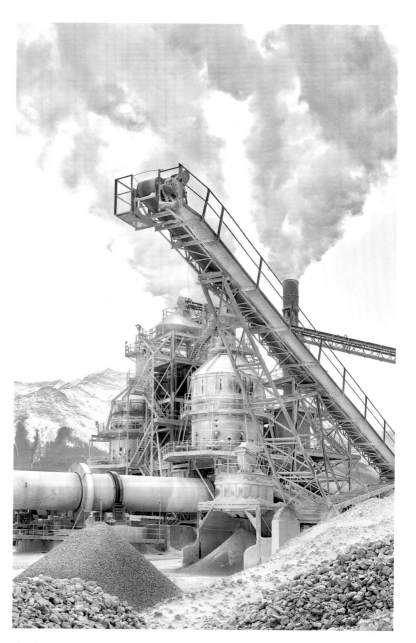

▲ *Figure 18.5c*
Although editing doesn't really replace the sun, lightening the left side of the piles and equipment does, I think, improve the image.

Image Editing is powerful. While it can't fix everything, it can sure improve a lot of images.

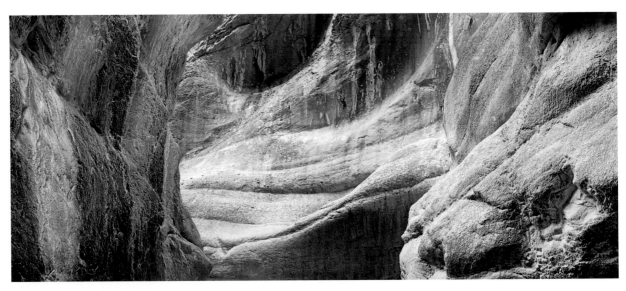

▲ *Figure 18.6a*
I tried hard to emphasize the middle subject matter as framed on either side but the right side is weak.

Pair 6 – Jura Canyon

This pair of images (figures 18.6a and 18.6b) is challenging. Both have interesting features. The problem I have with figure 18.6a is that the right side of the image fails. It's just a blob of rocks and does not complement the other side. I have tried cropping it out but then I lose too much of the middle (unless I leave a dissociated blob in the bottom right corner of the cropped image). In figure 18.6b, although the right side shapes are different, they act as a view block to the sweeping curves of the left side. Originally the image went further to the right but I cropped it, preferring this off center split to the image. The highlights on the right also are good.

It is too bad those horizontal stripes in the middle of figure 18.6a don't continue all the way across. You might be wondering why I didn't move forward so I could have emphasized them more. In fact, even one more inch forward and a bright section of sky would have intruded one third of the way across the top of the image, so moving forward was not an option. Perhaps I should have done the opposite and moved back and used a longer lens. The left hand side would have receded and the horizontal striped canyon wall would have become relatively more prominent.

If I had only two images from Jura, I suppose I'd include both original images, but having been to this location that is only an hour out of Calgary on several occasions, I have better choices available. Were an editor to say "send me everything", I probably wouldn't send figure 18.6a because if it did end up being published, it would continue to bother me.

▲ *Figure 18.6b*

The original image had as much on the right as the left but I prefer this off balance framing.

Thoughts On the Images

There are five years and several thousand miles to these images, so rather than comment on the images themselves, I want to emphasize some lessons learned.

1. The right light is crucial to many images and can make or break an image.

2. More images are spoiled by full sun than are ever made by it. Passing clouds are a photographer's best friends.

3. Understanding the properties of longer and shorter lenses (or zooms) is important to composition.

4. An image is never finished—just resting.

5. An image that is 75% good is not a good image.

6. If telling a story is an important part of an image, then it better do it well.

7. If you can't choose between two good images, don't worry. Time will either change your opinion or it won't, and tossing a coin is cheap and fast.

8. When editing images, the right contrast and brightness of the tones is the one that remains right to you several days later; the one that satisfies you and still looks good when held up against good work by others. It doesn't have to be the same to be right!

Finding, Recognizing, and Making High Quality Prints

Curators and collectors know that many photographers go through periods and styles, and that these phases or styles change, sometimes quite dramatically. Some debate Ansel Adams' worth as a photographer but few doubt his ability to make wonderful prints, yet he went through quite radical shifts in image contrast and darkness over the years, all the while maintaining a reputation for fine printing, and the public and critics simply accepted the variations as the work of a master.

When you struggle to get an image "right", remember that the target you aim for is not a single point in the first place and it doesn't stay still in the second. All you have to do is make the print look good to you today. You might wake up tomorrow and wonder what you had been smoking, but if you continue to like it in the next few weeks, then it was right for its time and nothing else matters.

What does happen is that novice photographers don't know what right *might* even look like and therefore wouldn't recognize it. Perhaps they have only seen images on the Internet or in books. Some current famous photographers insist on showing tiny images on screen or images with their name emblazoned across the front, as if stealing a decent sized screen image would be a crime instead of a come-on for buying the real thing. Learning from these tiny images is difficult. I don't even see how they can attract customers. I suspect that they simply use the website as a catalog for those who have already seen the original prints and just need a reference for arranging an order. Certainly, getting sales from one of these websites is very doubtful. As to stealing images from a website, anyone who is satisfied with a 1000-pixel print or screen image would never in a thousand years drop money for a real print. They have no idea what they are missing. Fortunately, there are a number of excellent photographers who do display their work in decent sized screen images.

For an amateur or hobby photographer to protect their website images is a joke—perhaps it makes them feel more important. On my blog, I display images that can be clicked on to come up in their own window, to fit within 800 pixels high by 1000 pixels wide. I have seen prints made by other people of these small images, but I don't think I'm losing anything when people do that. A 1000-pixel wide file will make a good print of 3.3 inches width. The images on my website are currently smaller than that due to a matter of loading speed and I will likely fix that—if I ever stop writing books and blogs.

Anyway, back to knowing what a good print looks like. A good place to start in your search for high quality images that are reproduced extremely well are the magazines *Lenswork* for black and white images and *Phot'Art* for color. Reproduction in these magazines is extremely high and these publications are quite suitable for holding up your prints against for comparison. If your prints look twice as dark, if your highlights don't sparkle like theirs do, if you can't see into the shadows in your prints but you can in the magazine images, then you clearly have work to do. I had the opportunity to compare prints to magazine reproduction when *Lenswork* printed a portfolio of my industrial images in issue # 57. Quite frankly, I was shocked to see how well the magazine did with the images (they were working from the digital files) and for a time questioned my own print making. Since then, I have talked to others known for their top quality prints who have

had the same experience, because that's how far the very top quality printing for magazines and books has come. Magazines like B&W, *Color*, *Focus* and others are far behind in printing quality, though in general, color printing is miles ahead of black and white. I have several images in *B&W 2009 Portfolio Edition* and the quality of my largest print in the magazine is sad to see, with whites that have been grayed down to a painful degree. Other images in the same magazine, even some of mine, look fairly good. If you use magazines to learn printing, however, I'd stick with *Lenswork* and *Phot'Art* for now.

Since *Take Your Photography to the Next Level* came out, *Lenswork* has restarted their Special Edition prints. The prints are inkjet on Harman Gloss FBAL paper, which does a wonderful job of displaying images. No, the paper doesn't quite look like darkroom paper. At times the ink seems to sit on the paper instead of in it like a silver gelatin print. What some critics fail to mention is that in some ways these inkjet prints are better than silver prints from a real darkroom. The subtlety of tones, the depth of the blacks, and the color of the images can be noticeably better.

I had never noticed that darkroom prints had issues until I started comparing best to best— prints made by master printers, from large format negatives, that aren't all that sharp, that have a slightly yellow (not cream) paper base. There's nothing wrong with the photographers' technique. These people are known for their prints, it's simply that the state of the art has moved on, just as it did when Edward Weston showed that his glossy dried matte prints were able to show a range of tones that platinum printers could only dream of. Sure, there were things platinum could do better. Progress almost always brings with it disadvantages; yet that experiment by Weston was the beginning of the end for platinum. Yes, I know that it has made a small comeback in the last few years,

and for a limited number of images platinum/ palladium can make wonderful prints.

From my prior experience getting my images into book form, you should be able to get a fairly good idea about print tones right from this book, at least the 95% of the tones from white to not quite black. The very blackest tones require more than one ink. If you try making a small print on matte paper with a good printer, you should be able to slip your print into the book across from one of my images and decide whether you are at least in the ballpark. If you know yours are right, then you don't need my help, but for those of you who are relatively inexperienced, doing a side-by-side comparison will be quite helpful.

Back to the *Lenswork Special Editions*. The point about their inkjet images is that they are beautiful. They are inexpensive and you should buy some. Print costs are on the order of $10-$15 each. Of course, you have to buy a whole folio, but there's nothing to stop you from sharing out the prints among your photographic friends and pinning a couple above your printer for a ready comparison. Although *Lenswork* is nominally a black and white photography magazine, it currently has two color folios and I'd be surprised if more don't come down the pipe. This truly is a wonderful opportunity to own top class images from famous and highly skilled photographers.

As you can see, I feel strongly about owning good prints and using the best magazines as a reference for the fine print. I will insert a small plug for my own images here. I included a print offer in the back of *Take Your Photography To The Next Level*—four prints shipped anywhere for $100. I made this offer specifically so that people could use my images as references at a very reasonable price. Since that book remains in print, I guess I'm just going to have to extend the offer to the images in this book too.

19 Sunflower

- *Photographing strangers*
- *Working with no agenda*
- *Photographing graffiti*
- *Capturing images of ordinary life*

The "walkabout" is an important part of photography. Whether you have simply wandered around your own neighborhood, nipped downtown for the afternoon, or grabbed your camera for an hour while on a business trip, the idea of having no preconceived notions of what you will find and being open to any possibilities that present themselves makes for an interesting challenge. It's also nice that it requires no planning, doesn't take a ton of equipment (good excuse to leave your tripod home), and can be "organized" in a flash. You take the weather "as is" and if it happens to be high noon, well, that's okay too. Without an agenda, you simply work with what you are given, warts and all.

Last year Uwe Steinmueller of Outback Photo invited me to do a workshop with him in San Francisco. There was even a Brett Weston show on at the time and I arranged to arrive a day early to visit it. A freak late April dump of a foot of snow in Calgary closed the airport for a day which ruined that part of my plans, but I did fly out the next day to get to the workshop on time.

▼ *Figure 19.1*
Corner house, a feeling of brightness in the air.

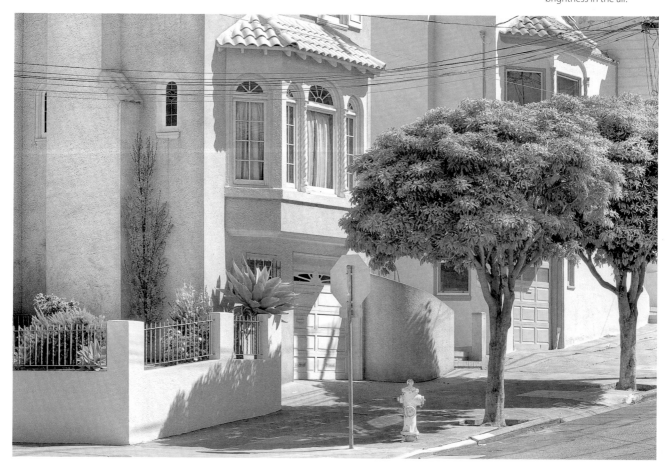

As part of the workshop, we took the participants on a "walkabout" in the local neighborhood. It was a mix of commercial buildings, apartments, corner stores, and a number of the classic San Francisco "Painted Ladies" homes, decorated in three and four colors, with gingerbread trim and lovely, flowering bushes and trees (remember, there was nothing green in Calgary in April).

My first observation was how easy it was to "see" potential photographs compared to being at home. Even in areas of town that didn't look much different than Calgary, I found myself experimenting, trying subjects I wouldn't bother with normally. It was quite liberating. One of the obstacles to making good photographs is that we tend to label the familiar. We see a chair rather than a series of angled lines and interesting shadows, thus missing an opportunity. Further, we tend to discount the familiar as being of no interest. We miss the curious juxtapositions and contrasts, the lines and shapes, shadows and reflections that would turn the ordinary into interesting.

The fundamental problem in finding possible subject matter is in recognizing its potential; of not seeing it as a possibility in the first place.

The next observation is that the participants had such strong preconceived notions of what makes a good photograph that they would walk right past subjects of great potential. Interestingly though, as soon as I'd point it out, they would catch on and happily start shooting. I had noticed this previously when out photographing with a friend and I had pointed out some lovely grasses swaying in the wind. He'd never considered them as a potential subject but, in fact, one of the grasses images

he took turned out to be his favorite of that expedition.

One of the first potential subjects we came across was a vintage E-Type Jaguar— British racing green, leather, wood, and even an eight track stereo. The men in particular all ogled over the car, but few took any pictures of the vehicle and those were mostly for record shots. To be fair, it wasn't going to be easy, parked next to a chain link fence, in the shade of an apartment building, and surrounded by other vehicles. The participants didn't seem to even consider working around these problems, choosing to move on, despite the initial interest in the vehicle.

Photographing is often about problem solving. We teach our children not to give up if something proves difficult on a first try, yet we are guilty of the same thing when photographing.

With such sexy curves, the car cried out to be photographed and I spent some time walking around it, looking for an angle that would work. I still managed to capture some reflections of the chain link fence, but was able to keep it to a minimum and cloned out a couple of spots where it spoiled the image (figure 19.2).

Apart from the practicalities of not being able to photograph the whole car because of the unattractive background, it does point out that photographing part of something, often the part which best represents the whole, can actually make a more powerful image than capturing the entire subject. This works whether it is a car, as in this case, or a landscape.

I didn't do justice to the curves of the Jaguar, but I like the composition; the lines in the

windshield, the mirror, and shell of the car as backdrop work for me. We make the best of what we find and where we find it and then move on.

One prominent feature of the neighborhood was the frequency of metal grills/gates blocking doorways. Someone had started the idea of making these security doors attractive and it obviously caught on because virtually all were decorative as well as functional. A straight photograph of the grills and gates wasn't going to be very interesting, something more was needed. In the first image (figure 19.3) it was the shadows of the grill interacting with the patterns of the grill itself. In the second

▲ *Figure 19.3*
A window grill, with the shadows forming a complementary pattern.

▲ *Figure 19.2*
E-Type Jaguar.

▶ *Figure 19.4*
Working the foreground
lines of the lattice door
against the further lines of
the sun on the wall and the
steps.

image (figure 19.4), it's the diagonal sunbeams leaning into the doorway, contrasting with the lines of the gate.

The young man standing in the doorway of a corner market was challenging. With blue jeans, green shirt, white hat, and background signs, it was all a bit much—cluttered and distracting. To reduce the distraction, I chose to desaturate some of the colors, especially the red (figure 19.5). In the end, I went all the way to black and white for what I think is the best image (figure 19.6). Even here, the contrast in the background has been toned down a bit so as to not overwhelm the figure.

The whole business of street photography and taking pictures of people who are generally unaware of you, and possibly not happy when they find out, is tricky. The law is on our side, at least in North America, but that doesn't make it any less awkward. Interestingly, while I was

▼ **Figure 19.5**
In the doorway of a small convenience store, the son of the owner.

▼ **Figure 19.6**
The same image in black and white to further remove the distraction of color.

▲ *Figure 19.7*
A curious child until dad reminded her she was shy, after which she hid in the back of the car.

▲ *Figure 19.8*
Man in doorway of corner store.

in San Francisco, I found it much easier to ask someone if I could photograph them. I figured they'd just take me for some crazy tourist and most people said yes when I asked.

The young lady in figure 19.7 was intrigued with me photographing, and didn't react to me pointing the camera at her until her dad told me that she's shy, at which point she hid in the recesses of the car. I guess even kids have reputations they have to live up to.

Craig Tanner (who teachers workshops on street photography) has some interesting things to say about the subject. Not the least of which is that our fears don't actually fit the real world because, he says, most people are okay with being snapped. Certainly, that was my experience in San Francisco.

I liked this corner store with its repeated arch windows and rough walls (figure 19.8). As you can see, this fellow was quite happy to stand in the doorway for me, probably more than a little amused at the antics of the photographer. Initially, I didn't include this image in the chapter, thinking that even though I liked it, it wasn't strong enough and was of too ordinary a subject (obviously I changed my mind). I like the placement of the man and even of the second fellow in the dark interior. The doormat and shadow below the doorway are interesting and interact with the edge of the image. The two lower corners work well with the diagonals of the building and the changes in surface of the sidewalk. All in all, I have persuaded myself that it is more than a snapshot. Whether I'm delusional, I'll leave for you to decide.

I thought that the color of the walls in this image were important to the photograph, but out of curiosity I converted the image to black and white (figure 19.9) and with some judicious use of both the yellow and red sliders in

the Black and White Adjustment Layer got the image of figure 19.9. So, now that you have a choice of black and white or color, do you think that the image is any less of a snapshot in black and white?

Consider this. Imagine that Paul Strand, took the image 80 years ago in France, in black and white, of course, and the image would of course reflect the times. The antiquity of the image automatically brings some interest, and unless you happen to live in France, the location itself adds some mystique. Remember, however, that when Strand photographed, those were contemporary buildings and people, the medium he used was the standard one of the day, and living in France as he did, there was not much mystique to the location. What was it about the scene that caused Strand to make the images if it was such an ordinary subject to him?

Is it the exotic location, the age, being in black and white, or just some extra magic in the image that makes an image legitimate? Why is it that for a long time I was uncertain (all right, very doubtful) about showing this storefront image to anyone, yet I liked it despite my doubts?

A photograph should be well composed but it also has to show something interesting and it should be informative. When we photograph the local gas station, we risk producing an image that fails to inform (at least inform anyone in North America) and also risks being uninteresting. Therefore, the challenge in photographing the ordinary is to find some previously unexplored aspect of gas stations, whether it is the staff, equipment, or the building itself. This is no small task but at least in recognizing what the challenge is, a good photographer might just be able to take it on.

> *When photographing the ordinary, first consider if it truly interests you, and if so, analyze why it does. Therein lies your avenue to make meaningful images.*

Applying all of the above logic to my storefront image, how do you think the image holds up in terms of informing and being interesting? How would you apply the above discussion to your own images of the ordinary?

At one point in our walk, we met the owner of one of these lovely San Francisco homes. I hadn't realized just how many of them had in fact survived the earthquake and fire of 1906. There was nothing special about taking a picture of her home, a minor compositional exercise, but it does make a few points. This image was shot at ISO 640, handheld, with Canon's cheapest lens, the 18-55mm IS lens.

▲ *Figure 19.9*

Decide for yourself whether you prefer the color or black and white version.

◀ **Figure 19.10**
Classic San Francisco house which survived the earthquake of 1906.

white windows to plants sitting in dark corners. Yet with some help from the Recovery and Fill Light sliders in Camera Raw, and subsequent further opening of the shadows, the image held together very nicely, thank you. I didn't need fancy HDR techniques to make the image. "We've come a long way, baby." Our tools are far better than our ability to see.

There was a fair bit of graffiti in the commercial part of the neighborhood and workshop participants were happy to photograph it, though I noticed that largely what they were doing was simply recording the graffiti without doing anything with it. In chapter 5 on photographing sculpture, I addressed the whole issue of essentially copying someone else's work. Graffiti is especially at risk of the photographer adding nothing to the art—after all, the graffiti is generally applied to flat surfaces and you risk the equivalent of photographing a painting and presenting it as your own work. If you take a straight on picture of a wall that has been sprayed painted, you have added nothing to what the original "artist" created. On the other hand, there is an opportunity to relate the graffiti to its surroundings, to take advantage of lighting and shadows to make something more of the image. In figure 19.11, it was the placement of the matching blue recycling bin in front of the doorway that added to the image, and because the image was not shot straight on I was able to emphasize the curves of the electrical piping. Frankly, I'm still not convinced I added enough to make this image worthwhile, but at least I tried.

The image (figure 19.10) makes a very nice 13 x 19, is tack sharp, and, despite noise in the shadows, it is well controlled and doesn't spoil the image. In addition, the lighting range was absolutely huge with sun on freshly painted

Graffiti in San Francisco.

In figure 19.12, I think I succeeded. The combination of the broken window, graffiti, posters, and the addition of the simple clear plastic glass works well. I think I can safely claim that I "own" this image.

In our final image (figure 19.13), we have a simple porch, and what is probably a plastic flower. That's not a lot to work with. Note though the angle of the shadows, the top of the opening to the porch, the railing at the bottom, and the contrast of all these rectilinear shapes and lines, with the single round, bright object. Can we make any statements about who lives here, based on their entranceway? Is it really plastic? If so, what does that tell us about a neighborhood that can produce houses like the one in figure 19.10?

Thoughts On the Images

When doing a walkabout, we are looking for stories, for the odd, the unexpected, the undiscovered, so that we may show these to our audience. We may choose to find the parts that represent the whole—that one building in the neighborhood that tells us about the rest of the area.

If you are someone who takes your photography seriously and who has forgotten that it can also be fun, the walkabout is a terrific opportunity to simply react to what you see. I would only work the scene if I have already seen something interesting as opposed to working to find something interesting, and that takes a huge amount of pressure off and sets you well on the way to making the walkabout fun.

▲ *Figure 19.12*

There's a lot more than graffiti working for this image.

Sunflower on porch of row house.

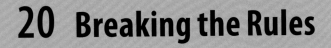

20 Breaking the Rules

- About depth of field
- Odd images
- Multiple exposures
- Missing the obvious
- Dealing with "seeing things" in images

As you've probably gathered by now, most of my images use every bit of depth of field they can get, and then I start focus blending to get even more depth of field. However, like all rules or policies or even simply habits, sometimes it pays to break those rules. In this chapter are a series of examples in which I have broken one or another rule, ending with my "Pipes Within Pipes" image which relies heavily on a *lack* of depth of field to work, for several reasons.

In figure 20.1 I have deliberately overlapped multiple different images. In the old days, I would have shot this on a single piece of film. In this case, shooting digitally, I simply took a series of tripod-mounted shots, so that the machine is steady, but with the hands in varying positions as they move the lathe controls to position the work. I actually prefer to do this in Photoshop where I have better control. I can determine which image sits on top of which and, through masking, control where

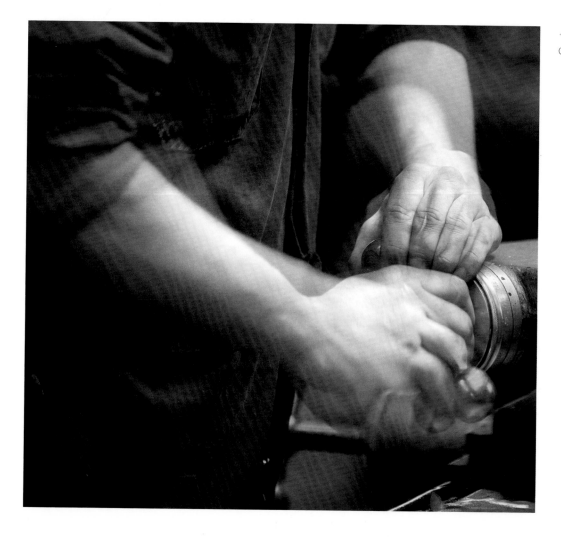

◀ *Figure 20.1*
Greg at lathe.

and to what degree each of the layered images shows up in the final. The alternative would have been a single slower exposure. Yes, I could easily have done that, but I quite like the multi-positioned hands and think it shows the movement better than a long exposure would have done. In other situations you'd clearly want the trails caused by movement within a single long exposure. Of course, you could certainly shoot it both ways and give yourself a choice. I didn't in this case, having decided this is what I wanted and I'm happy with the result.

This brings up an important subject, that of suiting yourself. The fundamental difference between a commercial photographer and a fine art photographer isn't the skill, or the amount of work put into the image, or the skills in composition and other components of the image. The single biggest difference is that in a commercial photograph the image is guided by what will please the client. In fact, it might be better to say that it is entirely driven by the needs of the client.

> *You are a one-person fan club for your work. The images had better work for you, first, last, and foremost. You are your own client.*

It is all too easy for the serious fine art photographer to slip into pleasing the client. I know, I'm not wild about the term "fine art" either, but it does nicely separate the serious amateur and even the fellow who sells the occasional image, from someone who hires himself out to a client and first and foremost wants to please that client or his art director. If you prefer, replace "fine art" with "serious hobbyist" or "amateur" or "creative" or whatever adjective you think fits best.

Anyway, back to the artist-photographer. Novice photographers often have one or two heroes and they would be pleased to have work that looks like theirs. It's as if you were trying to please Ansel Adams, as if he were your "client", influencing your work from the grave. As photographers improve and learn from more and more masters, we gradually develop our own style and can shoot pretty much any darn thing we want, in whatever style we feel like.

If photographers start to sell a fair number of images, there is tremendous pressure to make more images like the ones that sell well. It's all too easy to become focused on the selling and therefore future potential clients. We make assumptions about what they want to see (and usually presume that what they will want is more of the same). If what has sold well are pretty landscapes, we will forego more personal work that might not sell as well (though you never know), for more living room decorations.

Actually, to my surprise, my industrial images have been quite popular, being published and generating good sales. Therefore I don't think it is healthy to speculate on what will sell. After all, would you rather sell to 10 people who think your images are pretty and plan to hang the prints over the living room sofa, or to one person who actually gets what you are trying to do?

> *The further from the expected your images are, the greater the satisfaction when you produce some significant work.*

Once photographers have success with galleries, often it is the gallery that puts pressure on the now well-known photographer to do more work in a similar vein. If Bruce Barnbaum suddenly takes it into his head to photograph flowers in color with a digital camera, he's going to have a tough sell. On the other hand, Huntington Witherill has done exactly that, going from 4 x 5 black and white landscapes to heavily Photoshop manipulated flower images

that owe as much to painting as to photography. This isn't especially surprising as Huntington has a background in art, and in the past used hand painted backdrops for his black and white flower photography.

Thus, at every level of photography, there are external influences on our work; whether it's what we think will sell, what we have been asked to do, or what we think we will be asked for, doesn't really matter. The influences exist. Any way you cut it, we end up trying to please others and our photography suffers. We need to be very cognizant of outside influences and to be aware of when we are serving another master

Really, the only thing we can bring to our images in a world with millions of other photographers with just as much skill and training and practice, is to shoot the way we feel like it, pleasing ourselves, and on the way imbuing our images with our personality, our upbringing, the way we see the world and how we see it as influenced by the mood we are in on a given day. This lifetime of adventures, catastrophes, tragedy, glory, love, and all the other emotions and experiences is behind every image that we make when we don't aim to please someone else.

An offbeat idea that doesn't contribute to the strength of an image is just off.

Figure 20.2 shows a radical departure from my usual landscape or industrial images. It's purely abstract. It was a hand-held shot and came after taking a shower. I noticed the twisting effect of the glass block wall of the shower. I took a number of images that look quite different from each other, but this is my favorite.

Another unique feature of this image is that right from the start I saw it as two skulls or alien creatures facing away from each other. I don't normally see things in my images and on the few occasions when I have, it has been after the fact or even distracting.

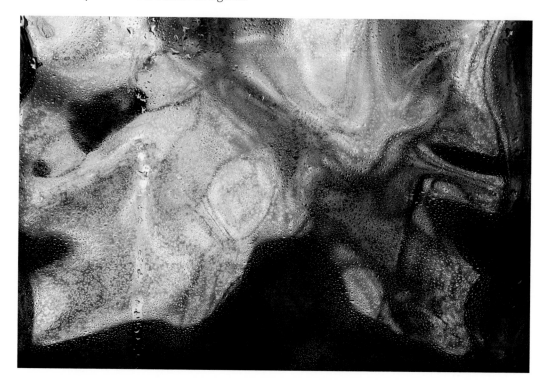

◀ *Figure 20.2*
Glass block patterns.

▶ *Figure 20.3*

Can you see the figure of a barnyard animal and if so does it spoil the image for you?

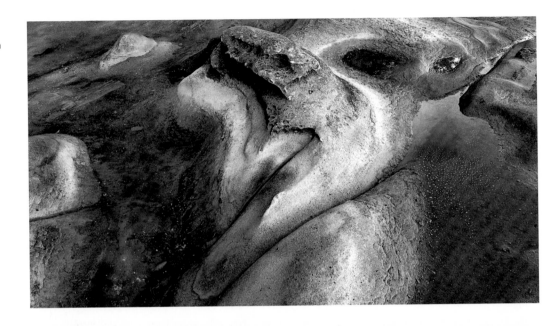

▶ *Figure 20.4*

Less piggish but now the image isn't quite as strong.

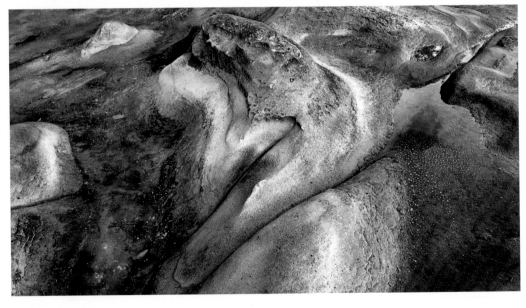

I *was* especially fond of this image (figure 20.3) until a reader of my blog pointed out that it looks like a pig. That was a year ago and every time I look at it I still can't get this thought out of my head. In an attempt to remove the pig-gishness, I did some cloning work and figure 20.4 is the result of that effort. While certainly less piggish, it is now missing an important compositional element, so it remains a bit disappointing.

So, do you think that seeing a pig in the first version spoils the image? Would you still consider including it in your portfolio, selling it, and/or submitting it for publication? What

if it weren't a pig? Figure 20.5 seems to show a horse's head—and I don't have any problem with it. I have it on display my examining room, so all my patients see it and I put in my first book without a qualm. Does this mean I'm prejudiced against pigs?

I was attending a workshop out of Canmore, Alberta led by Craig Richards and Keith Logan and we'd gone to Lake O'Hara for a day's shooting. We hiked up to the Opebin Plateau where the larches were in full color. There was snow on the mountain peaks and it was a beautiful day. I made the requisite shots of the white mountain peaks, the yellow larches, and blue lakes.

Although I enjoyed being there, I wasn't excited photographically. As I was hopping over rocks working my way back to the group, I noticed a lovely pink rock about three-feet square with lichen on it. There were some nice curves to the patterns of the lichen and now I was excited. So, while everyone else aimed their cameras upwards, I pointed mine straight down (figure 20.6). This was the first of my rock-face images, a series that I have continued to shoot ever since with considerable satisfaction.

Seeing everyone go one way is pretty much a reason to go in the opposite direction, whether you are talking geographically or aesthetically.

Most often I find it best to photograph these rock surfaces when the sun isn't shining. Some rocks will glow when they are wet, yet other rocks just look dirty and dull once dampened. In processing the images, the trick is to maintain the subtlety of color and contrast while restoring the image to what you saw rather than what the camera captured. Sometimes you can take advantage of a rock in shade that

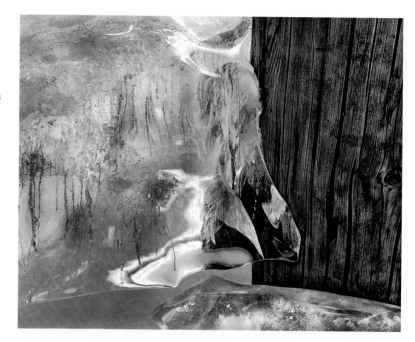

▲ *Figure 20.5*
Ice and post… and horse?

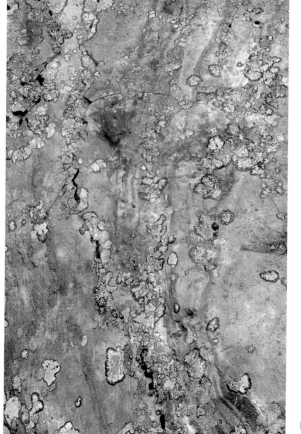

◀ *Figure 20.6*
Lichen on rock.

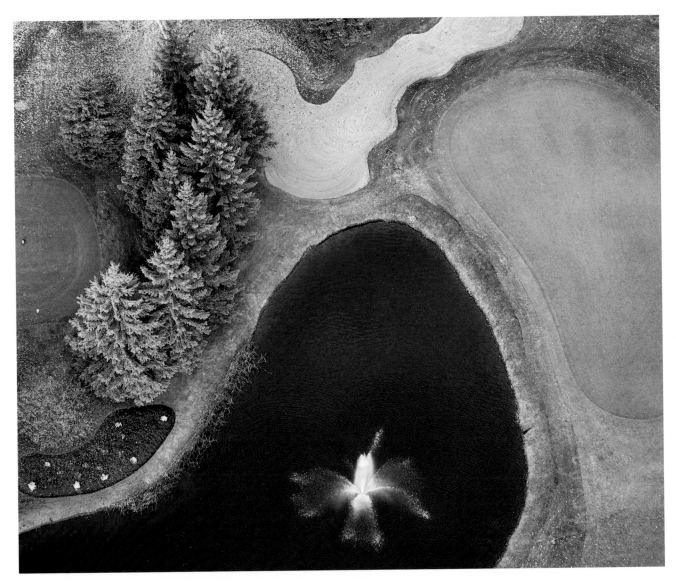

▲ *Figure 20.7*
Golf course fountain from balloon.

is lit only with an intense blue sky which will add some subtle blue, especially if there is a sheen to the rock.

Figure 20.7 is one of my first images shot from a hot air balloon. I quickly found that photographing horizontally from the balloon was pretty boring, but in looking straight down from only 200 feet up, the world changed from ordinary to a series of interesting shapes and patterns. I had a highly successful trip. I didn't have an image

stabilization lens and some images were not as sharp as I would like. While the 600-pound wicker basket is very solid, other passengers moving about results in it not being the steadiest of platforms. My 70-200 mm zoom was just about perfect for capturing the best images (on a full-frame camera).

I found I had to work very quickly in the balloon. Even things that drifted toward us changed so fast that framing and capturing were tricky, and things that appeared from

under the basket where I couldn't see them coming had to be captured especially fast. Although there had been almost no wind at ground level, we were drifting with the wind at about 10 miles an hour. Although not cheap, I highly recommend a balloon ride. As flights are usually arranged in early morning (less wind), the light is often optimal.

I was attending another workshop, this time with Bruce Barnbaum and Tillman Crane in Nova Scotia. We were too early for the fall colors, but on the ground I found a single red maple leaf, lying not too far from a cut tree stump, which had decayed to the point that it looked like a painting, complete with brush strokes. It isn't my habit to arrange things in nature, other than occasionally yanking out a blade of grass in front of my lens, but it just seemed so obvious to place the leaf on the stump. I guess you'd call this a natural still life.

Lying on the ground at Pioneer Acres northeast of Calgary was a series of augur bits heaped together. I figured the repetitive shapes had to work, those lovely curves interrelating. However, I tried a few images of the bits from the end, and was not satisfied with any of the images. Spirals are in fact just a series of repeated S-curves. When two spirals are interlocked, well, what more do you need?

When I went to the side, and used a longish lens, and didn't go for maximum depth of field, the blurred background, the slightly soft second rank of twisting steel, and the sun on the first rank of twists worked well together. Still, some considerable adjustment of tones was needed to bring out the best in the image (figure 20.9).

For practical reasons, I used shallow depth of field for the "Pipes Within Pipes" image (figure 20.10). The pipes were huge and couldn't be moved. The view through the pipes was distracting even in black and white. The only option

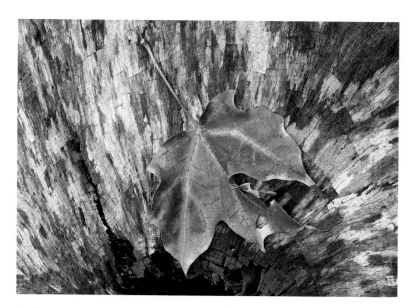

▲ *Figure 20.8*
The only fall colored maple leaf anywhere around and placed on a nearby rotting stump.

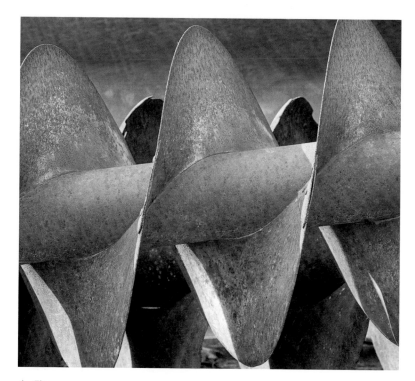

▲ *Figure 20.9*
Augurs behind augurs.

would have been a difficult editing job, or to blur the heck out of the background. It was only afterwards, and especially in black and white, that the lovely tones of the circular blurred pipes came to my attention—I sure didn't see the image this way in the viewfinder, even though technically it must have been blurred like this.

Thoughts On the Images

We often wait an hour for the wind to die down long enough to capture an image without leaves, grasses, and branches moving. Yet, I have seen many lovely images in which the movement wasn't completely eliminated, and also some truly wonderful images in which the movement was celebrated.

Andre Gallant and Freeman Patterson are Canadian photographers who have gone out of their way to move the camera during exposures to produce some gorgeous ethereal images.

Breaking rules is fun and it's even better when you can pull it off. Often, our ideas of what makes the ideal image are too rigid; whether it our ideas are about colors, tones, composition, subject matter, or approach. Shattering those rules instead of merely stretching them a tad can be rewarding. If you have decided to break a rule, then consider the properties of the rule you plan to break and determine how you might do the exact opposite to come up with an interesting image.

Think that all images have to have a full set of tones? Well, I broke the rule with the fan image of chapter 7 (figure 7.2) in which the image has no tones below middle gray. See what rules you can come up with, figure out how to really smash them, and see if you can make it work for you.

Most have heard of the rule of thirds. It might be better to rewrite it along these lines:

"*For lack of a better idea*, place the main elements of the image at the 1/3 position in the image, across or down."

This just might put the rule into perspective. If you have a really solid idea for a composition and it doesn't happen to follow the rules yet seems to work well, then feel free to ignore the rules—you have moved on past them.

If you want to have fun, then go out of your way to break the rule—place the main element exactly dead center, jammed up against one edge, or even tucked in the corner—and see if you can make it work. You'll certainly have more fun and you might just come up with an original image.

Consider, though, that before you can learn to break rules you have to learn to follow them or else you risk simply making a mess. Understanding the whys and wherefores behind rules is essential to understanding when and how to break the rules.

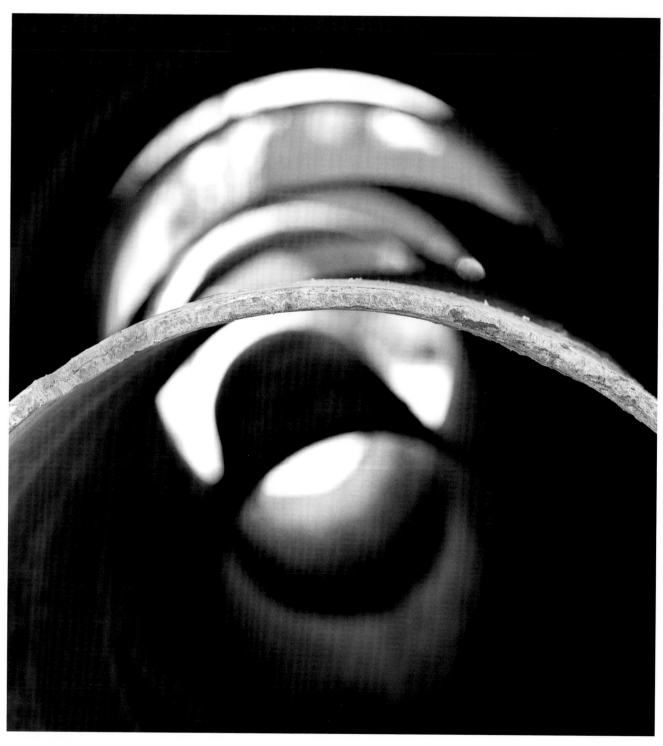

▲ *Figure 20.10*
Pipes Within Pipes.

21 Snow Plow

- *Techniques for enhancing local contrast*
- *Further use of the Black & White Conversion Adjustment Layer*
- *The Canon18-55 mm IS lens*
- *Taking local contrast (and sharpening) too far*
- *My sharpening routines*
- *Going "over the top" with image processing*
- *How to use Photoshop to do what Akvis Enhancer does, and reworking an image when you do*
- *Returning to an old image to rework it from scratch*

This rather ordinary image (figure 21.1) of a railway snowplow was made at Heritage Park, Calgary, in the roundhouse where it was lit by overhead mercury lighting. Despite the less than ideal situation, I liked the curves of the blades, the weathering on the surface, and the symmetry that can work (rule of thirds notwithstanding).

I did need to decide what to do with the unrelieved red of the plow; whether to leave it or convert to black and white. In the end I have absolutely no doubt that going to black and white was the right decision. You can see from the following images how I worked, backtracked, and came up with the final workflow. A single solid color can work for an image, especially when it's subtle, but I wasn't convinced an entire image of red would be good.

Images can alter radically in the conversion to black and white, with or without using the color sliders. Objects that are intense in color appear to be closer than those of more muted hues. Areas that contrasted dramatically in color can have similar tones in black and white. The sliders of the Black & White Adjustment Layer let you choose whether a fairly saturated color tone should appear anywhere from white to black in the output image depending on where the color sliders are set.

You need to know in the field what you can do with the black and white conversion process during editing because images that don't work in color or even in a straight black and white conversion may work wonderfully with adjusted black and white conversion—via filters or sliders.

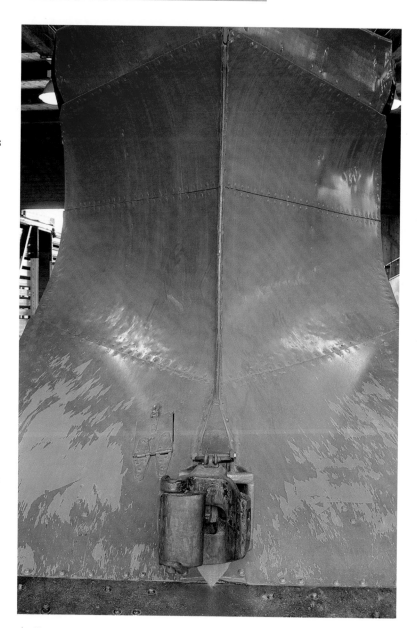

▲ *Figure 21.1*
Classic railroad snowplow, sitting inside display roundhouse at Heritage Park, Calgary—the output from Adobe Camera Raw.

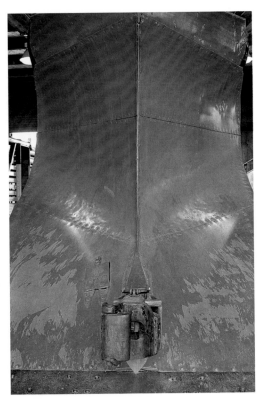

▲ *Figure 21.3*

Conversion to black and white without using the Black &
White Adjustment Layer sliders.

By playing with the red and yellow sliders, I was able to get better separation in the red snowplow blade. You will note though that it still is a long way from the streaky, detailed final black and white image (figure 21.3).

When I came to crop this image, I did something a little different. I selected the whole image (Command A), then did a Free Transform (Command T) on it (which allows the image to be stretched) and dragged the corners (hold down the Command key while dragging) until the base of the plow was horizontal and the background disappeared. This has the effect of "enlarging" the image a little so you might lose sharpness, but as you can see from this image (figure 21.3), I only had to stretch it about 20%, an amount that is, in my experience, insignificant. I stretched the top of the image a bit more than the bottom to fill the image with the blade.

In figure 21.3 you see the "unfiltered" black and white conversion using the default slider positions above. The next version (figure 21.4) included moving the red slider to the left, and

then adjusting the yellow slider to produce maximum details even though the image is too dark. I can deal with that later.

In any editing step, it is possible to create both good and bad at the same time. Sometimes the bad is easy to fix later and the small cost in effort is worth it to get the good parts just right. Other times an editing step will create untold headaches that will be hard, if not nearly impossible, to fix later. Only experience will tell you which is which. For example, in chapter 1, the Athabasca Falls image, I wanted more drama in the water and let it go too dark in order to bring out detail in the whites. In the snowplow image, I am more concerned about separation of tones in the blade than overall darkness. This is an easy thing to fix

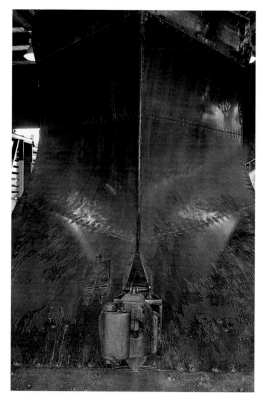

▲ *Figure 21.4*
The black and white image after using the sliders.

later, so I happily accept what the black and white conversion does. In chapter 8, the view of the mountains image, I needed to do a lot of work on the mountains and the risk was that if I was careless, I could end up with hours of fixing the trees in front of the mountains that would then be almost black from all I had to do to increase contrast in the mountains.

> At each editing step, consider both the good and the bad that your proposed next step edit can do to the image and ask yourself whether the bad can be easily fixed later, or are you in fact creating a future nightmare of editing hassles.

Following the two filtering examples, you see the effects of: 1) stretching the image as

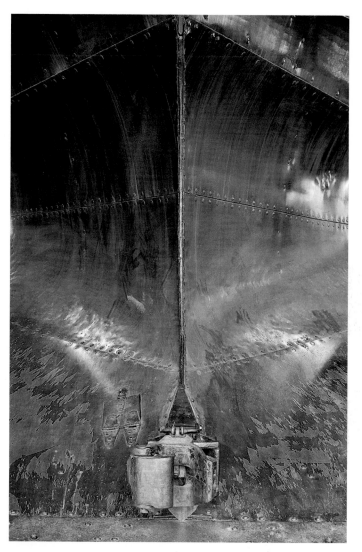

▲ *Figure 21.5*
Image has been stretched and a local contrast enhancing Unsharp Mask applied.

described above, 2) lightening the image a bit with a Curves Adjustment Layer, and then 3) applying Unsharp Mask (USM). Here I am attempting to increase the local contrast in the image, increase the streakiness of the blade, and accentuate the paint patches in the lower part of the blade.

This can be done a number of ways. For example, you can work with USM at settings

of 25, 50, 0, and can enhance contrast in the midtones, though it doesn't do much for highlights or shadows. The amount of Unsharp Mask applied is 25, and 50 is the radius of the Unsharp Mask. Where for sharpening effects, you'd normally use a radius of less than a pixel (e.g., .6), for this effect, you run it all the way out to 50 pixels, thus enhancing local detail contrast rather than simply sharpening details. The zero refers to the threshold of pixel-brightness differences to which you would apply the effect and zero means you apply it to every difference greater than zero. To sharpen an image with USM, you might use 200/.6/4. The advantage of Unsharp Mask is that it comes with Photoshop. You don't have to order or pay for anything. However, it does have its limits, and not surprisingly there are third party alternatives that will do what USM does and quite a bit more besides.

Alternatively, you can use third party plug-ins or scripts to enhance local contrast. The two I use are Akvis Enhancer and Digital Outback Photo's Detail Extractor and Resolver scripts.

Filter/Sharpen/Unsharp Mask 25, 50, 0 can be a quick, easy, and free way to enhance local contrast.

Figure 21.5 is the USM version. I have no doubt that further work with contrast enhancing Curves Adjustment Layers would further bring out texture. For the final result I used Enhancer instead because of its effect in the shadows and highlights, while USM tends to affect mostly the middle tones.

The process of enhancement does tend to emphasize noise. This image was shot handheld with my Canon 40D and the 18-55 mm IS lens at ISO 400. USM does not usually increase noise since noise is largely a function of dark areas—though, were you to lighten shadows to midtones, then, yes, it could increase noise.

▲ *Figure 21.6*
Image before use of Akvis Enhancer.

▲ *Figure 21.7*
Image after applying Akvis Enhancer.

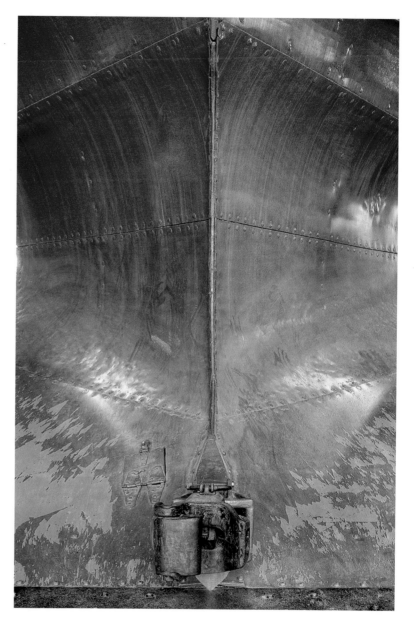

▶ *Figure 21.8*
The image as enhanced and further masked Curves applied.

Alternatives to Akvis Enhancer

By now you have realized that I use Enhancer a lot; even if I don't use it on all images, only occasionally use its full effect, and sometimes on only part of an image. It is possible, however, to duplicate the effect of a third party local contrast enhancing plug-in with only the tools that Photoshop offers.

First consider what Enhancer does to an image. It significantly opens up the shadows while at the same time separating the tones. Throughout the image, there is an increase in local contrast that enhances textures and reveals details not otherwise seen. Before Enhancer came along, I would simply use contrast enhancing Curves Adjustment Layers applied to selected areas, often using dozens of different curves, each to work on a particular brightness range of the print. While this would take time (okay, a lot of time), it could do something similar to Enhancer. Combining this technique with an application of Unsharp Mask described above, I could come close to the effect of Enhancer, for free, costing me only in terms of time spent. Obviously, I have felt it worth the price of the software or I wouldn't have been using Enhancer. But perhaps you don't want to alter your images this much and will be quite happy with a combination of Curves and USM for your images. Interestingly, I see that George DeWolfe has just started marketing his own plug-in, which in glancing at the ads, seems to do similar things to images.

If you are willing to spend a little money, then some of the actions and scripts sold by OutbackPhoto.com work very well, and with their plug-ins you can get a tremendous amount of control over local contrast control, sharpening, and tone control.

The snowplow was photographed with my 18-55 mm IS lens from Canon. I have been very pleasantly surprised by the lens. This "kit" lens is inexpensive and plastic but it does in fact produce some excellent images. The

center is sharp at any aperture, and if you are photographing people, really sharp edges are not essential. Stopped down, however, to f/8-11, the images are crisp corner to corner. The IS works extremely well, coping nicely with my 59 year old shaky hands, and the lens is quite tiny for a zoom, being not much longer and no wider than the "normal" lenses we used to purchase with our SLRs in days of yore.

Thoughts On the Image

It is remarkable the degree to which texture was brought out by the various techniques used to finish the image; Enhancer, Curves, Black & White Conversion with filtering, more Curves and, finally, a liberal application of Dodge Highlights. I would argue that had you not seen the original, you would think the final result quite natural. I have been criticized for "over Photoshopping" my industrial images, and as with much criticism there is probably some truth, some of the time.

In black and white we can concentrate on the tones and reflections in the blade of the snowplow.

Sharpening, Noise, and Print Quality

Image Sharpening

Entire books have been written on image sharpening, but since it is a part of my workflow for every image, I do want you to understand what I personally do—which isn't necessarily the same as what lots of other experienced photographers do—it's simply a system that works for me

I apply sharpening in a series of steps.

1. Modest sharpening in Adobe Camera Raw using the default settings, applied to every image and without playing with the settings to suit particular images.

2. Occasionally, I will do a second sharpening with Smart Sharpen in the Filters/Sharpen/Smart Sharpen menu, but this is image dependent and more often than not is unnecessary. I will often play with the settings here since there was some initial sharpening already done. Therefore, I will use Edit/Fade Smart Sharpening to reduce the effect, or I will duplicate the image in a new layer, sharpen that layer then use the Opacity Slider to reduce the effect or even use a mask to control where the sharpening is applied, avoiding sharpening in water and sky, for example.

 Do remember that if you brought RAW files directly into your stitching or focus blending software, no sharpening will have been applied and you will now have to do it all yourself. Here I'd use a full dose of Filter/Sharpen/Smart Sharpen, the settings being dependent upon the camera I used for the image. I found that with the Canon 1Ds2, the best setting was 300 for amount, .6 for radius. While Smart Sharpen allows you to play with the sharpening of highlights and shadows separately if you click on Advanced, I normally just use Basic. If you had already sharpened the image before, then adding this much sharpening results in horrible white pixels around everything—not at all what you want, so be wary when sharpening for a second time.

3. Using PhotoKit Creative Sharpening, specific sharpening can be applied to slightly out of focus areas to extend the apparent depth of field. I rarely use it but sometimes it can save an image. It was used in the image of the locomotive coupler in chapter 16.

4. All images receive output sharpening before printing via PhotoKit Output Sharpener. This is dependent upon print size and so I don't save the image with this applied, but add it each time before printing. Briefly, sharpening is needed for a number of legitimate reasons, some of which are described here.

 a. All digital cameras have a low pass, image-blurring filter in front of the sensor. Each pixel or light receptacle has a color filter over it. These red, green, and blue filters are laid out in a pattern. This means that any given pixel is only sensitive to one type of light, yet somehow we need to convert them all to full color. The math that does this is called the Bayer algorithm. It uses adjacent pixel information to determine what color to make each pixel, as well as what brightness. The "fuzzy" filter is there so that when photographing patterns like cloth, the Bayer algorithm that translates the various color filtered pixels of the sensor into a full color image doesn't go haywire and produce Moiré patterns that look something like the rainbow on an oil slick.

 b. The Bayer algorithm itself blurs the image somewhat in comparison to full color pixels.

 c. Small f-stops produce diffraction that can soften an image and this can be somewhat compensated for via image sharpening.

 d. Flaws in lenses and camera technique can contribute to undesirably soft images.

a. Ink tends to spread when applied to Inkjet paper. It does so more with some papers than others. For example, the latest glossy papers, such as Harman FBAL gloss, tend to spread the ink much less than most. This spread is called "dot gain" and that is why there is output sharpening of all images.

Over sharpening and prints that are too large are two of the most common faults of novice photographers.

Large prints are exciting and dramatic, but only if the images can stand up to the process. I am making a print for a very large home and the collector wants *big* prints. I made a 13 x 19 test print from the center of the image both to satisfy myself and the customer that the image would reproduce well the size requested. The print, from a single image from my Canon 1Ds2, will be printed 30 x 40 inches and it looks like it will be just fine at that size. I didn't add any extra sharpening nor did I scale up image file size. I simply did the appropriate output sharpening for that size print.

The one flaw I did find in making this big a print was that where I had fairly dramatically lightened some dark green water, there was now substantial noise that even the customer noticed on the test print. Although I never shoot at really high ISOs and have never felt the need for noise reduction software, in this case I decided to give it a try.

Fortunately you can download trial versions (or water-marked versions) of the most commonly used software. I tried Noise Ninja but didn't like the effect it had on the water that now looked a lot more like a painting—the noise was gone—but so was the detail. I tried fading the effect but couldn't come up with a good compromise. I tried Nik Dfine but it too had issues. I then went on to try Neat Image and found it did an adequate job on the noise without smearing detail, and that is what I will use on just the water of this unusually large print.

Any of these noise suppression plug-ins can do a great job in general, and the fact that one specific plug-in worked best in this rather unique example of dark green water does not necessarily tell you anything about which product is best overall. If you have a unique problem, you may, in fact, have to do what I did and see which works best for you for your particular image.

I don't have a 44-inch printer with which to make this image, nor the $7,000 to buy one, so I'll go to a high quality commercial printer to get a pigment ink print on my choice of paper. I will do my best to make sure that the image is profiled correctly. I will make a small print to bring along and I'll ask the printer to first make a small test print that can be matched to my print before having them make and then dry mount the large print.

In theory, if you are using a profiled monitor, understand color spaces, and have all the right settings in Photoshop, you should have no difficulty making prints that match the images you see on screen. But in practice, there are dozens of ways to screw up. I have a strong recommendation for those of you setting out on the quality printing trail: purchase the downloadable video called Camera To Print from Luminous-Landscape.com. This multi-hour video featuring Michael Reichmann, photographer and teacher, talking with Jeff Schewe, photographer, Photoshop, and printing expert, will save you untold hours of experimenting with settings. It is entertaining and informative and, at $35, a bargain.

It is a bit like sharpening your images. If the effect is obvious in the final print, you have overdone it. I had occasion the other day to make a large print of one of the industrial images from *Take Your Photography to the Next Level*, and while I like the overall tones, the local contrast enhancement looks definitely over the top to my eyes now.

Quality is a moving target—as you get better, what you accepted and even liked a few years ago is no longer good enough.

What I propose to do with this "over the top" image is go back to the RAW file and start completely fresh. I'll keep the tones of the final image in mind, but I'll try to do a better job on the details, hopefully producing an image that is natural yet with power—always a tricky balance and one that takes both practice and a critical eye.

◀ *Figure* **21.11**
I started over and didn't get quite so carried away and produced this result.

▲ *Figure* **21.10**
Too much sharpening had been applied to the old image.

Never be afraid to start completely over. Sure you spent hours working on the image, but if you now have doubts about it, at the very least give yourself a choice of images. It is only time you are spending.

For the photographer who is serious about their images, when it is a tradeoff between time spent vs. quality, quality wins every time.

Okay, I'm procrastinating, so here it is: first the crops of the old (figure 21.10) and new (figure 21.11), then the whole re-edited image (figure 21.12). I'm actually a bit embarrassed about just how far I took the original image. This time, I used the Hue/Saturation Adjustment Layer a couple of times with the Saturation Slider moved to the left to reduce color saturation, and didn't adjust local contrast in the background gravel, and didn't get as greedy with the texture of the pipe. nd didn't get as greedy with the texture of the pipe.

▼ *Figure 21.12*
The whole image as re-edited. Never fear starting over.

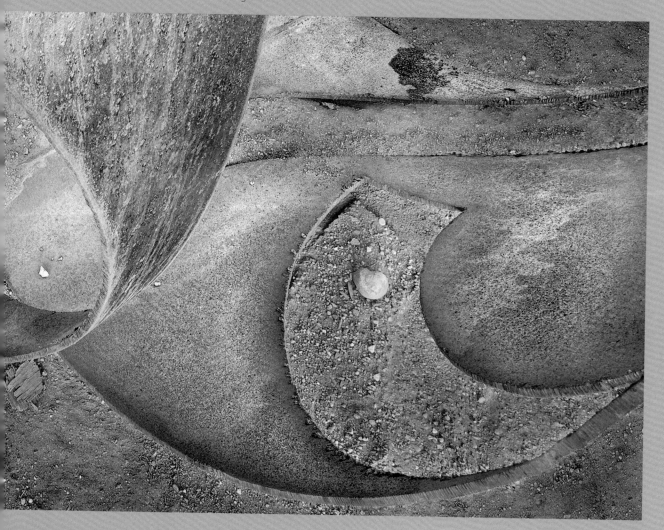

22 Still Life

- *Finding, adjusting, and creating images from found objects*
- *Zooms vs. fixed focal length lenses*
- *Checking depth of field*

Perhaps the most challenging subject for photographers is the still-life image. With complete freedom to choose subject, background, placement, and usually lighting too, it's possible to avoid problems. The choices available are infinite and knowing where to start is challenging to say the least.

Some photographers' entire reputations are based on still-life photography—of books, pages of music, dead birds, and all manner of odds and ends. It does allow for tremendous creativity and you can get into allegory and political messages and other intriguing ideas. You can also work with more ordinary material, simply trying to make a lovely image.

Material for a still life can come from your garden, tool shed, workroom, or the bottom drawer in the kitchen that holds all the domestic detritus that doesn't fit anywhere else. One of these days I'm hoping to photograph a huge chest full of tools my friend inherited from his father. I have no idea what to expect but I imagine I'll have fun figuring out what to do with them.

Still-life images have a number of advantages:

1. You can usually photograph them any time of the day.

2. They don't rely on weather, and in fact you can stay warm and dry while shooting.

3. There's no question of things not quite lining up and wishing that 1,000-pound boulder were a little bit to the right.

4. You can control contrast, shadows, and angle of lighting.

5. You can add a fill light with a piece of cardboard. It doesn't take a lot in the way of fancy lighting.

6. You can choose whatever objects you find interesting and which look like they might photograph well, whether it's peppers or medical instruments.

7. You don't need a lot of fancy equipment—just about any flimsy tripod will do, and if your current lenses don't focus close enough, a closeup lens or extension tube kit are not very expensive.

8. Perhaps the biggest advantage is that, if you don't like the image, you can quickly go back, make a change and reshoot, all within five minutes.

Even if the idea of still life photography isn't all that appealing to you, it can certainly be a good exercise, as you try to make meaningful relationships between the objects, their shadows and reflections, and the edges and corners of the image.

I suggest that you start by finding something interesting and refining its composition by moving the parts around. You can then graduate to entirely creating the still life—selecting objects, placing them, and lighting them.

Be on the lookout for interesting backgrounds—handmade paper, an old weathered board, rusted steel, even crinkled food wrap or tinfoil.

In the case of this image (figure 22.1), I had actually gone to photograph a steam engine (see chapter 16), but the 'boys' were doing some clean up and behind the locomotive

were a few piles of scrap steel plate. I ended my day shooting by working on these piles and I'm quite sure the fellows thought I was completely mad.

▲ Figure 22.1

Scraps of steel plate arranged into an interesting composition—as output from Adobe Camera Raw..

I was free to approach the stack from almost any angle and spent some time circling it to see what might make the most interesting composition. As is my usual strategy, when I see a possibility, I refine it via positioning of the camera, carefully choosing framing, and making one or two images before continuing the search for the best possible composition.

I eventually decided that the best position was opposite the window, but I wasn't quite happy with the arrangement of the sheets. I saw this as a square composition. (I'm very fond of square images.) To make the square work, it was necessary to rotate some of the items while shifting others. A little bit of repositioning was done (though there's nothing worse than inadvertently drawing your finger across a layer of dust, or, even worse, producing skid marks).

In moving found objects, we are hoping to balance one object against another. We rotate things to make interesting angles or to place a line in a corner of the frame. Areas that are flawed can be hidden and the more interesting parts made more prominent. With a lot of experience, you may simply move things around until they feel right, but for many with less experience, that feeling of rightness is elusive and it is better to have a strategy for moving the objects.

I now had my composition. The only technical issue was that of depth of field. Would I have enough depth of field to capture both near and far, bottom and top? I was photographing almost straight down over the bottom part of the image, but this did mean the top was a bit further away. In closeup photography, even wide-angle lenses can run out of depth of field.

I could have used my 90 mm tilt and shift, but I would have had to stand 7 feet over the composition, which would have been difficult at the least (though not impossible with a decent tripod and a step stool). I used my 24-70 mm lens so I could frame ideally.

While a fixed focal length lens, say my 50 mm f/2.5 macro, could have been used, I know that at f/16, the zoom is just as sharp. This isn't the case at f/5.6, but choosing a lens on the basis of it being great at an f-stop that you are not planning to use isn't especially helpful. Of course, the macro lens has other properties that make it useful. Plus, it's small and light and not a bother to carry around.

Would I need to stitch? Could I encompass the entire image depth with f/16? What I did was to make the image, then check for focus in the recorded image via magnification on the rear LCD, and in checking both the top and bottom of the image I saw that I had enough

▲ *Figure 22.2*
First version of the image—uneven lighting needs work.

▲ *Figure 22.3*
Much better balance of the brightness across the image.

depth of field—stitching would not be necessary. With my latest acquisition, a Canon 5D2, I would have used Live View and manual focus with magnification and checked all parts of the image.

Processing of the image wasn't especially tricky. I did use Akvis Enhancer to bring out surface detail. I had some balancing of brightness to do since the image wasn't evenly lit. I had to increase contrast because, while the light was somewhat directional, it was still pretty soft. This resulted in unrealistic color saturation and I had to carefully desaturate the colors in some areas but not others. I used a Hue/Saturation Adjustment Layer with masking and another similar layer with the yellow selected to tone down the orange rust a bit. I cloned out a few marks and junk but as you can see, left plenty behind.

The first version of the image (figure 22.2) was not especially good. It's still too uneven and the lighter areas of the image detract from the lines and shapes in the image. I actually had to back down a bit on contrast and further

darken the light areas until I was satisfied with the result.

The next image (figure 22.4) was even more of a still life. I found this heat exchanger end that had been converted to store lengths of steel and was hanging on the wall of a shipping container. I casually lifted it down only to find that the plate was one-inch thick steel—rather heavier than I'd anticipated. Still, I was able to move it and found some sheet steel lying on the floor of the container by the doorway and thus adequately lit. This made for a suitable background to the object. I moved the sheets around a little so the seams would work with the end plate and then circled the object, trying to find the best viewpoint, while now and

again rotating the plate. I specifically didn't want everything to line up. Perhaps it would have been nicer had the background line at the top of the print been located further to the right to balance the line in the bottom left, but as it was the edge of the same sheet, that would not have been practical.

I am told that I have the image (figure 22.4) upside down, that the "flames" which seem to be sprouting from the copper tubing are in fact corrosion that dripped downwards—still, I like the illusion of flame and continue to show the print this way.

Thoughts On the Images

I had at least as much fun photographing the tidied stack of steel scrap as I did the rest of the locomotive shop. Often these unplanned and unexpected images turn out to be the best of the day. Of course, if you aren't open to "off-topic" subject matter, then you can lose out. Even when I don't have a camera with me, I still frame images in my mind, noting arrangements and compositions. When I'm speeding down the highway, I'm still scanning for images—even without any plans to stop. This mental work keeps up our skills. More than one famous photographer has gone on re-cord saying that they need to keep their eye in practice, often by photographing every day, or at the very least by always looking at the world around them in a naive way, as if everything they see is completely foreign to them, and therefore fascinating.

▲ *Figure 22.4*

The cut off end plate for a heat exchanger.

23 Turbine

- *Working the scene*
- *Gradually refining images*
- *Some thoughts on success rate*
- *Productivity*

Funny how things work out. I'd decided on an overnight trip to Lake Louise but thought I'd travel the back roads and take my time. On the way is Ghost Dam on the Bow River. It's not especially huge or spectacular but I thought I'd check it out—you never know!

As I took a small dirt road to the dam, I passed what I recognized must be a turbine. About 10 feet across, brown on the top, and concrete looking on the bottom, it didn't especially strike me. However, having found that the dam was not working for me, I turned around and almost passed by the turbine again. Fortunately, I elected to have a closer look, and despite the rain starting, I made my way over to it.

I recognized the possibilities not so much of the entire object, but rather in the details. The blades that had looked dark brown and boring from a distance, were streaked and corroded, and the rain had started to trickle down from the mushroom-like top of the turbine.

As so often happens when I see something, I started by trying to photograph the whole thing. Figure 23.1 shows an early effort, keeping most of the width of the turbine but cropping top and bottom. I was concerned that soon the

▼ **Figure 23.1**
Old turbine sitting in a field—overall view.

turbine would be freckled with rain spots, which wouldn't help the appearance. I rushed to get my images. Funny just how often a subject like this, which should in theory be unchangeable, in fact is only available for a brief time. The sun comes out, the rain gets

▼ *Figure 23.2*
Close detail of corrosion
and rain water.

heavier, the wind picks up (okay, not relevant this time), or tourists show up.

I found that the narrow "waist" of the turbine meant bright areas on either side in any composition that would include the full width. Not good. Time to zoom in a bit closer. To my surprise there was significant flare here—the underneath of the turbine being 1.3 seconds at f/11, quite the difference to the bright albeit cloudy sky. When I switched to a wide-angle lens and moved almost under the overhanging top of the turbine, the sky was largely cut off and flare disappeared as an issue.

I walked around the entire turbine, but definitely the side that I first saw was best, and now it was simply micro management of position and cropping to make the best possible image. I sure wanted those lines of water streaking down but didn't want any distracting elements. There were bright bits of metal that looked like repair jobs. I wasn't sure about them.

Figure 23.2 was my first successful image. While I had planned to include an entire blade, moving in on the rain trickling down made a good abstract image. It did seem a pity to not include the blade edges, and so I tried a wider shot (figure 23.3).

This type of image is best handled by blending multiple shots in a focus blend. I think that I could well have gotten away with the deepest recesses of the turbine being blurred, but I hate things that are just a little bit blurred. Yet, that's exactly what happens when you stop down for maximum depth of field and it's still not enough—exactly the situation here. It can be better to open up considerably and go with more blurring, but that requires all the parts that need detail to be on the same plane, which wasn't the case here as the leading edge of each blade curved away. Neither a tilt and shift lens nor a view camera can handle this

kind of problem. Besides, focus blending works extremely well here.

For the last image I included more of the blades but didn't include the problematic top as in the previous image. You can see in figure 23.4 that the output from the RAW converter is a bit dull. I had to use the Recovery slider in Camera Raw just a tad to save the bright reflecting repairs. The image needed some life. One way to perk up a flat image like this with no pixels near either white or black is to move the ends of the curve. Moving the top end of the curve to the left will move pixels closer to white. Of course, it is very easy to go too far. A worse problem is that now many pixels are very close to white and won't show much texture or contrast. Ditto the issues with the shadows and moving the bottom of the curve to the right. I have found that the best solution in such a case is to move the top and bottom only half as far as they could go without losing pixels to pure white or black. Since this results in a steep, straight line-graph, contrast has been increased throughout the image. Alternatively, a series of S-shaped curves could be used, each applied to a small part of the image to eventually increase contrast everywhere.

Be cautious when shifting the black and white points of an image early in the editing process—better to leave yourself some wiggle room that can be fixed later than get too aggressive now and create problems handling the almost whites and near blacks.

Notice how I have cropped the final image (figure 23.5). I eliminated that distracting bright spot of metal at the bottom left. I took away some of the almost black area at the top, feeling that the amount that remained was about right. I

have trimmed all the way down the left side to bring the line of the blade to the upper left corner.

I suppose it would have been nice if I'd been able to take the other blade and make the line of it come to the bottom right hand corner, but as it is, there are diagonal lines in the shadows

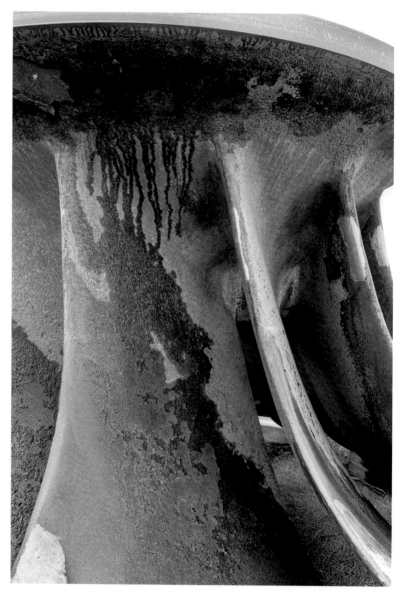

▲ *Figure 23.3*
You can see more but that sky sure is problematic.

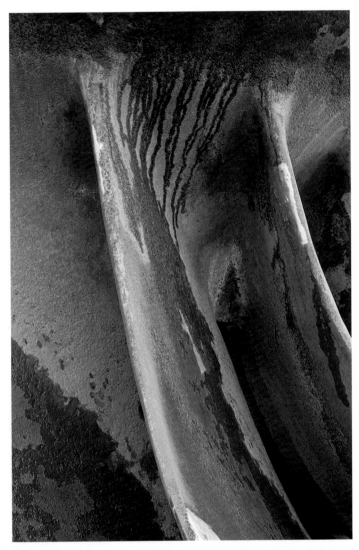

▲ *Figure 23.4*
Close enough to eliminate sky but including enough to get a hint of purpose. Note the flare causing low contrast.

Thoughts On the Images

The subject was nothing from a distance, a boring brown mass. Sometimes you have to take a gamble. It might be better close up. Sure, you walk away from lots of situations when up close it is just as bad, or perhaps even worse than you suspected. Occasionally, though, you are rewarded for your efforts. Sometimes the whole scene opens out when you move in; other times you find one particular detail that is fascinating.

The failed attempts outweigh the successes 100:1. But that means that if you make 100 attempts at finding an image, then more than likely one will work out well. Fortunately, it doesn't take 100 scenes to find one good image, it's more like one in four, so if you thoroughly work three scenes in a day, the odds are pretty good you are going to come home with one pleasing image. More days than not will be successful. We need enough successes to encourage us to head out the next time.

My excursions typically involve several scenes, separated by hiking or getting back into the car. Putting all your hopes on a single scene is risky. An exception would be if the scene were something like a long canyon where there are many possible setups as you wend your way to the other end. Often it pays to have a backup or secondary stop in mind in case the main scene proves disappointing, or if you simply don't seem to be able to solve the image puzzle today. You may be able to solve it on another occasion when you are fresher, less desperate, or just in a better mood. Sometimes the best image doesn't come from either situation but is a "find" as you travel between locations. Certainly I was there for the dam but the turbine was the find.

that lead there and I'm quite satisfied with the way it is.

Which image of the three is the best? Why do you think so? Can you apply these observations to any of your own sets of images?

Of course, the moral here is to always give yourself an option or two for later selecting, refining, and editing so you don't have to make these kind of decisions in the field.

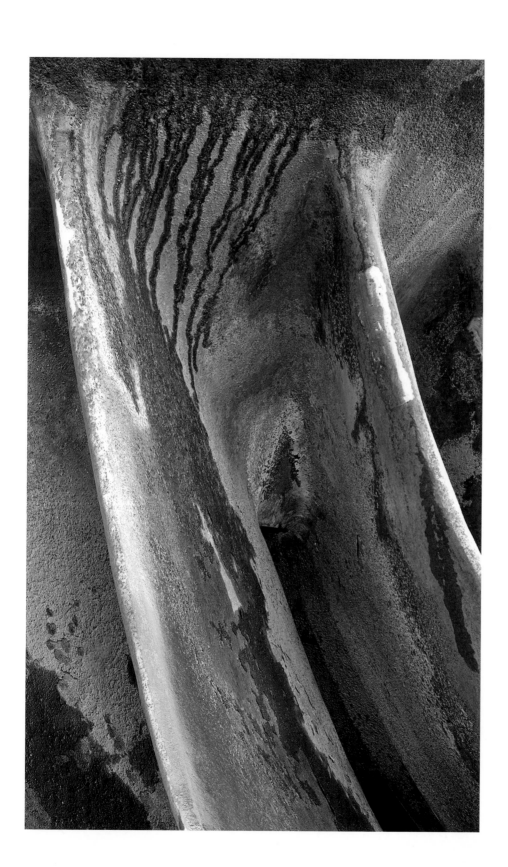

◀ **Figure 23.5**
The black point has been
corrected as well as other
changes to enhance texture
and contrast applied.

Afterword

That's All Folks

If you are reading this after finishing all the other chapters, you now have a darn good idea of my workflow, of what I will and will not do to improve an image, and of what is possible in the way of improving an image while still looking natural. All of the main images for each editing chapter are to be found on my website *www.georgebarr.com* and you are welcome to use those images to assess changes and even more effectively to try your own edits. I ask only that you do not use the resultant images on the Internet or in any other way than for your personal edification.

For each image that is posted, I will also include either the output straight from the RAW processor or the just-stitched or blended image before any editing was done on it so you can do your own editing and cropping. Remember that I use ProPhoto color space.

I wrote this book because a fair number of experts leave you with the impression that once you have fixed color balance, brightness, and contrast over the whole image, your editing job is finished. Either that or they show you only over-the-top editing which is hard to relate to real-world photography.

Excluding the chapter on manipulations, I would like to think that the end result of my edits is an image which looks natural and which someone familiar with the scene would recognize and still feel comfortable with. They might be shocked to see the difference between the original captured image and the final presentation image, but that's just the point—there can be dramatic differences, improvements, enhancements, or what you will, while still being unquestionably an image

of that scene and not something out of one's imagination.

I would like to think that someone could take my image of Athabasca Falls (chapter 1) or of the view of the Rocky Mountains from Stoney Reserve (chapter 8) to the scene and hold up the print and feel comfortable with my interpretation.

I didn't discover Akvis Enhancer until long after I was making good prints and getting published. You may well want to "do it the hard way" for some time before even checking out Enhancer. I fear that if you start relying on plug-ins like this, you will not learn the subtleties of fine art image making. Certainly, I would strongly recommend you do everything you can with the normal tools to get the best possible image and only then experiment with adding Enhancer to see if you can make your image even better, rather than using it early in the workflow as I have done in some examples. Not only will Enhancer possibly improve some of your images, it may help point out where your own editing work was less than perfect.

Helicon Focus, on the other hand, is a tool that lets you create depth of field that previously was only a dream. While a tilting lens may alter the plane of focus and, if you happen to be recording something that is flat, then all well and good, but most of the world is three dimensional. Objects stick up and out of any possible plane of focus. Only focus blending will create good depth of field in this situation. I have convinced myself that Helicon Focus is the best tool for the job and some recent reading on the net has informed me that others agree.

Even more than in my previous book, I have laid myself bare, both as to techniques and

cheats, but also in showing you a lot of poor images, hoping that you will learn from my mistakes. Andy Ilachinski, who helped with the technical editing of this book (and made it a lot better thanks to his suggestions), pointed out that there is a book of Henri Cartier Bresson proof sheets that show the master working toward his great images, not simply taking the camera out of the bag, firing off a single image, and next thing you know it's famous. Far from it. Truth is, the best photographers take a lot of bad images. It is part of a path, a workflow, a process toward making the great images.

The concept of taking many images of a scene is about learning from your mistakes, but that implies carelessness or lack of skill. It might be more accurate to say that you are refining your image, working toward a goal. People have written to indicate that ideas like this are all very well but surely it can't work for candid images, street photography, and sports shooting since your subjects won't wait for you. I disagree. I work to refine a single image, but the candid shooter also refines technique as he or she shoots, improving backgrounds, looking for stronger images, improving focusing speed, working on lighting and more, all the while waiting for the perfect enigmatic (Mona Lisa) smile. The alternative is to be ready for the smile but to screw up the image with poor lighting, bad background, camera shake, wrong depth of field (too little or too much), and the net result is a perfect smile surrounded by trash. How clever is that?

I continue to get emails indicating that photographers didn't realize just how much work could go into an image, either in working the scene, or in the editing. So, if I could offer two "take away" messages it would be this: first, working the scene is effective, practical, learnable; and, second, if you only make corrective adjustments in Lightroom or Photoshop, you have severely limited yourself in producing the expressive fine print.

Many photographers can see what needs to be fixed, but they have a harder time seeing how to go beyond to making stronger images, and in this book I have given you a number of examples of doing exactly that. May you have success in making your images more expressive of your feelings at the scene.

A Photoshop Primer

The following information will help you use Photoshop in the ways that I do. It most certainly isn't a complete guide to Photoshop, which would take up more than twice the size of this entire book.

When you open Photoshop directly instead of opening Photoshop by double clicking on an image, you get the screen shown here. Apart from the menus across the top, the areas you will use for this book are the toolbar on the left, the Histogram in the upper right, the History, Adjustments, Actions palette in the middle, and the Layers palette at the bottom right. Things may be arranged differently on your machine, either because someone previously moved things around or the version of Photoshop is an earlier one. It shouldn't be difficult to find the same parts of Photoshop

even if they have moved or are hidden. Check the Window menu if you don't see equivalent items on your computer screen and remember that if you hover the mouse over something, an explanation of what it is will appear after a few seconds.

I have not mentioned the many other areas, palettes, and so on because to use Photoshop for image editing in my style, you do not need them.

Tools Palette

You won't need most of the tools very often or at all. The following are tools that you do need to use.

Crop

The Crop tool does exactly what it says—you trim the image with this tool. Remember that if you have done some work on your image, just before cropping would be a good time to save the image, so do a Save As under a modified name. This way you keep your new work but can rescue your old work if needed.

Healing Brush

The Healing Brush tool copies an area and then applies the texture but not its brightness to another area of the image. The edges are feathered and what is covered nicely disappears. This is a super tool for removing hair and dust shadows from skies, blemishes from faces, and even softening wrinkles (by using less than 100% opacity as you apply the brush). You use Option-click on an area with similar texture to the area around the thing you want to hide, and then simply paint over the thing and, voila, it's gone. The only exception is that if you paint near an edge to a different color or brightness, the area over the edge will influence the blending and a mark

will appear that you don't want. When working near edges like this you have to use the Clone tool.

Clone Stamp

The Clone Stamp tool copies pixels from one place and then applies them to another place—brightness and all. In Photoshop CS4, you can see a representation of the area you sampled (Option-click) in the current position of the mouse. This is helpful when what you are cloning is something with lines in it—say a picket fence—since you can use the ghost of the area cloned to line up the pickets. Now you can painlessly remove the No Parking sign.

Paint Brush

The Paint Brush is the tool I use to do 95 percent of my work. It paints into masks to control where and how much effect a given Adjustment Layer has (see Layers below). It is rare to need to paint into an image itself but you can. When painting into masks, you generally paint with pure white or pure black, using the Opacity setting for the brush (top of the window) to control how white or how black the paint is applied. If you set the brush at 10% opacity, then each stroke over a given area will apply 10% of either white or black, whichever is selected. A second stroke will change the accumulated paint laid down to 20%, and so on.

If you apply 10% white on top of an area that is already 40% white then you will end up with 50% white. If you paint 10% black on top of 40% white, you get 30% white, since you subtracted from the whiteness instead of adding. Whatever color of mask you started with, black will darken by removing 10% white, white will add 10% until you reach pure white or black respectively.

If an Adjustment Layer is selected in the Layers palette rather than an image layer, and if you have not selected the associated mask (the rectangle on the right of the particular layer in the Layers palette), then you won't be allowed to paint. You will see a small circle with a diagonal line through it as your cursor, indicating "not allowed". If, instead, you select an image layer, then you will apply paint to the actual image, which you would rarely want. If a mask is associated with the layer (framed rectangle to the right of the link symbol), then your painting will be done with one of the two shades of gray shown at the bottom of the tool palette. Usually it starts out with black and white. In theory, you could change one or both to a gray, but since you can get full control of your painting into the mask via opacity, there really isn't any point in changing the paint color used.

History Brush

In the History palette, you can select a stage in the history for the image to be at, and then select another stage for the history brush. You can then paint the stage of the history brush into the current stage.

Let's say that you applied sharpening to an image, but before you get too far (i.e., more than the 10-20 steps you set your history to track in Photoshop preferences), you realize that you have sharpened both water and sky, and it has introduced a grainy texture that might show in the print and which you don't like. You go to the History palette and scroll back to the step just before the sharpening. You click in the box to the left of the step, and then, if you use the History Brush to paint with, wherever you paint, the image reverts to the stage before the sharpening. You can even do it the other way: Select the step before sharpening and click the box to the left of the last step at the bottom of the list of steps. Now, there is no sharpening anywhere until you use the History Brush to apply sharpening, perhaps just to the main object(s) of the image, leaving everything else not quite as sharp and thus less prominent.

Dodge

The Dodge tool is mainly used for lightening the already light parts of an image to brighten highlights (or create some new

ones). You can change the Dodge tool into a Burn tool by clicking on the bottom right corner of the icon for Dodge and selecting the Burn tool from the mini menu. At the top of the window, you will see settings for the tool, Brush Size, Opacity, and most importantly the Mode. You can set either Burn or Dodge to Shadows, Highlights or Mid-Tones, thus controlling the part of the image over which the tool has effect. 99% of my use is Dodge Highlights.

Hand

Use the Hand tool to move the image on your screen (but the space bar does the same thing). Double clicking the hand tool fits the image to the screen.

Zoom

The Zoom tool changes the size of image on-screen (but I use the scroll wheel on my mouse for that). Double clicking on the Zoom tool takes you immediately to 100% magnification—one picture pixel equals one screen pixel.

Other Tools You Don't Need to Know About (For Now)

Histogram

The Histogram is a graph showing the number of pixels of a given brightness on the vertical axis, and the brightness of the pixels from pure black on the left to pure white on the horizontal axis.

History Palette

The History palette simply lists the steps you have taken in editing the image. In Photoshop preferences you set the number of steps backwards that Photoshop can remember. I have mine set at 20. The more steps you can back up, the more memory used. You choose a setting that works for you based on the size of images you tend to work on; how many other applications are running at the same time; and how much memory you have in your computer.

Adjustments Palette

The Adjustments palette shows the sliders applicable to whatever Adjustment Layer you are currently on. It shows immediately when you create the new Adjustment Layer. It hides when you do other things. You can double click on the Adjustment Layer icon for that layer to re-show the sliders, graphs, and so on.

Actions Palette

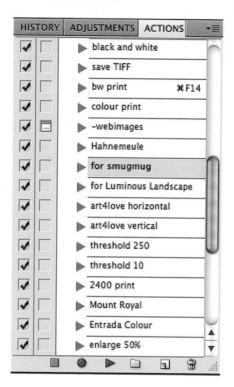

The Actions palette is simply a list of short-cuts, either supplied as imports or ones you have recorded yourself for convenience. I have a shortcuts to resize images for a particular website, or to do any of the dozens of other multi-step processes for which I would like a short cut.

Layers Palette

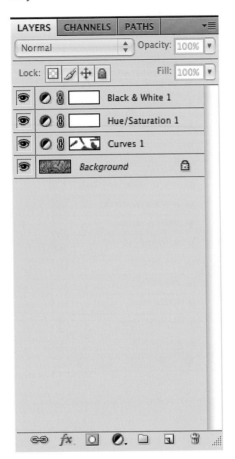

The Layers palette is where all the editing action takes place. If you load an image into Photoshop, an icon for the image will appear in the Layers palette, marked as background (i.e., your image sits on the bottom of a future pile of adjustments). At the bottom of the Layers palette are a series of small icons which let you add a mask (black or white), add a new Adjustment Layer, duplicate a layer, or throw out a layer.

During image editing, I rarely have to access the menus across the top of the screen, as most are not needed to edit an image, and for the few that I use regularly I either use the keyboard shortcut that was already present, or I create one of my own (Edit/Keyboard Shortcuts). I created one to flatten the image (i.e., compact all the layers, maintaining their effect).

The F key lets you toggle through: image on top of other applications or image on top of gray screen or image on top of black screen with menus, tools, and palettes hidden.

The X key reverses the active and background colors for tools (these colors are the two rectangles at the bottom of the tool bar on the left.

Color Boxes

When a mask is active, the two colors are automatically black and white. If they are colored, then you didn't select the mask of the current layer like you thought you did. If you try to paint but you can't (the circle with diagonal line through), then you aren't on the layer you thought you were on. I find the most common scenario here is when you undone something and not only does Command-Option-Z undo the previous action(s), it also changes back to the layer selected just before you started the current activity. You simply have to reselect the appropriate layer after the undo.

Command-I inverts an image, or a mask. That is, if the mask is white, it turns it black, if the image is selected instead of the mask, you get a negative of the image.

There are many other single-key shortcuts, but I only ever use them by accident.

Some Basic Menu Items

File/Import is where you will find the drivers for using your scanner (if they were installed properly), and Photoshop must be restarted after any tool, driver, plug-in, script, or automation has been added before they will show up in the menus.

File/Automate is a useful menu selection. Here you will find such things as Fit Image, which takes whatever image is on screen and active, and resizes it to fit within a certain size, specified when you select this submenu.

Here too you will find PhotoKit Sharpener, Capture, Creative, and Output. Also you can find Merge to HDR and Photomerge (which is Photoshop's stitching facility).

The Edit menu has Step Backward (Command-Option-Z) and Step Forward (Command-Shift-Z). Remember that the number of steps you can go back is set in Photoshop Preferences found in the Photoshop menu.

Edit/Fade if used immediately after applying an effect on a layer (e.g., sharpening), will allow you to not only fade the effect anywhere back to zero (no effect at all), it even lets you control the blend mode for the effect (e.g., darkening, color burn, etc.). Once you do anything else at all, even clicking somewhere, the Fade is no longer available. Use it immediately or not at all. Fade is handy for those things that don't create their own layer—for example, sharpening.

Edit/Transform and Edit/Free Transform allow you to change the shape of the image. Transform lets you control which way you change an image (resize *or* stretch *or* warp, etc.), while Free Transform allows you to change the image in a number of specific ways through on screen manipulation with the mouse (dragging corners or edges, rotating the image, etc.).

Color Settings

Edit/Color Settings is a critical control that you use once and generally forget afterwards. Here you see the settings I use so that colors come out correctly in prints, and images loaded into Photoshop are treated with the respect they deserve.

The first setting is the RGB color space I use for my image editing. sRGB is a very limited color space (range of possible colors) used for the internet and in some cheap cameras. Adobe RGB 1998 is a larger color space, often used by better digital cameras and an acceptable color space for image editing. ProPhoto color space is even larger (greater color range and saturation) that can take advantage of even the best color produced by the latest batch of professional quality printers. Gray Gamma controls the contrast of images and how various levels of brightness are mapped. Your setting doesn't really matter so long as it agrees with how your monitor was profiled (you did profile your monitor, right?). The rest of the settings are not as critical, but it is best to simply copy mine until you are familiar enough with the various settings to change them with confidence.

Edit/Convert to Profile is useful when you want to save an image in a format other than

your usual, for the web for example (in which you'd convert from ProPhoto to sRGB).

Image/Mode is useful in that you can convert from 16 to 8 bits (for the web or for contest submissions, for example). It lets you switch from RGB to Grayscale (though I rarely use this for my black and white images, preferring to keep them in RGB. Grayscale is useful to me for one thing: is to take advantage of duotone tinting of black and white images (though there are other ways to do it).

Image Size

Image/Image Size is used to resize your images up or down. I generally follow Photoshop's advice—using Bicubic Sharper for downsizing and Bicubic Smoother for upsizing. I rarely upsize (unless I am making a truly gigantic-sized print). Jeff Shewe, printing guru, suggests that you go down to printing at 150 dots per inch to make larger prints before considering upsizing (for a given image, changing the setting to fewer dots per inch means a bigger print size, if you don't resize the image at the same time).

Pixels-per-inch is often confusing a concept. For a given image file, you can set the pixels-per-inch to anything you want and you don't change the file size. What you do change is how large a print you default to when you go to print the image. Thus, pixels-per-inch really has no relevance before printing. If you turn off resize image in the dialog box that comes up with Image/Image Size, you can change the pixels-per-inch. As I have Adobe Camera Raw to set every processed RAW file to 300-pixels-per-inch, I normally don't have to change this setting at all.

Image/Canvas Size lets you change the size of the virtual canvas upon which your image lies. For example, if you increase the canvas, there will be blank areas around the image—useful for stretching an image.

Image/Rotate Canvas is frequently used, especially if you don't have Auto Rotate Images in your camera.

I never use the Layers Menu other than that I set up Flatten Image as F13 on my keyboard, and very occasionally use Layers/Merge Down to apply one layer to the next one down (thus eliminating one layer).

Select/Select All and Select/Deselect All are useful, but I normally use the Keyboard equivalents of Command-A for Select All and Command-D to Deselect All.

Filter/Blur/Gaussian Blur is handy for softening an image, or more often part of an image—for example a background.

Filter/Distort/Lens Correction is used to correct perspective distortion, pin-cushion and barrel lens distortions, and other problems.

Smart Sharpen

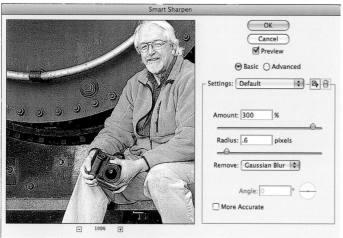

Filter/Sharpen/Smart Sharpen is useful if you haven't applied enough sharpening in Camera Raw (or skipped that step when you loaded RAW images right into stitching or blending software).

Filter/Sharpen/Unsharp Mask can be used for sharpening, but I normally use it only to enhance local contrast, by using the settings 25 for amount, 50 for radius, and 0 for threshold.

Below the normal Filters list you'll see any that you might have installed, such as Akvis Enhancer or Nik Silver Effex Pro and so on.

View/Proof Setup allows you to choose the profile for a particular combination of printer/printer settings and paper.

A profile is basically a foreign language dictionary. Instead of translating words, it translates colors and brightness levels. Profiles can apply to cameras, monitors, scanners, or printers. In the normal course of events, I deal with monitor profiles and printer profiles.

In the case of a monitor profile, it is necessary to purchase some sort of color reading sensor (for example, a Spyder). The profile takes the color your monitor actually produces from particular color information in an image, and knowing what the color should have looked like, produces a translation. For example, let's say your monitor underestimates how yellow something should be, and not only that; it makes the color appear a bit greenish instead of pure yellow like the image file dictates. In the profile-making process, the software knows how yellow your monitor can make things and knows what it would take to remove that green cast from what are supposed to be pure yellows. The profile then instructs the monitor to increase the saturation of the yellow a bit so it matches what was intended (as accurately as possible anyway) and it instructs the screen to display the yellow a bit warmer to compensate for the tendency to display yellow as yellow-green. Net result, much more accurate color. As most monitors can produce the necessary colors, it's more a matter of translating those color shifts. Using a profile, yellow in a file is yellow on screen.

Having an accurate monitor, you now need to translate the colors on screen to the colors produced by your printer. Fortunately, modern printers are of such high quality that color differences between several printers of the same model are tiny and for the most part can be ignored. Color differences between models and makes, and even more so, between brands and surfaces of papers, is a whole other matter, and once again we need a translator so that the yellow you see on screen comes out as yellow in print. No printer can perfectly reproduce what is seen on screen, so a printer profile not only

translates from screen to printer, it can also translate back from what the printer is able to do, to the color on-screen. It is this backwards translation that gives you the ability to proof or preview what the print will look like.

For example, let us say that a particular printer/paper combination is unable to produce a really accurate green. The profile would help you print the best green possible, but the reverse translation facility in the profile would allow you to see on screen what the effect will be in print.

For most of us, we simply use commercially prepared profiles specific to the brand and model of our printer, and to the brand and surface of our paper. It is possible to buy a profile maker so you can profile your own papers, but so far, I have managed without one. The biggest advantage of doing your own profiles is when you are using less common papers for which there is no really good profile available.

View/Proof toggles on and off what your prints will look like. For example, if using a really glossy, high quality paper, you won't see a lot of difference when you proof the paper, but if you are using a matte paper, Photoshop will simulate the more muted colors and lighter blacks that are produced on matte papers. You don't have to use proofing, and most of the time I don't, but many professionals can't imagine not using it and for matte papers it can be very helpful.

To me, it is a way to predict how badly my printer and paper are going to let me down, and sometimes I'd rather not know, choosing instead to simply make the best possible print, knowing full well that a matte paper isn't going to produce an image that matches the screen, no matter what I do about it.

Window is useful for setting up two images side-by-side or one above the other for comparison purposes.

And believe it or not, that's it for menus. I left out far more menus than I described but the ones listed above are the ones I do more than 99% of my work with, and you won't have to go beyond these until you are a Photoshop expert (or are reading one of those Photoshop books written by a commercial photographer).

By now you know the tools I use from the Tool palette, what menus I work with, and where to find the History and Actions palettes, and most especially the Layers palette. If I haven 't mentioned something, it's because you don't need to know it.

The History palette is pretty self-explanatory and I won't go into discussing Actions for now (though it isn't difficult and is very handy for things like my Highlights Threshold action discussed in the book). I use Actions to change size to fit, alter color space for the web, convert from 16 to 8 bits, flatten an image file, and finally save it as a JPEG to a particular folder, all with a single button press or keyboard shortcut—very handy.

The Layers palette deserves more study since it and the concept of layers and adjusting layers is fundamental to how I edit my images.

Image Editing Philosophy

I use Adobe Camera Raw to set the overall image characteristics—color temperature, brightness, basic sharpening, and so on. When I bring the image into Photoshop, I start working on the image piece-by-piece. I will select an area of the image that either needs correction or improvement and work on that area. If I think that what I did to this area can be applied to other parts of the image, well and good, but

otherwise I'm ready to move on to the next area with its own Adjustment Layer(s). The total edit is the sum of all these corrections/improvements. I do sometimes do a global correction—generally lightening the image, for example, or decreasing color saturation all over—but for the most part it is piecemeal work, just like making a quilt. Each piece of the quilt needs its own set of tools for the fix or improvement. This isn't the only way to work, but it has been successful for me and this basic concept will help you understand the following.

Layers Icons

The fundamental concept of Photoshop is that you start with an image and to improve the image, you add a series of adjustments, each in its own layer on top of the original image. Layers can be an adjustment, another image (or the same image processed differently or a duplicate of the image), a text layer or a gradient. In practice, for normal image editing, I only use image layers and adjustment layers.

The whole point of Layers is that they can be readjusted later, toned down with the Opacity slider, or masked so that the adjustment only takes effect over part of an image. I don't often go back to make further adjustments with a given layer, preferring to add a new one rather than risk changing more parts of the image than I bargained for.

The Adjustment Layers I Use

Here is a list of the Adjustment Layers I use, followed by a description. Each Adjustment is selected from the Layers icons at the bottom of the palette.

- Curves
- Vibrance
- Hue/Saturation
- Color Balance
- Black & White Conversion
- Threshold
- Selective Color
- Layers Icons Curves

Curves

Curves is by far my most common tool for adjusting images. Curves controls brightness and contrast. There are other ways to do

this but this has been the best method for me—with complete control over how and where the effect takes place. When you add a Curves Adjustment layer, the Adjustment palette shows a graph representing a mapping of brightness levels. On the horizontal axis are the tones of the underlying image (or images with other adjustments). On the vertical axis are the output brightness levels after this layer is taken into consideration. A diagonal straight line running from bottom left to top right means that every tone in the image below is unchanged by this layer. Anywhere that the line is pushed higher than this "neutral "position, the output tones are brighter than the input tones. In Photoshop CS4, you can place your mouse over the graph, and below the graph you will see what happens as the input and output brightness level are recorded. Although you may be in 16-bit mode (32,000 shades from black to white), the graph is always shown as a range of brightness from 0 to 255, black to white. Try moving your mouse around and you will see that if you move in a horizontal line, the output brightness doesn't change but the input brightness does. Likewise if you move vertically, the input brightness doesn't change (in the numbers below) while the output brightness numbers do.

You can do three basic things with this curve. You can move either of the end points or you can change the shape of the curve that runs between end points. If you were to move the white end point (upper right corner) to the left, you are basically saying that any tones that were originally to the right of this point in the graph will now be pure white. This can be useful in a very low contrast image in which there are no whites, or even near whites, but you would like some. You can do the same with the black point bottom left by moving it

to the right along the bottom, thus turning any tones that fell to the left of this point pure black.

If instead of moving the white point left, you moved it down, you would not clip any tones, but the output image would not reach pure white anywhere because the graph never reaches the top (pure white = 255 brightness). Raise the black point, and nowhere on the output image (the image as affected by this adjustment layer) will there be pure black. Both of these situations are rare, but not unheard of. There is at least one example in this book of doing this for selected parts of an image.

In between the white and black points, you have a line, which through setting points along the line by clicking on the graph. The part of the line immediately above or below where you click will now jump to where you clicked and you have altered the shape of the curve. These set points can be dragged or deleted as needed.

In between the two end points you have the line of your graph. If there are no points set on the graph, it will be a straight line. If you click on the graph, you create a set point and the line now jumps to the point you set. You can add, move, and delete set points as desired to produce the necessary curve.

Anywhere on the graph where the line is now higher than the previous 45-degree diagonal straight line from black to white (1:1 ratio in to out), the image will become lighter. Below and the image will be darker. Any place that the slope of the line is steeper than 45-degrees and you increase contrast in the tones of this area. Flatten the slope and contrast goes down. Reverse the slope and you get bizarre and unreal effects (see chapter 17 on manipulations).

If you create an S-shaped curve, the steep part of the S increases contrast while the head and tail of the S reduce contrast. Move the

steep part left or right and you control which tones in the image have contrast increased. Move the steep part of the curve right and the increased contrast is in the light tones. Move the steep part left and it is the darker areas that increase. As it is simple to play with curves, you can quickly learn the effects of any curve on your image.

Vibrance

Vibrance is a new control to Photoshop CS4. While Saturation increases have little effect on the most muted colors, it has a dramatic effect on the most saturated. Often we'd like to increase the subtle colors but don't want to drive the really saturated colors to cartoon level. Vibrance does exactly that by having more effect on the muted colors than on the saturated colors. You can do the same thing in Camera Raw and I don't often use this slider inside Photoshop. It would be rare to turn down Vibrance, but you can—if, for example, you overdid it in Camera Raw, or if you wanted to create a mood effect by taking color out of the image.

Hue/Saturation

Hue/Saturation does as described above. The slider most affects the strongest colors. In addition, there is a second slider that affects hue—that is the type of color as opposed to the amount of it. Adjusting the Hue slider can create some bizarre colors in the image, but a very small adjustment to the left can warm up colors—and there is an example of this in chapter 8.

Color Balance

I don't use Color Balance often, much preferring to get the color temperature right in Camera Raw, but sometimes you need to make adjustments. I remember a portrait session in which I had north light from a window on one side and incandescent floods on the other—boy was that a mistake. Color balance was helpful in that situation, literally changing half of each face so the temperatures would more closely match. I don't use it very often because the changes occur across the board and affect the neutral tones too. My preference is for a control where I can work on one color at a time.

Black & White Conversion

This is not my usual method of converting to black and white. I refer to alternative methods in the book, but the Black & White Adjustment Layer is very powerful. It comes with sliders for the various colors and so I can lighten greens while darkening yellows; darken blues but lighten greens; and do all manner of "filtering". In addition, I can use a second Black & White Adjustment Layer with the first (lower) layer having some areas black masked. Where the mask is black, the second conversion is the one that controls the tones, and so I can have one part of the image set one way, and another part a different way. For example, I could darken blue sky with one layer while lightening blue water with another.

Threshold

The Threshold Adjustment Layer feature is used for one specific purpose. It lets you set a number between 0 and 255, and it will turn every pixel of brightness less than that number to black, while leaving all the other pixels as they were.

Selective Color

With Selective Color, you select the color from a menu and then you can change that color by adding or subtracting yellow, cyan, or magenta.

For example, you could select yellow and add a bit of magenta, and then all the yellow leaves in the image are a bit warmer—closer to orange instead of the yellow-green as recorded by the camera, but you didn't remember seeing.

Above are all the Adjustment Layers that I use. In addition, I sometimes duplicate the image so I can work on a copy layer. This is done by taking the image layer and dragging it to the "Create A New Layer" icon at the bottom of the Layers palette.

The real power in Layers is that you can do things to a layer. You can control where the layer takes effect through masking, you can fade the effect by using the opacity slider at the top right of the Layers palette, and you can choose a variety of blending methods from the pop up menu on the top left of the Layers palette. I only occasionally use any blending mode other than Normal, and I'd suggest that playing with blending is the "Advanced Class" of learning Photoshop, but it can be powerful and useful if you know what you are doing. For example, if you set the Blend mode to Lighten, then a given adjustment layer will only lighten pixels, never darken. If a pixel were to be darkened by the adjustment, then it doesn't change. If it were to be lightened, then the effect is applied as per normal.

Layers Icons

The tools across the bottom of the Layers palette that I use are the third from the left, "Add a mask" icon. If the Options key is held down, this will create a black mask or else it creates a white mask. Fourth across is "Create new fill or adjustment layer". I use this all the time as I add various layers. The new layer will be added directly above the layer that is currently highlighted, or at the very top if none are highlighted. There are times when you might want to add a new layer well down in the stack of layers. Let's say that you have been doing some work on an image and five layers up you decide it is time to convert the image to black and white. You want a dark sky but the blue was not very intense and the use of the blue slider in the Black & White Conversion Adjustment Layer isn't as effective as you'd like. You can go back down the stack to where the image was still color and add a Hue/Saturation layer, select Blues instead of Master in the pop up menu upper left in the Adjustments palette, increase the saturation of blue specifically, and now the Black & White Conversion Layer has some real blue to work on and can darken the sky nicely.

All of the above, combined with the usual Open, Save, Save As, and Print menus will allow you to do a tremendous amount of image editing and it could be some time before you will need to go beyond using these tools. Other people use Photoshop in different ways and that's just fine. Photoshop is a powerful tool and often there are several ways to get to the same place. I simply have been showing you my way and the way that will help you use this book to best advantage.

Once you have mastered the above controls, you can start to experiment with some of the other tools and techniques, but since the above are the tools I normally use, you shouldn't be in a hurry to add new techniques until you are thoroughly familiar and adept with the ones above.

Index